JOHN RUSKIN
the argument
of the eye

ROBERT HEWISON

JOHN RUSKIN
the argument
of the eye

PRINCETON UNIVERSITY PRESS
PRINCETON, NEW JERSEY

Contents

A Note on the References 6

Foreword 7

1 Ruskin and Nature 13
2 Ruskin and the Picturesque 30
3 Ruskin and Beauty 54
4 Ruskin and the Imagination 65
5 The Artist and Society 119
6 The Queen of the Air 148
7 Action 167
8 On Seeing What Ruskin Meant 191

Notes 213
Bibliography 219
Sources of Illustrations 224
Index 224

ὄλβιος ὅστις τῆς ἱστορίας ἔσχε μάθησιν

A Note on the References

Quotations from Ruskin's published works are taken from the Library Edition of 1903–12, referred to by volume and page number, thus: (28.312). References to editions of his diaries and correspondence are coded as shown below. All editions used are listed in the Bibliography on p. 220.

D: *The Diaries of John Ruskin.*
RFL: *The Ruskin Family Letters (1801–1843).*
L45: *Ruskin in Italy, Letters to his Parents 1845.*
LV: *Ruskin's Letters from Venice 1851–52.*
WL: *The Winnington Letters of John Ruskin.*
LMT: *Letters of John Ruskin to Lord and Lady Mount-Temple.*
LN: *Letters of John Ruskin to Charles Eliot Norton.*

Writings by Ruskin still in copyright are quoted by permission of George Allen and Unwin Ltd and of the Ruskin Literary Trustees.

Foreword

RUSKIN liked to say that his works were like a tree. The image is apt, for they have their roots in several different kinds of soil, and their branches end up pointing in different and sometimes opposite directions. He used the image to explain the alterations of direction as natural developments: 'All true opinions are living, and show their life by being capable of nourishment; therefore of change.'(7.9) To trace these changes I have followed certain themes as they spiral upwards around each other. The result is a chronological account of Ruskin's development, through a series of overlays, as each chapter returns to pick up the beginnings of a new theme enfolded in the old.

The common element is the visual dimension in Ruskin's work. In a sketch of autobiography Ruskin once marked the moments of change in his life as each taking place in front of, or as a result of, the work of a great painter. I have chosen these moments of visual persuasion as a motif. No one could put the case for a visual approach to Ruskin more strongly than he did himself: 'the greatest thing a human soul ever does in this world is to *see* something, and tell what it *saw* in a plain way. Hundreds of people can talk for one who can think, but thousands can think for one who can see. To see clearly is poetry, prophecy, and religion, – all in one.'(5.333)

This then is a study of Ruskin's visual imagination. It is not exactly art history, literary criticism, aesthetics, economics, or philosophy. Instead it tries to show how these formal disciplines found their relations within Ruskin's mind. I have not attempted to state definitively where Ruskin stands in terms of any 'tradition', either looking forward or looking back. Of course this study could not exist without the help of the specialized studies which do try to fit Ruskin into the formal categories I have mentioned. I have tried to show my obligations in my notes and bibliography, but I would acknowledge especially the work of Patricia Ball, Paul Walton, George Landow, and Francis Townsend. Above all, I must stress that this is not the first attempt to see Ruskin's work in terms of the mind that made it, and John Rosenberg's study *The Darkening Glass* suggested many ideas to me.

My personal debts are numerous. To Leslie Megahey, who commissioned the television documentary which first fired my enthusiasm for Ruskin; to Mary Lutyens, who first introduced me to the Ruskin circle, and to James Dearden, who welcomed me to it. As curator of the Ruskin Galleries at Bembridge and secretary of the Ruskin Association James Dearden is a key figure for all students of Ruskin, and I thank him for his generosity in time and knowledge. I owe a particular debt to Rachel Trickett, who supervised my belated attempt to turn enthusiasm into academic seriousness, and guided me through my B.Litt. thesis. My college tutor, Eric Collieu, has given me much welcome advice and encouragement. I would also like to thank Sam Brown and Van Akin Burd, both eminent Ruskinians, for the interest they have shown in my work.

To Catherine Williams I owe first of all a formal acknowledgement of her permission to quote from her unpublished thesis; but I have also learnt a great deal from our many discussions, and I look forward to the publication of her own study. Finally, I must thank my sister, Anthea Ridett, for all her efficient help and practical criticism; and I would also like to thank, in my various ways, Katharine Crouan, Gwyneth Henderson and my editor.

FETTER LANE

1 *Paolo Veronese,* Solomon and the Queen of Sheba *(detail). Ruskin's study of the painting in 1858 led to an 'unconversion' away from narrow religious scruples and into full acceptance of sensual art: 'working from the beautiful maid of honour . . . I was struck by the Gorgeousness of life'(7.xli). See p. 123.*

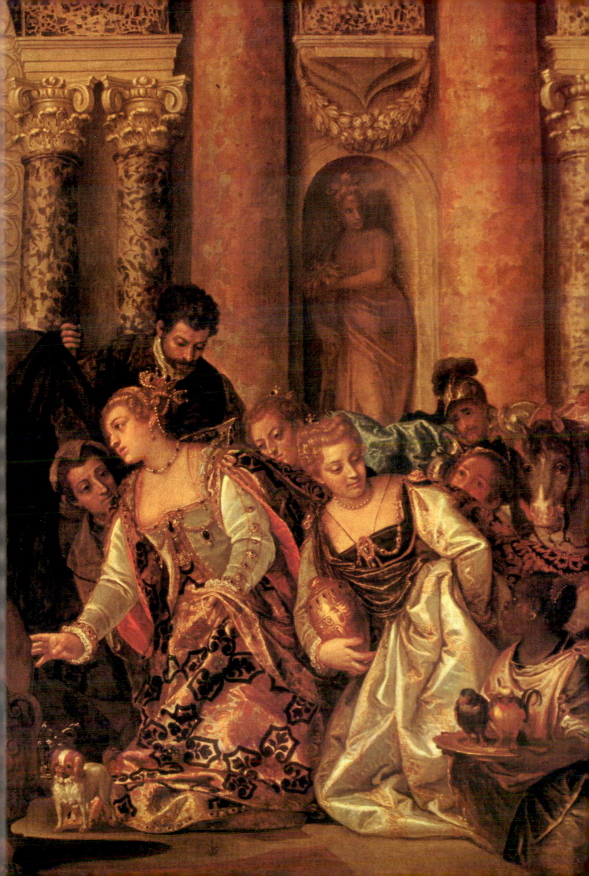

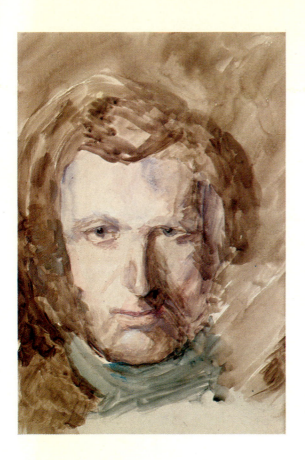

2 John Ruskin, Self-portrait, 1874. Ruskin at 55,
wearing the blue stock he customarily wore.

3 John Ruskin, Amalfi, 1844. A full-scale attempt
to imitate Turner's later manner, based on a drawing
of 1841 (illustration 23). See p. 66.

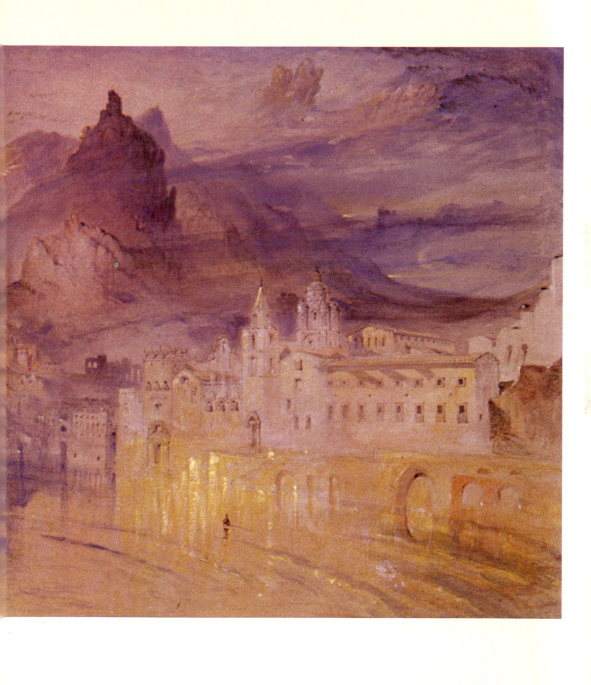

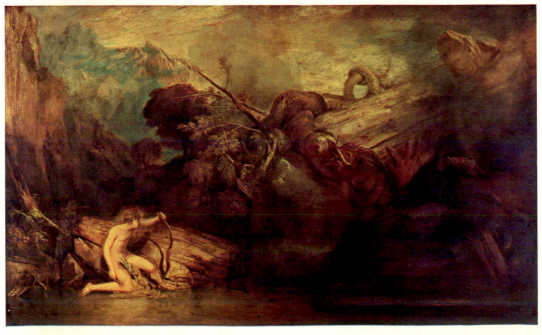

1 Ruskin and Nature

RUSKIN'S first recorded memories are of mountains. He thought of the joy and awe felt in the presence of natural scenery as 'in a sort, beginnings of life'(5.365). A deep love of art was built on these beginnings, but his conviction of the beauty of the natural world was established first; only later did he learn to express through the criticism of painting what he saw as the significance of its beauty for mankind: 'The beginning of all my own right art work in life, . . . depended not on my love of art, but of mountains and sea.'(22.153)

If later his world darkened, and the glory of nature seemed to fade, the beauty of the sky and hills could still restore and inspire him. His first lessons in how to see, how to respond, and how to express his feelings, were all learnt through the study of natural scenery. He claimed to have a greater capacity for taking pleasure in landscape than most men; it was, he said, 'the ruling passion of my life'(5.365). But whatever his spontaneous enthusiasm for mountain scenery, the lessons learnt from it shaped his mind in a specific way.

He first saw mountains as a tourist. Safely boxed up in a carriage, the Ruskin family would set off from London every May towards the north, to Wales, Scotland or the Lake District. Both Ruskin's parents were imposing characters – and imposed themselves on their son. They were cousins; Margaret Cox had lived with John James's parents in Scotland, and so they had known each other since adolescence, but they were unable to marry until she was thirty-six and he thirty-two. John James's father had proved unsound both commercially and mentally, and cut his throat, leaving a pile of debts that John James undertook to pay off, for the honour of the family, before starting a family of his own. The scandal behind him, John James went on to make his fortune. When he

4 *J.M.W. Turner,* Evening on Mount Rigi, Seen from Zug, *c. 1841. A 'delight-drawing' from the series which revealed to Ruskin the secret of Turner's art. See p. 40.*

5 *J.M.W. Turner,* Apollo and Python, *1811. For Ruskin the victory of good over evil, of light over darkness: 'Colour . . . is the type of love.'(7.419) See p. 81.*

and Margaret finally married in 1818, after a nine-year engagement, he was partner and prime mover in the sherry importing firm of Ruskin, Telford & Domecq, Billiter Street, London. By the time John James sent his son to Oxford he was able to buy him a way out of the commercial class.

In business Ruskin's father was a determined, serious-minded man; at home he liked to relax by taking an interest in literature and painting, and he communicated his own tastes to his son. In his youth he had learnt to paint in water-colour, and he collected pictures as he gradually became able to afford to. Ruskin attributed his early appreciation of poetry and literature to his father's habit of reading aloud from Shakespeare, Byron and Scott. John James was determined that, however much his own talents had been sacrificed to the sherry business, no potential should go undeveloped in his son. The child's aptitude for writing poetry and drawing was encouraged by praise and rewards, a habit John James maintained until his death (it was his money that made the publication of *Modern Painters* possible). The attitude of Ruskin's mother was no less influential; while John James stimulated his imagination, she ensured that it ran on correct moral lines. Her son had been born in 1819, when it was almost too late for her to have children, and for a devout Evangelical Protestant it was natural that she should follow the example of the Biblical Hannah and dedicate her child to God *(RFL2.456)*. Both parents had great expectations of their son, who remembered their hopes that he would 'write poetry as good as Byron's, only pious; preach sermons as good as Bossuet's, only Protestant; be made, at forty, Bishop of Winchester, and at fifty, Primate of England' *(35.185)*. He was being ironic when he wrote this, for things had turned out quite differently.

Ruskin's own account of his childhood in his unfinished autobiography *Praeterita* (1885–89) gives an impression of enclosure and solitariness under strict Evangelical discipline, but the publication of surviving family correspondence shows that his memories were distorted by time and disappointment.[1] True, he was an only child, but that was because of the age of his mother and her illness after his birth, and he lacked neither playmates nor presents. The early chapters of *Praeterita* present the Ruskins' suburban home in Herne Hill as a paradise, yet a paradise within walls, where the young Ruskin developed his powers of observation: serene, but untouched by the realities of outside life. But one of his purposes is to emphasize the pleasure he felt when released into mountain scenery after the enclosed life of London. He recalls the joy of a Sunday walk in Wales with his

father, and how it was mixed with 'some alarmed sense of sin of being so happy among the hills, instead of writing out a sermon at home' *(35.95)*. Young Ruskin was indeed obliged to make a summary each week of an Evangelical sermon, but the real pleasure of the yearly summer excursions was that the family could be together. John James Ruskin disliked the necessary travelling in search of clients which separated him from his wife and child; as the sherry business prospered he was able to make the summer tour with his family less and less of a business trip and more and more of a holiday. On such a journey in 1830 John and his cousin Mary (who was taken in as part of the Ruskin family after her mother died) kept a joint travel journal in imitation of grown-up tourists; their remarks show the tastes in which John James was educating his eleven-year-old son.

The family was bound for the Lake District, and on their way north via Oxford they called at Blenheim Palace, hoping to see the pictures. It was their established practice to visit the great houses that they passed, and ask the housekeeper to show them round. John and Mary noted:

There were a great many invaluable pictures By Rubens Guido Carlo Dolce Teniers Rembrandt Sir Joshua Reynolds and Many others There was one picture of Charles the 1st on horseback which was pronounced by Sir Joshua Reynolds to be the finest equestrian piece he had ever seen. There was also a most beautiful picture by Carlo Dolce and a very fine Bacchanalian piece by Rubens. There was a very pleasing picture of the late Duke and Duchess and their six eldest children by Sir Joshua Reynolds. We then entered the library where was a beautiful statue of Queen Anne by Rysback, the sculpture of which cost 5,000 pounds.[2]

At the age of eleven Ruskin could hardly be expected to disagree with the conventional taste of his father's generation, and he shows a similar respect for the Old Masters in the description of the great house at Chatsworth.

There was a very long gallery filled with numberless sketches by the best masters amongst which were some by Carlo Dolce, Claude Lorraine, Rembrandt, Carracci, Urbini, etc they were wonderfully done, and every touch showed the hand of a master, some appeared to be so carelessly thrown off you could hardly distinguish the outline, but yet such an effect was produced you could easily see, whose pencil had touched the canvass.[3]

He was learning to look at pictures early – and to exercise his observation, for he also notes that the carvings at Chatsworth had worm.

Ruskin's father was being no more than conventional in taking his son round Chatsworth to admire the Old Masters, and he was being equally conventional in taking him to the Lake District to admire the scenery. The taste for mountain scenery was at least partly the creation of the painters they had seen in the Chatsworth gallery. The tourist was expected to express his response to the scenery, according to the extent of his talent, in a travel journal, in descriptive verse, or sketches. The precocious young Ruskin did all three. He worked up his and Mary's joint travel journal into a long descriptive poem, *Iteriad*.

Appropriately, Ruskin's model was Wordsworth's *Excursion*, although the jingling rhymes of *Iteriad* owe more to Byron. Wordsworth himself appears in the poem, for the Ruskins, as true tourists, went to church at Rydal in order to catch a sight of the great man. In *Iteriad* he appears as

> . . . old Mr Wordsworth at chapel of Rydal,
> Whom we had the honour of seeing beside all.*(2.315n)*

Wordsworth was to become one of the three major formative influences on the adolescent Ruskin. The influence was most directly felt through Wordsworth's poetry, but it is worth considering first how Wordsworth himself expected tourists such as the Ruskins to respond to the scenery, in his *Guide through the District of the Lakes*.[4] Unlike a modern guide book, with its historical information and recommended routes, Wordsworth's is primarily a guide as to how to *see*. The chief places of interest are listed (and the Ruskins visited most of them); but even here the emphasis is on how the tourist should perceive his surroundings, and categorize them according to the aesthetic terminology of the day. He advises a visit to the tiny valley of Glencorn, above Ullswater: 'Let the Artist or leisurely Traveller turn aside to it, for the buildings and objects around them are romantic and picturesque'. Or again, in the valley of Grisdale on the way to Grasmere, 'a sublime combination of mountain forms appears in front while ascending the bed of this valley'.[5]

While earlier writers on the Lakes scenery were more concerned to find views that fitted predetermined categories of the sublime or beautiful, Wordsworth expects the traveller to 'observe and feel, chiefly from Nature herself'.[6] To observe, he must abandon conventional attitudes and look at the object itself, without trying to adapt it into some ideal composition. The traveller must rid himself of artificial ways of seeing, just as the poet must rid himself of artificial ways of speaking. This was one of the principles of the *Lyrical Ballads*: 'I have at all times endeavoured to look steadily at my subject, consequently I hope it will

be found that there is in these Poems little falsehood of description, and that my ideas are expressed in language fitted to their respective importance.'[7] The *Guide* exemplifies this principle with its careful, accurate descriptions of mountain scenery; but truthful apprehension was only the first part of the process. Having observed, the spectator must also feel.

Feeling was the proper subject for poetry, and here of course Wordsworth's own was the example. Through the feelings, the traveller might do more than enjoy the sight of a pretty view. He might feel a sense of emotional identification between himself and his surroundings, and become aware of the Nature Spirit informing all things, as Wordsworth himself had done:

> A presence that disturbs me with the joy
> Of elevated thoughts; a sense sublime
> Of something far more deeply interfused,
> Whose dwelling is the light of setting suns,
> And the round ocean and the living air,
> And the blue sky, and in the mind of man:
> A motion and a spirit, that impels
> All thinking things, all objects of all thought,
> And rolls through all things.[8]

Thus the traveller, if he opened his heart to natural scenery, could experience an emotional communion between himself and nature that was, according to the strictness of his religious orthodoxy, an awareness of the benevolence of God, or a more mystical and pantheistic sense of identity between man and his surroundings.

Although Wordsworth defined such moments, when turned into poetry, as 'the spontaneous overflow of powerful feelings',[9] the mind of the poet or painter had to be carefully prepared before this spontaneous overflow could take place. In an essay written when he was nineteen, Ruskin argued that a landscape painter 'must be capable of experiencing those exquisite and refined emotions which nature can arouse in a highly intellectual mind'*(1.279)*, and one can imagine him cultivating his own mind to receive just such sensations. While at Oxford in 1837 he produced a passable evocation of Wordsworth's Nature Spirit in an attempt to win the Newdigate Prize for poetry:

> . . . through earth and sky,
> Is breathed an influence of Deity.
> To that great One, whose Spirit interweaves

The pathless forests with their life of leaves;
And lifts the lowly blossoms, bright in birth,
Out of the cold, black, rotting, charnel earth;
Walks on the moon-bewildered waves by night,
Breathes in the morning breeze, burns in the evening light;
Feeds the young ravens when they cry; uplifts
The pale-lipped clouds along the mountain clifts;
Moves the pale glacier on its restless path;
Lives in the desert's universal death;
And fills, with that one glance, which none elude,
The grave, the city, and the solitude.
To This, the mingled tribes of men below,
Savage and sage, by common instinct bow. . . .*(2.33–4)*

From Wordsworth Ruskin learnt a context in which to place his natural sensitivity to the beauty of the earth, a beauty felt most powerfully in mountain scenery. Landscape was to be closely observed, and represented, not as a generalization of an idea of what nature should be like, but as truthfully as possible. For Wordsworth the natural vehicle for such a response to nature was poetry, for Ruskin it was passionate prose. Later Ruskin's response was to be tempered by experience, and the influence of Wordsworth was to fade, but in the five volumes of *Modern Painters*, which cover the first half of his life, Wordsworth is referred to more often than any other poet. A passage from *The Excursion*, which appears on the title page of every volume of *Modern Painters*, encapsulates the elements in Wordsworth's thought which most impressed him:

Accuse me not
Of arrogance, . . .
If, having walked with Nature,
And offered, far as frailty would allow,
My heart a daily sacrifice to Truth,
I now affirm of Nature and of Truth,
Whom I have served, that their Divinity
Revolts, offended at the ways of men,
Philosophers, who, though the human soul
Be of a thousand faculties composed,
And twice ten thousand interests, do yet prize
This soul, and the transcendent universe
No more than as a mirror that reflects
To proud Self-love her own intelligence.[10]

This quotation from Wordsworth is Ruskin's claim that his know-
ledge of nature forces him to call men away from their petty self-
interests to the reforming experience of the beauty of God's creation.

Other people, besides poets, taught Ruskin that the beauty of the
natural world led to awareness of God. During the 1830 tour of the
Lakes he was not content merely to admire the scenery as a poet might,
he also wanted to study it. *Iteriad* reveals a busy interest in his sur-
roundings(2.291):

> Now surveying a streamlet, now mineralizing, –
> Now admiring the mountains, and now botanizing, –

His scientific interest in landscape began at an early age. As John James
wrote proudly: 'From boyhood my son has been an artist, but he has
been a geologist from infancy.'[11] Among the earliest surviving drawings
by Ruskin are a series of maps made when he was eight; there can be no
more literal way of expressing the features of the earth than to present
them as a map. By the time he was twelve he had gathered a mineral
collection which he tried to catalogue in a specially created shorthand.
(Later, he found he could no longer remember its key.) His minera-
logical and geological interests were encouraged by the gift of books.
First there was Jeremiah Joyce's *Scientific Dialogues* for children, then
Robert Jameson's *System of Mineralogy* and *Manual of Mineralogy*; then,
most important of all, the gift, at his request, of H. B. de Saussure's
Voyages dans les Alpes.[12]

Ruskin's first reading of Saussure was a prelude to his own dis-
covery of the power of the Alps, so much more sublime than Words-
worth's English Lakes. In 1833, stimulated by the plates in Samuel
Prout's *Picturesque Sketches . . . on the Rhine*, the Ruskins took John on his
first full-scale tour abroad. They journeyed up the Rhine, through
northern Switzerland and into Italy as far as Genoa, returning via
Chamonix and France. In *Praeterita* he tried to recreate the first ecstatic
sight of the Alps.

Suddenly – behold – beyond! There was no thought in any of us for a moment
of their being clouds. They were clear as crystal, sharp on the pure horizon sky,
and already tinged with rose by the sinking sun. Infinitely beyond all that we
had ever thought or dreamed, – the seen walls of lost Eden could not have
been more beautiful to us; not more awful, round heaven, the walls of sacred
Death.(35.115)

But this appropriately romantic experience was disciplined by his

growing scientific knowledge. He could see the Alps as a poet might, or in terms of the geological outlines in Saussure, for there was already 'so much of science mixed with feeling as to make the sight of the Alps not only the revelation of the beauty of the earth, but the opening of the first page of its volume'*(35.116)*.

Significantly, Ruskin does not regard science and feeling as mutually exclusive; rather science provides a firmer basis for aesthetic response. The chief occupation of the early nineteenth-century scientist was description and classification; Saussure's *Voyages dans les Alpes* are accounts of his journeys through the mountains, noting their shapes and identifying their materials and structure. Theoretical experiment and analysis played little part in this process; Saussure's principle was that geology must work from the facts to the theories: 'it must be cultivated only with the aid of observation, and systems must never be but the results or consequences of facts'.[13] This emphasis on accurate observation helped to discipline Ruskin's response to nature. True, Wordsworth had called for a direct apprehension of the external world, free of preconceived ideas, but Wordsworth wanted to get rid of these preconceptions in order to heighten the *personal* experience of communion between self and the Nature Spirit. Science stressed the universal significance of the natural world, and Ruskin preferred the objectivity of the scientist to the subjectivity of the poet. He was later to say of Wordsworth: 'he could not understand that to break a rock with a hammer in search of crystal may sometimes be an act not disgraceful to human nature, and that to dissect a flower may sometimes be as proper as to dream over it'*(5.359)*. In many ways Ruskin was only applying more thoroughly Wordsworth's own principle of truthful perception; but whereas for Wordsworth, and even more Coleridge, the purpose of perception was the emotional fusion between the artist and what he saw, Ruskin followed the scientists in seeking first to establish an object's individual identity, and then read its meaning.

The scientific practice current during Ruskin's early years was exactly suited to his temperament; it involved walking, drawing, collecting, listing, and its ultimate purpose was in sympathy with both the poet's and the theologian's: to reveal the glory of God in his Divine ordering of the universe. During Ruskin's lifetime, however, science advanced beyond the descriptive and classificatory phase, and began to reveal a very different picture, in which blind forces struggled ruthlessly for domination of a world without God, and therefore without reason. As analysis and experiment superseded earlier methods science began to threaten the optimism of the poet and the faith of the theologian.

Ruskin was to suffer acutely from this change, as the ground of science shifted underneath him. He may have criticized Wordsworth for dreaming over a flower instead of dissecting it, but when science came to mean for him the anatomist poring over a dismembered human corpse, he recoiled in horror.

Ruskin's resistance to the change that took place in science in mid-century is symbolized by his clinging to Saussure as an authority throughout his life, even though further research outdated a work whose first volume had appeared in 1779. He liked Saussure's approach, because it had become his own: Saussure 'had gone to the Alps, as I desired to go myself, only to *look* at them, and describe them as they were, loving them heartily – loving them, the positive Alps, more than himself, or than science, or than any theories of science'*(6.476)*. The use of the word 'love' may seem unscientific, but this was the twofold process, 'to observe and feel', in operation. Truthful observation allows the sensual pleasure of the eye to lead to the truth of God; to try to do more than *see* truly, either by theoretical analysis or emotional self-identification, is mere egoism.

The principle of direct observation and resistance to speculation leads to an attitude to nature that rests upon externals. All you need to know can be discovered by simply using your own eyes. The 'laws of the organization of the earth are distinct and fixed as those of the animal frame, simpler and broader, but equally authoritative and inviolable. Their results may be arrived at without knowledge of the interior mechanism; but [Ruskin adds significantly] for that very reason ignorance is the more disgraceful, and violation of them more unpardonable.'*(3.425)* This determinedly non-speculative, non-analytical approach – he says of the Alps, 'we must begin where all theory ceases; and where observation becomes possible'*(26.112)* – may seem limited, but he was following a common method of his time. Jameson's *System of Mineralogy*, for instance, is 'founded on what are popularly called the External Characters of Minerals, and is totally independent of any aid from Chemistry. This . . . may be termed the *Natural History Method*'.[14]

Whatever the scientific limitations of this method, its benefits for Ruskin were enormous. It was a training in observation and description that developed his most important critical tool, the use of his own eyes: 'precisely the same faculties of eye and mind are concerned in the analysis of natural and of pictorial forms'*(26.386)*. The result was a critical approach to painters that tested their accuracy by their treatment of geology, and a geology that looks at its material with a painter's eye (ills 7,8). Geological concerns are uppermost in *Modern Painters 4* (1856),

where he makes his own classification and description of the materials of the earth. But the classification does not depend on an analysis of the structures in terms of their history; instead they are divided, as a painter might divide them, into their visual characteristics and shapes. The failure of earlier landscape painters to make such a careful study of their subject matter was the basis of his argument for the greatness of Turner. In Jameson's *Manual of Mineralogy*, which he read as a boy, the scientist makes just the same criticism:

A long-experienced eye can, at a glance from the summit of a mountain, point out with considerable certainty the different formations of which a country is composed. Landscape-painters, by confounding together all these differences, or by combining them irregularly, fail not only in accuracy, but in giving their work that appearance, which shows, at first glance, that it is not only a copy of nature, but a copy by one who has formed a distinct conception of the general and particular features of the inequalities observable on the surface of the earth.[15]

Ruskin was following Jameson's principle in his *Panorama of the Alps* (ill. 7), and it is tempting to see in Jameson one of the sources of the argument for fact in *Modern Painters*.

For a brief period, the harmony between science and religion that existed in the eighteenth century survived into the nineteenth, and the natural scientist could still call himself a natural theologian. The very existence of the world was proof that God existed as its Creator, and the world seemed wonderfully arranged for the benefit of man. At the beginning of the nineteenth century it was still possible to expand the idea of nature to fit the fresh discoveries of science; for the more complex the world turned out to be, the greater the intelligence of its Creator. The cooperation of science and religion reached its zenith in the 1830s, when the eighth Earl of Bridgewater provided funds for the publication of a series of treatises designed to show the goodness of God in the relations of man and nature, as seen in astronomy, physics, geology, and animal, vegetable and human physiology. The Bridgewater treatise on geology and mineralogy was written by the Reverend William Buckland, of Christ Church, Oxford, University Reader in Geology. When Ruskin went to Christ Church as a gentleman scholar in 1837, it was natural that his geological studies should be guided by Buckland.

'No reasonable man', wrote Buckland in his Bridgewater treatise, 'can doubt that all the phenomena of the natural world derive their origin from God; and no one who believes the Bible to be the word of

God, has cause to fear any discrepancy between this, his word, and the results of any discoveries respecting the nature of his works'.[16] Confidently, he meets the issue that helped to destroy the belief of so many Victorians, including Ruskin: the conflict between Moses' account of the Creation in the Bible, and the discoveries of geology which quite clearly contradicted it. Buckland ingeniously adjusts the meaning of the Bible to fit the facts. To begin with, what in English are called 'days' were really to Moses much longer, indefinite periods of time; further, the elements of the world may have existed in many different forms, 'in the beginning', before God finally decided to express his will through the creation of man. As a young man Ruskin accepted such explanations, but the facts of science could not be reconciled with a literal reading of the Bible for ever, and like many of his contemporaries he was to suffer a spiritual crisis when the former basis of his belief was shown to be false.

For the time being, though, Buckland's teaching encouraged an optimistic view, and provided an excellent justification for him to pursue his natural delight in mountain scenery. The nature that Ruskin found in Buckland – as in Wordsworth – was essentially a benevolent one. The good things of this world were to be enjoyed, since they had been provided for man by God. Take, for instance, the mineral wealth of the earth. According to Buckland,

We need no further evidence to show that the presence of coal is, in an especial degree, the foundation of increasing population, riches, and power, and of improvement in almost every Art which administers to the necessities and comforts of Mankind . . . we may fairly assume, that, besides the immediate purposes effected at, or before the time of their deposition in the strata of the Earth, an ulterior prospective view to the future uses of Man formed part of the design.[17]

Ruskin was later to say almost exactly the same about marble*(11.37)*. God looked upon his work, and saw that it was good, and Ruskin came to believe that it was the duty of the artist and the scientist to expound that goodness, 'even in all that appears most trifling or contemptible' *(3.483)*.

But even Buckland recognized that something more was required than simply the realization that the world bore every mark of having had an intelligent Creator: 'The disappointment which many minds experience, at finding in the phenomena of the natural world no indications of the will of God, respecting the moral conduct or future prospects of the human race, arises principally from an indistinct and

23

mistaken view of the respective provinces of Reason and Revelation.'[18] Natural science, like Romantic poetry, helped the Christian to perceive the glory of God, but his faith and conduct must be guided by the Church. Science for Buckland was secondary to spiritual knowledge of God; geology testified to God's wisdom and benevolence, but it remained 'the efficient Auxiliary and Handmaid of Religion'.[19]

Margaret Ruskin instilled habits of mind in her son that persisted long after the faith that had inspired them had disappeared, and they affected everything he said or did – even the way he saw mountains.

The foundation of her faith was the text of the Bible. To an Evangelical, it was a cardinal and absolute principle that the word of the Scripture was inspired by God, and that everything in it was literally true: 'Show us anything plainly written in that Book, and however trying to flesh and blood, we will receive it, believe it, and submit to it.'[20] So wrote the Reverend J. C. Ryle in *Evangelical Religion, What It Is, and What It Is Not*. Ruskin's education therefore began with the Bible, and as soon as he could read his mother began to take him through its text, chapter by chapter and verse by verse, much of which he had to learn by heart. When the whole text had been covered they began again at the beginning, and the process was continued until he went up to Oxford. As a result his prose echoes and re-echoes with the texts he learnt as a child and continued to study as a man. His constant Biblical references have sometimes been dismissed as a kind of nervous tic, but the early emphasis on Scripture gave him a great deal more than a clerical style of address: it was a link to an unfailing source of wisdom and truth.[21] His references were not a decoration designed for audiences more familiar with the Bible than ourselves, they were an appeal to a fundamental authority; and when Ruskin refers to it, it is always worth checking at its source.

After the authority of Scripture the second fundamental principle of Evangelicalism was the doctrine of the essential wickedness and corruption of man. This gloomy view contrasted with the more optimistic ideas of the Romantic poets, who shared Rousseau's belief that man, uncorrupted by society, was naturally good. No such optimistic sense of innocence was permitted to an Evangelical, for as the consequence of Adam's fall men 'are not only in a miserable, pitiable, and bankrupt condition, but in a state of guilt, imminent danger, and condemnation before God'.[22] Being so constantly reminded of his condition as a miserable sinner, Ruskin was discouraged from thinking about himself and the pit of corruption he was told he would find there, and directed

his thoughts outwards. He told a friend that 'the "beautiful world of external nature" was open to him but the unattractive internal one was all obscure . . . what he thought goodness of heart turned out to be wickedness'.*(WL.77)*

This avoidance of introspection, together with the solitary security of his childhood, severely retarded the development of Ruskin's emotional life. He complains in *Praeterita* that although he learnt 'peace, obedience, faith', he learnt nothing about love.

My parents were – in a sort – visible powers of nature to me, no more loved than the sun and the moon . . . still less did I love God; not that I had any quarrel with Him, or fear of Him, but simply found what people told me was His service, disagreeable; and what people told me was His book, not entertaining. I had no companions to quarrel with, neither; nobody to assist, and nobody to thank.*(35.44–5)*

Consequently, when as an adolescent he fell in love with the daughter of his father's Spanish partner, the effect was disastrous. His emotions were violent, 'utterly rampant and unmanageable'*(35.45)*, and when Adèle Domecq showed no interest in him at all he had no outlet but sentimental poetry and illness. Only in nature, in flowers and rocks and stones, could he find any emotional satisfaction free of the taint of sin.

His feelings before rocks and stones had the advantage of serving as a link between his Romanticism and his faith, for both the poets and the Evangelical preachers believed in the need for an individual emotional experience as the means to an awareness of God. The only way to transcend one's condition as a condemned sinner was through the grace of God, which had the power to restore those who had faith. For Wordsworth this transformation could take place in a non-doctrinal way, through the influence of the Spirit of Nature; for the Evangelical there was hope in 'the blood of God the Son applied to the conscience, and the grace of God the Holy Ghost entirely renewing the heart'.[23] This was what Buckland meant by the difference between Reason and Revelation. The Evangelical divine Henry Melvill, who preached in the chapel which the Ruskins attended, sounds very close to both Buckland and Wordsworth when he finds Revelation in the external world: 'every feature of the landscape, every tree of the forest, every flower of the garden, every joint, and every muscle of my frame, all are gifted with energy in proclaiming there is a Supreme Being; infinite in wisdom and goodness, as well as in might'.[24]

So far all three influences on Ruskin, Romantic poetry, science and religion, have been seen to confirm the same view of the external world as the source of beauty and goodness. Both poetry and science taught that this beauty lay in the natural world as it was, objective and real. Evangelical religion however raised the value of the real world by, without taking away any of its objective reality, interpreting it on a symbolic level as well. The poets saw rocks and trees as symbols of the Spirit of Nature; but their symbolism cannot match the elaborate system of typology used by the Evangelicals.[25] This other reading of the natural world was to be of great importance to Ruskin's approach as a critic, and shaped the processes of his imagination.

Typology was a long-established critical method of symbolic interpretation of the Bible; it was not difficult to extend this interpretation to the work of God, as well as his word. The Evangelicals believed, as has been said, in the literal truth of the Bible, but it had always been plain that it contained many passages of doubtful value. The answer was to interpret them as having a hidden meaning. Margaret Ruskin omitted nothing from her son's Bible reading, and he was taught that if a chapter was 'loathsome, the better lesson in faith that there was some use in its being so outspoken'*(35.40)*. Symbolic interpretation was thus a necessary technique, but it was used much more elaborately than simply to adjust doubtful meanings. Through the system of 'types', the confusing language and history in the Bible were shown to provide a coherent account of the past and future will of God.

It was an article of faith that the Bible was a continuous account of God's revelation of himself to mankind, first through the prophets of the Old Testament, then through Jesus Christ, and finally through the foretelling of the eventual Judgment Day, when all would return to God. Thus events in the Old Testament were presented as foreshadowing the coming of Christ in the New (and it is to be noticed that the authors of the New Testament frequently present Christ as fulfilling prophecies of the Old). Moses, although a real figure in the history of the Jews, was also seen as a 'type' of Christ, a symbol of what was to come. The system of types extended from persons and events in the Bible to things. Thus the water Moses strikes from the rock is symbolic of Jesus's baptism, and the waters of baptism themselves are symbolic of the regeneration of mankind. Since the Evangelicals placed such emphasis on the authority of the Bible they above all others developed the study of types to its highest degree, and the sermons of people like Ryle and Melvill, which Ruskin heard and studied, are full of the most ingenious interpretations, finding layer upon layer of meaning.

There is an important distinction to be made between an allegorical and a typological explanation. In allegory the object which is used to convey a meaning has no real existence; it is a fiction, a device whose only use is to stand for something else. In typology the figures and emblems are real people, real things, which retain their identity as well as conveying a symbolic meaning. This may seem simpler if one remembers that the Evangelicals believed that both the Bible and the external world were expressions of the same Divine Being: there was no doubt that the external world continued in its existence while expressing the will of God; and similarly the historical figures of the Bible performed their own worldly functions as well as foreshadowing the coming of Christ. The importance of this for Ruskin was that when he came to work out his theory of art he called for 'real' representation which also conveys symbolic meaning.

The Evangelicals taught Ruskin that the natural world was as full of God's words as the Bible, and he uses precisely this metaphor when he speaks of following 'the finger of God, as it engraved upon the stone tables of the earth the letters and the law of its everlasting form' *(6.116)*. In their writings and sermons Evangelical preachers drew the same lessons from the earth and from the Bible. There was even an old geological theory to support their view, for it was still argued that the present contours of the world were the result of the destruction caused by the Flood. William Wilberforce, one of the leaders of the Evangelical movement, wrote: 'This awful instance of the anger of God against sin is related in the inspired writings for our instruction. Still more to rouse us to attention, the record is impressed in indelible characters on the solid substance of the very globe we inhabit'.[26]

It was natural that Ruskin should find deep symbolic meaning in the geological forces of the earth: 'The first sight of the Alps had been to me as a direct revelation of the benevolent will in creation.' But in the ash and lava of Vesuvius he discovered 'if not the personality of an Evil Spirit, at all events the permitted symbol of evil, unredeemed' *(35.288)*. The very shapes of the mountains were found to contain moral and sociological meaning: 'the great truths which are the basis of all political science; how the polishing friction which separates, the affection that binds, and the affliction that fuses and confirms, are accurately symbolized by the processes to which the several ranks of hills appear to owe their present aspect'*(6.132–3)*. He shows the extent to which the sermons he heard every Sunday reinforced his simultaneously real and symbolic interpretation, by more than once drawing a parallel between the artist and the preacher. In *Modern Painters 1* he

marvels at the number of 'lessons' both have to teach: 'as well might a preacher expect in one sermon to express and explain every divine truth which can be gathered out of God's revelation, as a painter expect in one composition to express and illustrate every lesson that can be received from God's creation. Both are commentators on infinity' (3.157). The two have different spheres, but they are working towards the same end, with the same methods.

Ruskin's pleasure in landscape was the primary inspiration for his work in art, and it remained a 'ruling passion', but as his knowledge increased with experience, he was able to look on the source of his inspiration with a certain detachment. At the age of thirty-seven, in the third volume of *Modern Painters*, he tried to analyse just what it was about the natural world that was so important to him. His conclusions come in a chapter appropriately called 'The Moral of Landscape'. The visual pleasure felt in childhood was now part of a much more elaborate conception of the world. He recalls his first memories of mountains, and the joy that he felt in escaping from the enclosed life of London. He says that he did not then think of nature as God's work: rather God was in heaven, and nature was a separate fact of existence. But 'although there was no definite religious sentiment mingled with it, there was a continual perception of Sanctity in the whole of nature, from the slightest thing to the vastest; – an instinctive awe, mixed with delight; an indefinable thrill, such as we sometimes imagine to indicate the presence of a disembodied spirit'(5.367). The Wordsworthian echo is deliberate, for he parallels his own gradual loss of spontaneous joy in nature with Wordsworth's experience as recorded in the 'Ode: Intimations of Immortality'. The influence of Wordsworth was also fading when he wrote this, and he is critical of those who go to nature for a vague and undefined emotional experience. None the less he was sure that of two people equal in other respects 'the one who loves nature most will be *always* found to have more *faith in God*'(5.378).

The reveries of a poet before nature, although indicating the right state of mind, were limited in that they led to nothing useful. The poet's perception had to be sharpened by the hard thinking of the scientist, even to the extent of limiting the emotional pleasure to be felt in landscape. This was what had happened to Ruskin himself. But the science Ruskin had in mind was not that which had led to the invention of the steam engine or the other mechanical horrors of the modern world; it was what he called 'a science of the aspects of things' (5.387). This science included the love of beauty, for it was as important

to know of things 'that they produce such and such an effect upon the eye or heart . . . as that they are made up of certain atoms or vibrations of matter'*(5.387)*. It was in these terms that he thought of Saussure 'loving' the Alps. A science of aspects had the power, he believed, to persuade men to live in harmony with nature and with God:

to understand that God paints the clouds and shapes the moss-fibres, that men may be happy in seeing Him at His work, and that in resting quietly beside Him, and watching His working, and . . . in carrying out His purposes of peace and charity among all His creatures, are the only real happinesses that ever were, or will be, possible to mankind.*(5.384)*

2 Ruskin and the Picturesque

'more as picturesque than as real'

RUSKIN began his adult life sensitive, neurotic, dogmatic and inexperienced. He had had an enclosed childhood, and would continue to lead a protected adulthood, sheltered by his parents' wealth, free of any obligation to earn a living. His intelligence had flourished in the hothouse atmosphere of his parents' encouragement, and he had cultivated a sensitive appreciation of natural scenery which found its expression both in words and pictures. But his parents' praise made him uncritical of himself, and his indoctrination with Evangelical religion gave his opinions a dogmatic certainty that made their unlearning in later life all the more painful. His parents' protection meant that he had little experience of mankind, and directed his emotional energies away from people and into the natural world. His adult life virtually began with a nervous breakdown.

The catalyst for this not very promising material was an attack on his hero Turner. The result was a fusion of the three strands of his appreciation of nature – Romanticism, natural science and religion – into a theory of art. If any one moment should be chosen (and of course all such moments are the product of long developments), then it is July 1842. Some weeks before, while staying at Geneva, he had read a hostile review of Turner's exhibits at the Royal Academy show that year(3.666). Sitting in church, 'a fit of self-reproach . . . for my idling style of occupation at present'(D1.199) made him decide to write a reply. He continued his tour to Chamonix while meditating on what he should say, all the while noting in his diary the rocks, flowers and effects of weather in Alpine scenery. He later described how he watched the sunset on a stormy evening while lying by the natural fountain where the Brevent has its source. In a spontaneous overflow of powerful feeling, his inspiration wells up like the stream itself. The passage reaches its climax as the sun breaks through the storm cloud and lights up the mountain peaks(4.364–5):

The ponderous storm writhed and moaned beneath them, the forests wailed and waved in the evening wind, the steep river flashed and leaped along the valley; but the mighty pyramids stood calmly – in the very heart of the heaven – a celestial city with walls of amethyst and gates of gold – filled with the light and clothed with the Peace of God. And then I learned – what till then I had not known – the real meaning of the word Beautiful. With all that I had ever seen before – there had come mingled the associations of humanity – the exertion of human power – the action of the human mind. The image of self had not been effaced in that of God. It was then only beneath those glorious hills that I learned how thought itself may become ignoble and energy itself base – when compared with the absorption of soul and spirit – the prostration of all power – and the cessation of all will – before, and in the Presence of, the manifested Deity. It was then only that I understood that to become nothing might be to become more than Man. . . . It was then that I understood that all which is the type of God's attributes – which in any way or in any degree – can turn the human soul from gazing upon itself – can quench in it pride – and fear – and annihilate – be it in ever so small a degree, the thoughts and feelings which have to do with this present world, and fix the spirit – in all humility – on the types of that which is to be its food for eternity; – this and this only is the pure and right sense of the word

BEAUTIFUL.

John Rosenberg calls this a 'Christian rendering of the Romantics' vision of nature'.[1] It is the direct, personal experience of God necessary to inspire an Evangelical sermon or a Romantic poem. But Ruskin's self-distrust, one could almost say self-disgust, takes the moment of identification between poet and nature much further, so that he does not experience, as Coleridge might, an 'Awaking of a forgotten or hidden Truth of my inner Nature',[2] but a total annihilation of self. He is deaf to Wordsworth's 'still, sad music of humanity',[3] and seems to rejoice in the fact. Loss of self in the greater whole of nature is indeed a vital experience to a Romantic poet; but there must also be a return to self, to describe the experience, and account for its significance to the poet. Ruskin however resists such egoistical self-speculation; perhaps that is why he failed as a poet, but succeeded as a critic, that is, as an observer. Ruskin is transfigured by the moral and aesthetic beauty of this manifestation of God; on it he tries to build not a Romantic but an Evangelical theory of beauty.

Beauty, however, cannot be independent of the means used to convey it. Ruskin's own direct experience of nature proved to him that Turner recreated that beauty more truthfully than any other artist that

he knew, yet Turner was attacked by the critics because they considered his vision to be false. The purpose of *Modern Painters* was therefore twofold: to demonstrate the significance of the beauty that existed in the natural world; and to prove that Turner conveyed that significance. Ruskin's first problem, then, was to show that Turner did indeed communicate the beauty that they both perceived.

But it would be wrong to imagine that Ruskin's recognition of Turner's genius had been instantaneous; before appreciating the truth of Turner's vision he had had first to break through the pictorial conventions in which he had been educated.

In the third volume of *Modern Painters* (1856), Ruskin takes the reader on an imaginary visit to the annual exhibition of the Old Water-Colour Society. There, he says, the reader will be struck by the number of landscapes on display, and he might well remark: 'There is something strange in the mind of these modern people! Nobody ever cared about blue mountains before, or tried to paint the broken stones of old walls.' The Greeks painted heroes, the medieval artists saints, but 'here are human beings spending the whole of their lives in making pictures of bits of stone and runlets of water, withered sticks and flying fogs' (5.193–5). True, landscapes had often provided the background for a battle or a martyrdom, but the reader might well think that in the nineteenth century humanity had completely disappeared from landscape, and that 'all the living interest which was still supposed necessary to the scene, might be supplied by a traveller in a slouched hat, a beggar in a scarlet cloak, or, in default of these, even by a heron or a wild duck' (5.194). The characteristics of these paintings on the walls of the Old Water-Colour Society are those of the Picturesque, and it was this view of nature that Ruskin was brought up with, and then attacked.

The word 'picturesque' lacks a precise meaning. It can refer to anything between a narrowly definable set of visual qualities in a painting, and a broad attitude towards subject matter. It derives from the Italian *pittoresco*, 'in the manner of painters', but English usage makes the significant change from 'the manner of painters' (referring to their social habits) to 'the manner of paintings'. The term was in popular use throughout the eighteenth century, but its genealogy as an aesthetic theory can be traced back to Edmund Burke's *Philosophical Enquiry into our Ideas of the Sublime and Beautiful* (1757). Burke divided objects into two main categories according to our response to them. Objects which appealed to our reason by their regularity, smoothness, order and proportion, and thus gave pleasure, were *beautiful*. Objects which excited

the emotions of awe or terror through their vastness, irregularity, grandeur or wild disorder were *sublime*. The terminological distinction between the sublime and the beautiful became standard practice, but Burke's opposing categories did not satisfy those who could see with their own eyes that there were many objects in nature, and even more so in painting, which were irregular, wild and unproportioned, but which aroused no fear in the spectator, and certainly none of the pain which Burke claimed was at the root of the emotions of the sublime. The antiquarian, the tourist and the sketcher (the three activities often combined in one man) knew that such objects abounded in the English countryside, a countryside that was neither a classic Arcadia nor a savage forest. Such a person was the Reverend William Gilpin, who popularized 'picturesque beauty' with guide books, essays, and advice on how the scenery might be drawn. The theory was placed on a more philosophical basis by Uvedale Price, who in 1794, in an *Essay on the Picturesque, as Compared with the Sublime and the Beautiful*, formally suggested that the picturesque was a third category of aesthetic pleasure, somewhere between the beautiful and the sublime; precisely where, became a matter of controversy.

The theory represents the first step towards the modern idea that paintings can be appreciated solely for their objective qualities; certain features, such as roughness, broken lines, intricacy and variety of light and shade, were identified as characteristics of the picturesque, and were treated as qualities which could be appreciated for their stimulus to the eye alone. At the same time, however, there was an alternative view, derived from the theory of association. Archibald Alison, in his *Essays on the Nature and Principles of Taste* (1790), argued that our pleasure in pictures was caused by the train of thoughts the pictures suggested, and the imagination, working by association, helped to heighten the sense of sublimity or beauty. The same effect

is produced also, either in nature, or in description, by what are generally termed Picturesque Objects. . . . An old tower in the middle of a deep wood, a bridge flung across a chasm between rocks, a cottage on a precipice, are common examples. If I am not mistaken, the effect which such objects have on everyone's mind, is to suggest an additional train of conceptions, besides what the scene or description itself would have suggested.[4]

Theorists of the picturesque could not agree on the relative importance of the picture's formal qualities, and the ideas it conveyed. Richard Payne Knight, in the face of arguments from Uvedale Price, held that the pleasure of the eye consisted wholly in broken and gradated light

and colour, and that therefore the picturesque and the beautiful could be the same thing; but at the same time he drew on the theory of association to show that knowledge improved our perception. Thus the close study of pictures was required in order to appreciate their formal qualities, while the actual subjects aroused associated pleasant thoughts.

The literary and theoretical background however is less important than the practical effect the popularization of the picturesque had on people's way of *seeing*. As the word implies, it is essentially a visual theory. Whereas Burke's categories were concerned with reason and emotion, that is with internal operations of the mind, the followers of the picturesque were concerned with a way of looking, and the significant influences were paintings rather than books. What became at heart an essentially English appreciation of the English countryside has its roots in the two seventeenth-century Continental traditions of landscape painting, the Italian and the Dutch.

The Italian represents the 'high art' tradition, which made its appeal to aristocratic connoisseurship through allegory and classical reference. Three painters in particular who had worked in Italy contributed to English ideas of landscape, Gaspard Poussin (or Dughet, his real name), Salvator Rosa and Claude Lorrain. Though they had a combined influence, each is very different from the others. Salvator Rosa's craggy rocks and broken trees have a romantic violence that makes him closer to ideas of the sublime than the picturesque; Gaspard Poussin retains some of the classic regularity of design of his brother-in-law, Nicolas Poussin. It was Claude Lorrain who appealed especially to the landscape tastes of rich English collectors: he presented a classical subject (though often incongruously set among already ruined classical buildings), and a regularity of composition softened by water and trees in a warm landscape that fades into a blue distance. English collectors brought nearly all the best examples of Claude's work to England, and the richest among them set about turning real landscape into Claude-like compositions.

The 'low' aspects of the picturesque came from the Dutch, who had no mountains or classical ruins, but plenty of boats, carts, wooden houses, taverns and rutted roads supplying an entertaining irregularity and intricacy of texture, and their artists showed a frank appreciation of country life. The costumes and activities of the peasants, travellers and beggars who people the paintings of Cuyp, Ruisdael, Both and Hobbema stimulated the eye with their wrinkled faces and tattered clothes, while the effects of sky and weather in Dutch sea-painting had their appeal on the other side of the Channel.

These two traditions combined with a third, that of topographical painting. Artists had found work since the beginning of the sixteenth century in making records of gentlemen's parks and country houses, but these stiff delineations became more expressive as painters became interested in the landscape for its own sake. The Italian and Dutch idioms were translated into English forms, classical ruins became the Gothic churches and ruined abbeys which already decorated the English countryside, Italian forests and mountains became English woods and hills. The peasants of the Dutch became English cottagers and labourers whose existence – to the picturesque-buying public at least – seemed to relate so harmoniously with their natural surroundings.

The result of the fashion for the picturesque was a way of looking at landscape that involved, according to one's attitude to the genre, either an active and creative sense of the inter-relationship between man and nature, or the sentimental appreciation of small ideas. Because it was an essentially visual theory and encouraged the contemplation of natural scenery, it made a significant contribution to the development of Romantic art, but it still kept an eighteenth-century balance between reason and emotion, the beautiful and the sublime. The crucial point is that although it was a stimulus to the visual sense, it was a way of looking at nature indirectly, *via* pictures. The full title of Uvedale Price's work is *An Essay on the Picturesque, as Compared with the Sublime and the Beautiful; and on the Use of Studying Pictures, for the Purpose of Improving Real Landscape.*

Even when the tourist went to look at natural scenery he might if he chose turn reality into composition on the spot, by looking at it in a pocket mirror of slightly curved black glass, called appropriately a Claude Glass. The reflected image compressed the real view and reduced the brilliance of its colours so that it looked more like a painting. This was deliberately seeing nature at second hand, for one had to turn one's back on the view to use the mirror. Ruskin called the black mirror 'one of the most pestilent inventions for falsifying Nature and degrading art which ever was put into an artist's hand'*(15.201–2).*

Yet the first work by Ruskin ever to be published, a poem in the *Spiritual Times* for February 1830, uses Derwent Water almost like a Claude Glass to pictorialize a Lake view:

> Now Derwent Water come! – a looking-glass
> Wherein reflected are the mountain's heights;
> For thou'rt a mirror, framed in rocks and woods.
> Upon thee, seeming mounts arise, and trees

And seeming rivulets, that charm the eye;
All on thee painted by a master hand,
Which not a critic can well criticise.*(2.266)*

Ruskin came under the influence of picturesque artists in the most
direct way possible, through being taught by them. He was a talented
draughtsman, and might have developed further; but as Paul Walton
points out in his study of Ruskin's drawings, his parents were con-
cerned that he should exercise his skill only in so far as it was a suitable
minor activity for a gentleman.[5] The potential which he showed – and
the limitations he was under – can be seen in the vignettes he drew in
1833 to illustrate a long poem describing the Continental tour made
that year. They are imitations of the vignettes Turner drew to illustrate
Samuel Rogers's poem *Italy* (1830). They show technical skill, and it is
not every fourteen-year-old who could attempt to write and illustrate
to adult standards, but both verses and drawings are imitations; he has
even tried to reproduce the type-face for the title (ills 9,10).

Ruskin claimed in his autobiography that his passion for Turner
began when he was given Rogers's *Italy* when he was thirteen, but in
reality Turner was only one of a group of artists who made their
influence felt during his adolescence. The vignettes to *Italy* are unlikely
examples of Turner's work on which to base an appreciation of his
later landscape, for Rogers, who commissioned them, insisted on an
eighteenth-century formality of design.[6]

His first teacher, apart from his father whom he used to watch
sketching as a little boy, was Charles Runciman, who gave him model
drawings to copy and taught him to patch up compositions out of
appropriate bits and pieces. In 1832 Runciman was sufficiently im-
pressed to promote him to water-colour, as the first step towards oil.
Ruskin told his father that 'there is a power in painting, whether oil or
water that drawing is not possesed of, drawing does well for near scenes,
analyses of foliage, or large trees, but not for distance, or bare & wild
scenery, how much superior painting would be, if I wanted to carry off
Derwent Water, & Skiddaw in my pocket, or Ulles Water, & Helvellyn,
or Windermere, & Low-wood'*(RFL268)*. In his autobiography Ruskin
recalls that by 1832 he 'had constructed a style of pen-drawing with shade
stippled out of doubled lines, and outline broken for picturesqueness'
(35.622). The pen and water-colour of trees around a pond (ill. 6) shows
the first results of this training in the picturesque.[7]

In 1834 and 1835 Ruskin also had lessons from none other than
the President of the Old Water-Colour Society, Anthony Vandyke

Copley Fielding, the most fashionable drawing master of the day. From him Ruskin learnt the full range of techniques that the water-colourists had developed in their rivalry with oils: the laying of washes, spongeing out, scratching out, how to get a broken effect by using a dry brush. But he was discouraged by the elaborate nature of the technique – he later called it mere tyro's work*(15.140)* – and went back to drawing.

Since his chief interest was architecture, he modelled his work on the lithographs of Samuel Prout (whose *Picturesque Sketches in Flanders and on the Rhine* had inspired the Ruskins' first long tour abroad), although he acknowledged later that the 'rude and confused lines' *(35.623)* imitated from Prout meant that the results were stylish compositions rather than accurate architectural drawings. Gradually he modified his Proutish dots and dashes into a gentler curving line, and tried to get more accuracy. The work of David Roberts, whose drawings of Spain started appearing in 1837, encouraged him to soften his hard outlines. From Roberts Ruskin took over the use of 'flat grey washes, giving the forms of shade with precision and its gradations with delicacy, and finally touched, for light, with whitish yellow'*(35.625)*. A drawing of St Mary's Church, Bristol, shows a mixture of Prout and Roberts, the church done with Prout's broken lines, the boat in the manner of Roberts (ill. 18).

The extent to which Ruskin was committed to the picturesque point of view can be gauged from the long visit he made to the Continent in 1840 and 1841. The circumstances of this tour are important, for he was convalescing after the collapse of his hopes of gaining distinction at University; a success that would probably have led to a clerical career.

In later life Ruskin became somewhat bitter about his under-graduate life at Oxford. In 1853 he told his former tutor, the Reverend W. L. Brown, that he regarded his education there as a complete failure. As far as literature was concerned, 'I am conscious of no result from the University in this respect, except the dead waste of three or four months in writing poems for the Newdigate, a prize I would un-hesitatingly do away with.'*(36.154)* In fact he had an enjoyable time at Oxford, and had won the Newdigate poetry prize (meeting Words-worth as a result). The aristocratic gentlemen commoners in no way looked down on the promising intellectual in their midst, and his talent for drawing made him popular with both students and teachers. True, it was found a little odd that when he came up to Oxford his mother came to live there as well*(RFL373n)*; but the bitterness Ruskin later expressed was the result of his own and not the University's circum-stances.

The Spanish side of his father's sherry business was run by Pedro Domecq, who had four daughters. In 1836, at the age of seventeen, Ruskin conceived a passion for one of them, Adèle. His parents have been accused of trying to frustrate a marriage with a Roman Catholic, but it seems more likely that it was as Ruskin himself presents it, an adolescent passion for a girl who felt no interest in him at all. The experience was none the less traumatic for that, and his mother's decision to be near him in Oxford in case of sickness was justified. At the end of his second year at Oxford he undertook a heavy programme of reading in order to prepare for an honours degree. In April 1840, shortly after Adèle had married another, he coughed blood, and was forced to leave Oxford, for the time being without a degree. The doctors banned reading and sent him abroad to recover.

Ruskin said later that he had been travelling with 'sealed eyes' *(D1.113n)*, a curious phrase for a tour which, since he was forbidden to read, involved a great deal of drawing. Curious, that is, until one realizes how much ideas of the picturesque masked his vision. The word appears time and time again in his diary. He sees subjects in terms of Copley Fielding, Frederick Taylor, William Hunt, Frederick Hurlestone, Prout, Claude, Poussin, and – in comparisons of atmospheric effects – Turner. Whereas there was nothing in Florence 'thoroughly picturesque'*(D1.111)*, Rome was completely 'picturesque, down to its doorknockers'. Discussing this quality he produces the verbal equivalent of Samuel Prout's water-colour of the Forum of Nerva (ill. 17). It depends

not on any important lines or real beauty of object, but upon little bits of contrasted feeling – the old clothes hanging out of a marble architrave, that architrave smashed at one side and built into a piece of Roman frieze, which moulders away the next instant into a patch of broken brickwork – projecting over a mouldering wooden window, supported in its turn on a bit of grey entablature, with a vestige of inscription; but all to be studied closely before it can be felt or even seen*(D1.118)*.

Ruskin's drawing of the Piazza Santa Maria del Pianto contains precisely these elements. It is interesting to compare the original drawing with the lithographed version done for a collection called *The Amateur's Portfolio of Sketches* published in 1844 (ills 12, 13). The composition has been improved, and the picturesque elements already present in the original drawing have been heightened. The disposition of the figures has been altered, including the substitution of a cart for a group by the fountain, and they are arranged precisely in the manner advocated in

Prout's *Microcosm, the Artist's Sketch-book of Groups of Figures, Shipping, And other Picturesque Objects.* Prout provided a series of model groups from which the amateur might copy, with the advice that 'there should always be one principal group and smaller groups, with here and there detached figures, to express distances, and render the composition and effect more picturesque.'[8] The distant street scene that has been added on the right has in miniature the tall buildings and short figures one finds in the plates of David Roberts's *Picturesque Sketches in Spain* and 'The Tourist in Spain' (ill. 11).

It is clear that in 1842, one year before the publication of the first volume of *Modern Painters*, Ruskin was still fixed in a conventional way of seeing, producing pleasing drawings, but unoriginal and in a style that was already beginning to be thought a bit *passé*. How was it that he was able to discover a new view of nature, how indeed was it that the listless and depressed young Ruskin should hit upon the idea of writing *Modern Painters* at all? The answer lies in his own practice of drawing, a fresh perception of Turner, and what he presented in later life as an almost mystical experience of the forces of nature.

When he returned from his convalescence abroad, sufficiently recovered to take a pass degree, Ruskin began lessons under a new drawing master, J. D. Harding. Harding represented a new generation of water-colour artists, who had learnt from the water-colours by Turner which heralded his later style in oil. Harding sought a greater freedom of handling and a more naturalistic approach than the earlier picturesque artists. He himself was not a member of the Old Water-Colour Society at this time, for he had resigned, hoping, unsuccessfully, to be elected to the Royal Academy. He was critical of the Italian and Dutch artists who had contributed so much to English ideas of the picturesque. In his books on drawing he 'corrected' the compositions of Claude to give them more interest, and his stern religious attitude made him object to the 'low' subjects of the Dutch. His speciality was trees and foliage, concentrating on effects of light and shade to give a roundness that contrasts with the hard outlines of Prout. As part of his teaching method he got his pupils to copy the plates of Turner's *Liber Studiorum*, and Ruskin adopted a modified form of Turner's *Liber* style for his own treatment of leaves. Harding told the student to achieve his effects by a close study of nature, rather than by tricks of style; but he was not 'called upon to substitute botanical delineation for *pictorial effect*', he was not a painter of leaves in detail, but was concerned with 'the masses, the common forms, and their great distinguishing features:

and would but waste his time in prosecuting a study more within the province of the Botanist or the Gardener'.[9]

Harding's advice to study Turner's *Liber Studiorum* had special appeal to Ruskin, who by now had met Turner and owned some of his works. It is traditionally supposed that his passion for Turner began with Rogers's *Italy*, and was confirmed by the attacks made on Turner's pictures at the Royal Academy in 1836, but his real appreciation developed more slowly. True, Ruskin did write a juvenile essay in Turner's defence in 1836, but when he argued that Turner was 'not so stark mad as to profess to paint nature. He paints *from* nature, and pretty far from it, too'*(3.637)*, he showed that his appreciation was still in terms of a Neoclassical idealization of nature rather than a Romantic celebration of her power.[10] Much more significant is his first published reference to the artist in 1840, in an article on the proper shapes for engravings and pictures*(1.235–45)*. He concludes from an analysis of visual perception that the area of attention within a frame is oval, using as evidence the oval of Turner's vignettes. John James Ruskin's acquisition of works by Turner clearly denotes interest, but he already owned works by Prout and Copley Fielding, and bought a Roberts in the same year as his first Turner, *Richmond Bridge*, in 1837, whose trees echo those of Claude (ills 14, 15). As collectors of Turner, however, the Ruskins were bound to be approached when new works were available. One such approach, in 1842, gave Ruskin a new insight.

Turner had asked his agent Griffiths to secure commissions for a set of finished water-colours based on sketches he had made on the Rhine and in Switzerland. Four had been completed as samples, and buyers were invited to select a further six subjects from amongst the working sketches. The Ruskins were approached, and John was immediately enthusiastic, although there was a painful disagreement with his father over the price and the choice of subject. He was particularly excited by the rough sketches, which he came to call Turner's 'delight-drawings'*(13.237)* (ill. 4). He was familiar with the engravings and finished water-colours, but he had not seen a Turner sketch before *(13.507)*. These direct studies seemed to show a very different conception of nature from that in Turner's academic works *(35.310)*:

I saw that these sketches were straight impressions from nature, – not artificial designs, like the Carthages and Romes. And it began to occur to me that perhaps even in the artifice of Turner there might be more truth than I had understood. I was by this time very learned in *his* principles of composition; but it seemed to me that in these later subjects Nature was composing with him.

The idea that the artist, instead of imposing a predetermined shape on nature, cooperates with it, or even allows nature to impose its vision on him, marks the shift from a classic to a Romantic point of view.

The story of the 'delight-drawings' just quoted comes from Ruskin's autobiography, and it is quickly followed there by the account of two personal experiences which also happened in that year, and which also centre on the word 'composition'. Both are the result of drawing foliage, the exercise encouraged by Harding. The first concerns a piece of ivy, seen on the road to Norwood, near his home in London, which struck him as 'not ill "composed" '; having drawn it, he began to realize that 'no one had ever told me to draw what was really there!'(35.311) This break through conventional perception to a new sense of reality was repeated much more elaborately later that summer, while he was in France at the start of another Continental tour. He describes how, near Fontainebleau, ill and depressed, he drew an aspen tree.

Languidly, but not idly, I began to draw it; and as I drew, the languor passed away: the beautiful lines insisted on being traced, – without weariness. More and more beautiful they became, as each rose out of the rest, and took its place in the air. With wonder increasing every instant, I saw that they 'composed' themselves, by finer laws than any known of men. At last the tree was there, and everything that I had thought before about trees, nowhere.(35.314)

In this mystical moment of identification between self and nature the poet's imagination, the geologist's observation and the preacher's vision seemed to come together.

The woods, which I had only looked on as wilderness, fulfilled I then saw, in their beauty, the same laws which guided the clouds, divided the light, and balanced the wave. 'He hath made everything beautiful, in his time,' became for me thenceforward the interpretation of the bond between the human mind and all visible things; and I returned along the wood-road feeling that it had led me far; – Farther than ever fancy had reached, or theodolite measured. (35.315)

This is a persuasive account of how Ruskin's eyes might have been unsealed – but unfortunately it seems that in fact the old mode of vision was not sloughed off so quickly or in so startling a fashion. In his diary, unavailable to him when he reconstructed the experience forty years later, Ruskin describes his time at Fontainebleau in 1842 as 'an unprofitable a week as I ever spent in my life' and the only hint of a change of attitude is 'But I got some new ideas in my evening walk at

Fontainebleau'*(D1.223)*.[11] Neither the drawing at Norwood nor that at Fontainebleau has been positively identified, and we may question how it was that a sketching exercise in the manner of Harding could have wrought such a change. What is stranger, Harding himself is said to have had a similar experience. In an article on Harding which appeared in 1880 there is a description of him in some confusion at the beginning of his career as to what he should do. (Ruskin was in similar circumstances in 1842.) 'In this state of mind, whilst sketching some trees near Greenwich, the thought at once occurred to him that the trees obeyed laws in their growth, and if he could ascertain these *laws*, and put *them* on his paper, he would get at the truth he so desired.'[12] There is a remarkable similarity between these accounts, which makes one wonder whether Ruskin either saw this version or had heard it from Harding himself.

Ruskin's version in *Praeterita* emphasizes the Romantic-religious experience of nature at the cost of the chronology of his actual development, and even at the cost of the chronology of *Modern Painters*, as we shall see; but none the less it is imaginatively true. There *was* a change of attitude, and he did begin to see things differently. For confirmation we need go no further than the fact that later in 1842, after reading further attacks on Turner, he decided to begin *Modern Painters*, and in the first volume, which appeared in 1843, he began to criticize the picturesque.

The great theme of the first volume of *Modern Painters* is not beauty, but truth: 'The word Truth, as applied to art signifies the faithful statement, either to the mind or senses, of any fact of nature.'*(3.104)* Ruskin is primarily concerned with these 'facts' of nature, although he acknowledges from the start that truth is not limited to the accurate delineation of external form: 'there is a moral as well as material truth, – a truth of impression as well as of form, – of thought as well as of matter'*(3,104)*. His case is that if we cannot see external form clearly and accurately, it will be impossible for us to perceive the inner truth that the facts of nature convey. In order to see clearly we must abandon conventional perception, and study nature with our own eyes. But again, there is more than just the need to use an innocent eye, for the development of our visual sense will help the development of our moral sense:

with . . . bodily sensibility to colour and form is intimately connected that higher sensibility which we revere as one of the chief attributes of all noble

minds, and as the chief spring of real poetry. I believe this kind of sensibility may be entirely resolved into the acuteness of bodily sense of which I have been speaking, associated with love, love I mean in its infinite and holy functions, as it embraces divine and brutal intelligences, and hallows the physical perception of external objects by association, gratitude, veneration, and other pure feelings of our moral nature.*(3.142–3)*

Seeing is loving, seeing is a form of worship, and Ruskin devotes much of the book to the description of the external forms of mountains, trees, and clouds, as he saw and worshipped them.

The 'truths' of nature are contrasted with the conventionalized second-hand perceptions of landscape painters before Turner. The system of the old masters 'may be sublime, and affecting, and ideal, and intellectual, and a great deal more; but all I am concerned with at present is, that it is not *true*; while Turner's is the closest and most studied approach to truth of which the materials of art admit'*(3.265)*. By old masters he did not mean the great names like Raphael, Michelangelo, Leonardo or Titian, but those seventeenth-century Italian and Dutch artists who had contributed to contemporary ideas of the picturesque. (It is important to remember how much this narrows the field, for Ruskin's polemical writing sometimes seems to condemn every painter except Turner.) The artists he did attack were roughly handled. It is worth quoting at length his treatment of Claude's *Marriage of Isaac and Rebecca* (ill. 14) in his section entitled 'Of Truth of Earth'. We can see the power of his prose to convey the conclusions to which his geological observations and practice of drawing had led him.

In the distance . . . is something white, which I believe must be intended for a snowy mountain, because I do not see that it can well be intended for anything else. Now no mountain of elevation sufficient to be so sheeted with perpetual snow can, by any possibility, sink so low on the horizon as this something of Claude's, unless it be at a distance of from fifty to seventy miles. At such distances, though the outline is invariably sharp and edgy to an excess, yet all the circumstances of aërial perspective, faintness of shadow, and isolation of light, which I have described as characteristic of the Alps fifteen miles off, take place, of course, in a three-fold degree; the mountains rise from the horizon like transparent films, only distinguishable from mist by their excessively keen edges, and their brilliant flashes of sudden light; they are as unsubstantial as the air itself, and impress their enormous size by means of this aërialness, in a far greater degree at these vast distances, than even when towering above the spectator's head. Now, I ask of the candid observer, if there be the smallest vestige of an effort to obtain, if there be the most miserable, the most con-

temptible, shadow of attainment of such an effect by Claude. Does that white thing on the horizon look seventy miles off? Is it faint, or fading, or to be looked for by the eye before it can be found out? Does it look high? does it look large? does it look impressive? You cannot but feel that there is not a vestige of any kind of truth in that horizon(3.437).

This failure in aerial perspective, supposedly a particular feature of Claude, is compounded by worse errors of geology.

No mountain was ever raised to the level of perpetual snow, without an infinite multiplicity of form. Its foundation is built of a hundred minor mountains, and, from these, great buttresses run in converging ridges to the central peak. There is no exception to this rule; no mountain 15,000 feet high is ever raised without such preparation and variety of outwork. Consequently, in distant effect, when chains of such peaks are visible at once, the multiplicity of form is absolutely oceanic, [whereas Claude's simple shapes are] destitute of energy, of height, of distance, of splendour, and of variety, and are the work of a man . . . who had neither feeling for nature, nor knowledge of art.(3.48)

By contrast, Turner is shown to demonstrate precisely the qualities of energy and light, the dynamic balance between multiplicity of form and unity of conception, which Ruskin believed were the sources of beauty and the symbols of God's will. But these inner qualities were revealed by the most careful study of outward form. One recalls Jameson's comment in his *Manual of Mineralogy* on painters' ignorance of mountain structure, when Ruskin writes that Turner 'is the only painter who has ever drawn a mountain, or a stone; no other man ever having learned their organization, or possessed himself of their spirit, except in part and obscurely'(3.252). He goes so far as to assert that the tiny vignette of the battle of Marengo in Rogers's *Italy* (ill. 16) shows that Turner 'is as much of a geologist as he is of a painter'(3.429). (He makes no comment on the figure of Napoleon copied from David.) He does not mean that Turner actually studied geology, but his 'intense observation of, and strict adherence to, truth'(3.465) meant that the science of aspects matched the science of geology.

Since Ruskin is so critical of the old masters of landscape, what was his attitude to the landscape painters of his own day? In the light of what has been said about the picturesque, we should expect him to be equally critical, if not more so. But he is not, for reasons that require some explanation. According to his own account, his original idea had been to write a work entitled *Turner and the Ancients*, and he did not

intend to refer to any modern painter other than Turner. But, 'in deference to the advice of friends' (which may be taken to mean his father), his title became *Modern Painters, Their Superiority in the Art of Landscape Painting to the Ancient Masters(7.441n)*. The use of the plural committed him to writing not just about Turner, but his contemporaries as well, and he praises Copley Fielding, J.D. Harding, John Varley, Peter De Wint, James Pyne, Augustus Callcott, and other minor artists, who are used to show that Turner is part of a whole new school of landscape painting. Ruskin was right to say this, for the other artists were influenced by Turner, but they fall well below his standards.

Ruskin had another motive for not attacking the picturesque artists in the first edition of *Modern Painters*. Many of the artists were his acquaintances, and it would not look well if he attacked people his father liked to have to dinner. He was only twenty-four when the first edition appeared, and he tried to avoid being accused of youthful presumption by sheltering under the anonymous by-line 'A graduate of Oxford'. Two letters to Prout, who always retained Ruskin's favour, show what his real feelings were. The first, written not long after the book had come out, still playfully pretends that Ruskin is not the author, but a friend of his. Ruskin says he has been assured that the book would have had 'a very different tone from that which it has, had it not been for the interference of his friends, who feared the result of attacks on living men. [For 'friends' we may again read John James Ruskin.] Had it not been for them, I am pretty sure that . . . faults, instead of beauties, would have been pointed out in Stanfield and Harding.'*(38.335)* The second letter, written the following February, is more frank: 'The fact was, I had for a year or two been looking at M. Angelo and Turner, and had quite lost sight of Messrs. Stanfield, etc., so that I wrote the opinions of past time, and was horrorstruck in the Academy and the Water-colour, by the deeds of some whom I had praised.'*(38.337)*

This change of heart shows in his later revisions of *Modern Painters 1*. By 1846, the date of the third edition, his actual knowledge of art had increased dramatically. It is fair to say that when he began he had known very little about art at all; his visit to Italy in 1845 changed all that, and in consequence he made important alterations to his first volume and changed the direction of the second. This change of emphasis is disguised by the fact that we normally see only the 1846 edition. Many of the references to modern painters other than Turner are dropped in the 1846 text, and blame is substituted for praise. On the other hand he discusses an additional forty-five painters in expansions to his text.[13]

45

The extent to which his attitude towards the picturesque had hardened by 1845 can be seen in his comments on his last drawing master. Harding joined Ruskin in Italy, and they sat side by side in Venice, sketching the canals. John's comment on his former teacher was: 'His sketches are always pretty because he balances their parts together & considers them as pictures – mine are always ugly, for I consider my sketch only as a written note of certain *facts*'(L45.189). It appears that he had taken his own lessons in *Modern Painters 1* to heart, and in his revisions of the text in 1846 Harding's tree drawing, formerly 'an illustration of every truth we have been pointing out in foliage',[14] becomes 'comparatively imperfect, leaning this way and that, and unequal in the lateral arrangements of foliage. Such forms are often graceful, always picturesque, but rarely grand, and, when systematically adopted, untrue.'(3.601) Harding was not totally condemned however, for when Ruskin returned to the problem in *Modern Painters 4* he distinguished Harding's trees from the 'Modern Blottesque'. Is it significant that the tree he chooses to illustrate (ill. 20) is an aspen?

Ruskin's first line of attack on the picturesque, then, was that it was a false vision of nature, the product of an approach which made only a superficial study of the outward forms of natural scenery, and then only to select certain aspects to compose into an idealized picture which bore no resemblance to the 'facts'. His own 'science of aspects' involved a much deeper study of nature which uncovered the true laws of natural organization to which everything, including the painter, must submit. The source of these laws, expressed throughout the whole of creation, was God. The picturesque artist, with his superficial tricks of style and his preconceptions of what was and what was not suitable for painting, had little hope of approaching the inner truth of external form, except in so far as his subject matter managed to impose itself on him. But there was another direction from which Ruskin also began to attack the picturesque, a direction very significant in the light of his future development. It is well known that he evolved from a critic of art to a critic of society, but it is remarkable how early this evolution began.

The important event is, again, the tour of 1845. This was the very first time he had travelled abroad without his parents, and their absence had a liberating effect on his mind and spirit. He none the less wrote home daily, and we have a first-hand account of his developing sense of confidence and sureness of his powers. His widening horizons

even led him to question the social and economic basis on which his privileged position depended, and in a letter from Parma in July we find the first signs of a new attitude to the purpose of art. His comments arise from his difficulty with poetry, which he was still trying to write, although *Modern Painters 1* should have convinced him that his true talent was for prose:

I don't see how it is possible for a person who gets up at four, goes to bed at 10, eats ices when he is hot, beef when he is hungry, gets rid of all claims of charity by giving money which he hasn't earned – and those of compassion by treating all distress more as picturesque than as real – I don't see how it is at all possible for such a person to write good poetry. Yesterday, I came on a poor little child lying flat on the pavement in Bologna – sleeping like a corpse – possibly from too little food. I pulled up immediately – not in pity, but in *delight* at the folds of its poor little ragged chemise over the thin bosom – and gave the mother money – not in charity, but to keep the flies off it while I made a sketch. I don't see how this is to be avoided, but it is very hardening. (*L45–142*)

Ruskin came to see very clearly how the starvation of children could be avoided, but for the moment he leaves the painful story as it is, perhaps as an indirect reproof of his father's businesslike attitude. The phrase 'treating all distress more as picturesque than as real' puts the theory in question in a very different light. The ragged clothes of beggars were standard subjects of the picturesque because their rough and tattered quality appealed to the eye; the reasons for dressing in rags were not gone into. Theorists of the picturesque seem oblivious of the social significance of what they write. Take Uvedale Price: 'In our own species, objects merely picturesque are to be found among the wandering tribes of gypsies and beggars; who in all the qualities which give them that character, bear a close analogy to the wild forester and the worn out cart-horse, and again old mills, hovels, and other inanimate objects of the same kind.'[15] The Dukes of Devonshire, who possessed some of the finest Claudes in the country, were quite happy to remove an entire village that interfered with the view from Chatsworth, and then with unconscious irony rebuild it elsewhere with each building selected from a pattern book of picturesque cottages. In *Modern Painters 5* Ruskin tersely exposes the difference between the picturesque image of a Highland scene and the reality: 'At the turn of the brook I see a man fishing, with a boy and a dog – a picturesque and pretty group enough certainly, if they had not been there all day starving.'(*7.269*)

It would be wrong to think that Ruskin rejected the formal qualities of the picturesque, the 'catching lights, the deep shadows, the rich mellow tints' which produced such raptures in Price and Payne Knight, although it worried him that its subject matter should be gypsies, worn-out cart-horses, or starving men: The 'merely outward delightfulness [of picturesque subjects] – that which makes them pleasant in painting, or, in the literal sense picturesque – is their actual variety of colour and form.'*(6.15)* He uses the word in this sense without any implied criticism, and his definition is not far from William Gilpin's: that which is expressive of 'that peculiar kind of beauty, which is agreeable in a picture'.[16] We even have a picturesque photograph by Ruskin (ill. 41), which he included in an exhibition on Samuel Prout, and Prout always remained a favourite artist. He wrote in 1879 that Prout 'taught me generally to like ruggedness. . . . This predilection – passion, I might more truly call it – holds me yet so strongly'*(14.385)*. He did, however, consider Prout to be a special case, because his architectural subjects 'elevated' the picturesque. 'That character had been sought, before his time, either in solitude or in rusticity; it was supposed to belong only to the savageness of the desert or the simplicity of the hamlet; it lurked beneath the brows of rocks and the eaves of cottages'; Prout however turned his picturesque eye on the city and the cathedral: 'He thus became the interpreter of a great period of the world's history, of that in which age and neglect had cast the interest of ruin over the noblest ecclesiastical structures of Europe'*(12.313–14)*. The picturesque 'interest of ruin', the broken stones and flourishing weeds, became historical records of the effects of time, and symbolic of a decay in which Ruskin read the signs of national ruin. The formal picturesque qualities are genuinely expressive; Prout 'never attempts to make anything picturesque that naturally isn't'*(14.419)*.

It was not the formal qualities of the picturesque to which Ruskin objected, but the use to which they were put. *Modern Painters 1* represents the first stage of his argument, that thinking in terms of 'composition' led to a false view of landscape. The distinction between the visual aspects of the picturesque and the irresponsible use to which they might be put is developed throughout the following volumes of *Modern Painters* and his parallel architectural studies. To make his distinction clear he evolves a new terminology. In *The Seven Lamps of Architecture* (1849) he explains that he does not reject 'angular and broken lines, vigorous oppositions of light and shadow, and grave, deep, or boldly contrasted colour'*(8.237)* in architecture, because they were a part of nature, and in so far as these qualities in a building remind us of nature

they heighten our awareness of its power or, as Ruskin expresses it, following Burke's categories, of its sublimity. If painting or architecture remind us of 'objects on which a true and essential sublimity exists, as of rocks or mountains, or stormy clouds or waves'*(8.237)*, then the works of art are sublime rather than picturesque. But if they merely reflect the outward picturesque qualities of nature – as a tiny cottage roof can mimic a craggy mountain slope – then the picturesqueness is no more than 'parasitical or engrafted sublimity'*(8.238)*, and its pursuit is degrading to art, for it is superficial, not real.

The proper use to which the formal qualities of the picturesque may be put comes in the first chapter of *Modern Painters 4*, 'Of the Turnerian Picturesque'. It is a criticism of Ruskin that he pays little attention to Turner's work before 1800, when he too went through a picturesque phase. He tends in general to dismiss the early work as a period when 'Turner was still working in a very childish way'*(6.43)*; an embarrassing example of this blind spot is his mistaken attribution to Turner (in his selection of art examples for Oxford University) of two plates after William Gilpin.

In 'Of the Turnerian Picturesque' Ruskin distinguishes between the 'noble' and the 'surface' picturesque. Modern appreciation of the genre 'so far as it consists in a delight in ruin, is perhaps the most suspicious and questionable of all the characters distinctively belonging to our temper, and art'*(6.9)*. It is this which 'fills ordinary drawing-books and scrap-books, and employs, perhaps, the most popular living landscape painters of France, England, and Germany'*(6.16)*. We can see the extent to which the pricking of his social conscience in 1845 had changed him.

The lower picturesque is eminently a *heartless* one; the lover of it seems to go forth into the world in a temper as merciless as its rocks. All other men feel some regret at the sight of disorder and ruin. He alone delights in both; it matters not of what. Fallen cottage – desolate villa – deserted village – blasted heath – mouldering castle – to him, so that they do but show jagged angles of stone and timber, all sights are equally joyful. Poverty, and darkness, and guilt, bring in their several contributions to his treasury of pleasant thoughts.*(6.19)*

The shameful list continues, and lest there should be any doubt, he deliberately adds a documentary touch by quoting from his diary of 1854, describing the conditions of the slum dwellers of Amiens:

all exquisitely picturesque, and no less miserable. We delight in seeing the figures in these boats pushing them about the bits of blue water, in Prout's

drawings; but as I looked today at the unhealthy face and melancholy mien of the man in the boat pushing his load of peats along the ditch, and of the people, men as well as women, who sat spinning gloomily at the cottage doors, I could not help feeling how many suffering persons must pay for my picturesque subject and happy walk.*(6.20n)*

Although Prout is mentioned here, he and Turner are exceptions to the heartlessness of contemporary artists. They understand 'the opposite element of the noble picturesque: its expression, namely, of *suffering*, of *poverty*, or *decay*, nobly endured by unpretending strength of heart' *(6.14)*. The battered hulk of Calais church is picturesque in its decay, but its endurance of time and weather give it an inner nobility. Both Clarkson Stanfield and Turner may depict a windmill, but whereas Stanfield's pleases the eye, Turner's actually *functions*. What makes the work of Prout and Turner noble is 'sympathy', the ability to feel with the subject, not just view its externals abstractly with an eye to its conformity to artificial ideas of composition. In his own manual on draughtsmanship, *The Elements of Drawing* (1857), Ruskin demands sensitivity to abstract relations of shape and texture that have nothing to do with the representation of actual objects, but there must be a connection between the outer forms and their inner truth. Pictures 'meant to display the skill of the artist, and his powers of composition; or to give agreeable forms and colours, irrespective of sentiment' produce a 'spurious form' of landscape*(7.255)*. The only saving grace of the picturesque artist is that he is a bit sentimental: he takes pleasure in humble things, and his seemingly irresponsible interest in the poor is at least worth cultivating 'not with any special view to artistic, but merely to humane, education'*(6.22)*.

In spite of the foregoing criticisms of the genre, there is one aspect of the picturesque with which Ruskin was sympathetic from first to last: architecture. The shaggy textures and rough outlines of ancient buildings were acceptable to him because they were genuine qualities in the buildings themselves and testified to the nobility of their endurance of time. Buildings, however, had a greater significance than that, for Ruskin always considered architecture to be 'an essential part of landscape'*(5.130)*. He did not mean the sentimental admiration of people for 'a ruined abbey by moonlight, or any building with which interesting associations are connected, at any time when they can hardly see it' *(8.8)*, but architecture as an expression of man's inter-relationship with his natural surroundings.

This relationship had been the theme of Ruskin's most ambitious early work, a series of articles for J. C. Loudon's *Architectural Magazine* called *The Poetry of Architecture*, published in 1837 and 1838. There he follows Wordsworth's concern in his *Guide through the District of the Lakes* that architecture should be appropriate to the scenery in which it is set. The same interconnection of buildings and natural surroundings is the subject of Ruskin's drawings of Swiss towns, made in the 1850s and 1860s for a projected history of the Swiss that would demonstrate the effect of their mountainous surroundings on their character.[17] On the purely visual level, such a concern leads quite logically to a preference for the shapes and tones of Gothic architecture over the straight lines and harsh stucco of the Neoclassical; on the deeper level it points to the need for the same inner laws which govern nature to govern architecture.

'The Lamp of Beauty' in *The Seven Lamps of Architecture* (1849) analyses this influence of natural form. The Gothic shapes 'are not beautiful *because* they are copied from Nature; only it is out of the power of man to conceive beauty without her aid'*(8.141)*. The Gothic mason did not evolve his decoration *from* foliage, but *to* foliage, showing that true ornament can only legitimately follow the abstract lines of nature. He dismisses the idea that the spires and crockets of northern Gothic symbolize man's aspiration to heaven; rather they echo the serrated skyline of the pine forest, while the 'dark green depth of sunshine' *(9.187)* on the Italian stone pine may have its echoes in the domes and darkness of southern churches. We see Ruskin working out the problem of foliage in capitals, in his designs for the decoration of the Oxford Natural History Museum in 1856 (ill. 19), where real leaves are shown side by side with their stone counterparts; Gothic expressed the same naturalism that he sought in a painter, the sculptor who found 'his models amongst the forest leaves' expressed 'profound sympathy with the fulness and wealth of the material universe'*(10.244)*. Architects should not live in cities. Above all, architecture must express the great theme of Life, which runs through all things: 'good architecture, which has life, and truth, and joy in it, is better than the bad architecture, which has death, dishonesty, and vexation of heart in it, from the beginning to the end of time'*(9.412)*.

Ruskin is speaking here of genuine, pre-Renaissance Gothic. In the eighteenth century, the picturesque with its castles and ruined abbeys had promoted a taste for mock Gothic – or Gothick, as it is usually called. In the 1830s, under the stimulus of Augustus Welby Pugin, the antiquarian approach which had been content with mere poetic bits and

pieces was gradually supplanted by a more serious and archaeological one. Ruskin poured scorn on those who 'crown a turret six feet high with chopped battlements three inches wide'*(9.199)*, or support a tiny chapel with a bunch of flying buttresses at every corner. In architecture, just as much as in painting, the building must speak the truth.

The connection between architecture and nature in *The Stones of Venice* (1851–53) is so close that the one comes to be considered as a substitute for the other, an argument that leads to an explanation of the reasons for the existence of the picturesque:

We are forced, for the sake of accumulating our power and knowledge, to live in cities. . . . We cannot all have our gardens now, nor our pleasant fields to meditate in at eventide. Then the function of our architecture is, as far as may be, to replace these; to tell us about Nature; to possess us with memories of her quietness; to be solemn and full of tenderness, like her, and rich in portraitures of her*(9.411)*.

In Venice the Gothic supplied this need, but when the Renaissance abandoned religion for luxury it broke the link, and destroyed architecture and art, leaving nothing but 'the Alsatian sublimities of Salvator, the confectionary idealities of Claude, the dull manufacture of Gaspar and Canaletto, south of the Alps, and on the north the patient devotion of besotted lives to delineation of bricks and fogs, fat cattle and ditchwater'*(9.45)*. Ruskin tries to argue that the English picturesque artists were independent of the seventeenth-century painters.

The picturesque school of art rose up to address those capacities of enjoyment for which, in sculpture, architecture, or the higher walks of painting, there was employment no more . . . the English school of landscape, culminating in Turner, is in reality nothing else than a healthy effort to fill the void which the destruction of Gothic architecture has left.*(11.225–6)*

Ruskin may have a point, in that the picturesque taste began to flourish just as Britain's Industrial Revolution was getting under way, but he is wrong to deny the link between Italian and Dutch landscape and the painters of his own day. He contradicts his own detailed criticisms of the English picturesque when he writes that the new school 'differed inherently from that ancienter one [the Italian and Dutch], in that its motive was love. However feeble its efforts might be, they were for the *sake of the nature*, not of the picture, and therefore, having this germ of true life, it grew and throve.'*(5.409)*

Ruskin risks the contradiction because he is thinking of Turner. The purpose of his argument against the English picturesque as a

'spurious' form of landscape was to show that its vision of nature was false, and that Turner's was true. Having shown that, and excoriated the Italian and Dutch schools which were its antecedents, he could then turn to the one positive virtue of the English picturesque: that it was concerned with the relationship between man and nature, however inaccurately that relationship was conveyed. Turner, indeed the 'Turnerian picturesque', communicated it accurately. And that brought Ruskin to the next stage of his argument. Having shown that Turner had a true vision of the world, he could then proceed to demonstrate the significance of that vision, for 'the truth of nature is a part of the truth of God; to him who does not search it out, darkness, as it is to him who does, infinity'*(3.141)*.

The truth of nature that Ruskin had found out beside the fountain of the Brevent was 'the pure and the right sense of the word – BEAUTIFUL.'*(4.365)* His next problem was to show that the beauty he perceived was both aesthetic *and* moral.

3 Ruskin and Beauty

'the whole visible creation is a mere perishable symbol of things eternal and true'

THERE IS a gap of three years between the publication of the first and second volumes of *Modern Painters*. This pause was not part of Ruskin's original plan; when the first volume appeared in May 1843 (coinciding with the Royal Academy exhibition), he carried on writing, with the second volume in mind as the completion of his argument. But the going got harder and harder – and then the crucial tour of Italy in 1845 called for a reassessment of what he was trying to do. *Modern Painters 1*, in spite of the equivocations about the picturesque, is a polemic that conveys all the enthusiasm the young Ruskin felt for the natural world and for Turner. *Modern Painters 2* represents Ruskin's first attempt to establish universal criteria that would demonstrate, not just the virtues of Turner, but of all great artists.

In 1846 Ruskin published a thoroughly revised version of *Modern Painters 1*, and a new volume which speaks in a totally different voice. The voice he adopted was that of an Evangelical preacher, the change of manner is symbolized by the decision to model his prose on that of the sixteenth-century protestant theologian Richard Hooker. As a result many of the incidental beauties of description found in *Modern Painters 1* are missing, and his sentences are dry and cold. But he was writing in what he described as 'the moulting time of my life'*(4.148n)*, and the period immediately following 1846 was one of deep uncertainty. There was a further gap of ten years before another volume of *Modern Painters* appeared. The high Evangelical tone did not suit Ruskin, and he came to regret the dogmatism, the 'narrow enthusiasm'*(3.54)* and the 'affected language'*(18.31)* which he had brought to this formal statement of his theory of art.

The volume is divided into two parts, which in outline complete the scheme for the defence of Turner. *Modern Painters 1* has established that Turner saw truthfully; the next volume describes the elements of beauty that he saw, and the imaginative process through which he

conveyed it to others. Ruskin felt confident about the first issue, since the perception of beauty synthesized the modes of perception we have been concerned with: Romantic, scientific, anti-picturesque, and Evangelical – above all Evangelical. The problem of the imagination was to take a great deal longer to resolve satisfactorily, in spite of a breakthrough in 1845 as important as the breakthrough from the picturesque in 1842.

Ruskin's manuscripts reveal that while his views on the imagination were uncertain, his ideas on the nature of beauty were firm. In the light of the moment beside the fountain of Brevent, the basis of Ruskin's theory must be that beauty equals God. But in order to show that the beautiful is expressive of Divine qualities he had to be very careful to prove that beauty was an independent and objective reality. Its purpose was to express the nature of God, and there must be no confusion between this function and the incidental pleasure it gave to man. We could operate entirely successfully as human beings, he argues, without taking the least pleasure in what we saw. Therefore the pleasure that we do find in our surroundings must be taken as a gift from God, and not something resulting from our own nature. As a gift from God, we must seek this pleasure out, since the gift brings us nearer to God who gives it. Our delight in seeing and hearing is not a 'means or instrument of life, but an object of life. Now, in whatever is an object of life, in whatever may be infinitely and for itself desired, we may be sure there is something of divine; for God will not make anything an object of life to His creatures, which does not point to, or partake of Himself.' *(4.46)*

A sense of such a God-given delight could not be acquired through such subjective or accidental means as custom or association. The familiarity born of custom may deprive objects of their initial ugliness, but equally it deadens our response; either way, custom has nothing to do with our actual perception of an object, but rather with what we make of that perception. Ruskin had a more serious problem in dealing with association. As George Landow has pointed out,[1] it had become a popular notion that an object is beautiful because the mind associates it with certain qualities which we find pleasant, such as utility or harmony. Archibald Alison had defended the picturesque as a form of beauty because of the associated train of thought its elements summoned up. The problem for Ruskin was that association meant that it was not the object itself that was beautiful, but what we subjectively associated with it, and what we associated with it depended on the chance connections made by our experience and the operations of our

own mind. The perception of the beautiful moved away from external nature into those dark recesses of the individual mind, where he was unwilling to look.

The problem was answered by accepting that association did exist, but as something distinctive from perception itself. 'Rational association' may summon up what is known about an object – its history, for instance – but that is nothing to do with beauty. 'Accidental association', chance connections and memories individual to each perceiver, gives every object a personal association which often enhances them; but this, he argues, is in order to guide our conscience, and is not in itself a perception of beauty. These individual associations add interest and variety, but they cannot take into account the absolute basis on which beauty rests, external to each individual. George Landow argues convincingly that as man gradually replaced God at the centre of his world view, Ruskin had to make a greater acknowledgment of the importance of subjective association in our attitude to nature.[2] His first position, however, which he held on to for as long as he could, was that 'Happily for mankind, beauty and ugliness are as positive in their nature as physical pain and pleasure, as light and darkness, or as life and death'(5.45).

What then is this beauty whose objectivity it was so essential to uphold? Ruskin briskly defined it in *Modern Painters 1*:

Any material object which can give us pleasure in the simple contemplation of its outward qualities without any direct and definite exertion of the intellect, I call in some way, or in some degree, beautiful. Why we receive pleasure from some forms and colours, and not from others, is no more to be asked or answered than why we like sugar and dislike wormwood.(3.109)

This firm refusal of any discussion of subjectivity distracts attention from the more complicated idea that when we perceive beauty, we do not think. Beauty, for Ruskin, is neither simply a sense-impression, nor an abstract thought (a conscious thought *about* something he calls an Idea of Relation). True, there must be a sense-impression for an Idea of Beauty to exist; and in a discarded draft he went so far as to say that there existed a 'Sensual Beauty', 'that quality or group of qualities in objects by which they become pleasant to the eye, considered merely as a sense'(4.365). But the beauty he was seeking to define had to be more than a mechanical response. Neither could beauty be the result of conscious reasoning, since that would contradict his argument that the perception of beauty was instinctive, an object of life created by God.

56

The psychological terminology current when Ruskin was writing defined the area of the non-rational, of the feelings as opposed to thought, as the moral. When therefore he says that impressions of beauty are neither 'sensual nor intellectual, but moral'*(4.42)*, this is not simply tying beauty to religion. Morality is governed by the emotions, because it is through our emotions that we are able to identify ourselves with others, and so know how to behave towards them. This 'sympathetic imagination' made possible the identification between poet and nature, and it explained how beauty for Ruskin could be a sense of total identification with God. Beauty had to be greater than the human mind, and yet perceptible to it; our unconscious emotional response was the instinctive part of ourselves moving in sympathy with that which God had also created. The difficulty for Ruskin's theory of beauty was that, whereas he had excluded subjectivity by denying the relevance of association, an emotional response remained a necessary part of the perception of beauty; and that emotion was inspired by God. If faith in God faltered, as Ruskin's eventually did, then that emotion might turn out to be no more than subjective self-projection and our perception of beauty false.

When he turned to the problem of the imagination the role of the emotions again became a major difficulty. The human reaction to beauty, according to Ruskin's theory, is a process, through which an idea of beauty is conceived, rather than the operation of a single perceptual faculty of the mind. It is a process which leads from a sense impression through to the worship of God:

it is necessary to the existence of an idea of beauty, that the sensual pleasure which may be at its basis [sense-impression] should be accompanied first with joy [emotion], then with love of the object [sympathetic identification], then with the perception of kindness in a superior intelligence [Beauty = God], finally, with thankfulness and veneration towards that intelligence itself [worship].*(4.48)*

Ruskin needed some new word to describe this process, and he found it in the Greek philosophers' term for the highest activity of man: *theoria*, 'contemplation'. To describe the location in the mind where this process takes place, he created the term 'the theoretic faculty'. The faculty is more than sense perception, but stops short of conscious thought, a mediator between eye and mind: 'the mere animal consciousness of the pleasantness I call Aesthesis; but the exulting, reverent, and grateful perception of it I call Theoria. For this, and this only, is

the full comprehension and contemplation of the Beautiful as a Gift of God' *(4.47)*.

Armed with a term which he hoped could provide a satisfactory link between external beauty and the awareness of God, Ruskin could turn to consider the nature of the objective beauty which the theoretic faculty perceives. This beauty exists in two forms:

first, that external quality of bodies already so often spoken of, and which, whether it occur in a stone, flower, beast or in man, is absolutely identical, which . . . may be shown to be in some sort typical of the Divine attributes, and which, therefore I shall, for distinction's sake, call Typical Beauty: and, secondarily, the appearance of felicitous fulfillment of function in living things, more especially of the joyful and right exertion of perfect life in man; and this kind of beauty I shall call Vital Beauty.*(4.64)*

Vital beauty carries into art the optimistic world view of natural theologians like Buckland. The theoretic faculty perceives that the whole world works in purposeful harmony through an emotional identification with the natural world (and significantly, Ruskin's examples come from Wordsworth), 'the kindness and unselfish fulness of heart, which receives the utmost of pleasure from the happiness of all things'*(4.148)*. The sense of vital beauty is an indication of the state of our moral health, since 'he who loves not God, nor his brother, cannot love the grass beneath his feet'*(4.148)*. We detect and sympathize with the 'appearance of healthy vital energy'*(4.151)* in organic forms, which leads us to perceive the moral intention of the Creator in producing them. Here the influence of natural theology on Ruskin is clear: 'There is not any organic creature but, in its history and habits, will exemplify or illustrate to us some moral excellence or deficiency, or some point of God's providential government'*(4.156)*. Thus even ugly creatures can be shown to have their appointed place in creation.[3]

Natural theology sanctifies vital beauty; Evangelical typology sanctifies typical beauty. Ruskin's theological view of the world asserts itself; types express the nature of God, through the material facts of the world in forms accessible to man.

What revelations have been made to humanity inspired, or caught up to heaven, of things to the heavenly region belonging, have been either by unspeakable words, or else by their very nature incommunicable, except in types and shadows; and ineffable by words belonging to earth, for, of things different from the visible, words appropriated to the visible, can convey no image. *(4.208)*

These 'types and shadows' are those qualities in the material world to which we instinctively and non-rationally respond as the beautiful. Consciousness that these qualities express Divine attributes only comes afterwards, at a further stage of the process: 'I have repeated again and again that the ideas of beauty are instinctive, and that it is only upon consideration, and even then in doubtful and disputable way, that they appear in their typical character.'*(4.87)*

Ruskin lists the major forms of typical beauty that he perceives in the natural world. In all these types except one, Light (which he distinguishes as an 'actual substance', and as necessary to the apprehension of the others), typical beauty expresses itself as 'conditions and modes of being'*(4.128)*. As such, it is close to vital beauty, which affects us through our sympathy for the condition or mode of being of plants and living animals. To each quality he attaches an aspect of the Divine being. Thus, the sense of Infinity makes us aware of the greatness of God, and the impossibility of totally comprehending him. Light in the far distance, at dawn or dusk, on the vanishing-point of the horizon, 'is of all visible things the least material, the least finite, the farthest withdrawn from the earth prison-house, the most typical of the nature of God, the most suggestive of the glory of His dwelling-place'*(4.81)*. Infinity does not only exist perspectively in space; it is present in the infinite number of curves, no two alike, which go to make up the Creation. The infinite curvature of nature necessarily means an infinite variation in the play of light, so that colour, in full light or shade, is constantly gradated in a manner that few artists, except Turner, can follow.

There is an emphasis on order in Ruskin's typical beauty which has its origin in eighteenth-century ideas of universal order as an expression of the Divine will.[4] His choice of Moderation, 'the girdle and safeguard of all the rest'*(4.139)*, as the type of government by law, shows a concern to limit the extravagance and violence associated with some Romantic poetry and art. His reasoning is that, in the same way as God, though all-powerful, yet acts with self-restraint, obeying his own laws, the artist must act with similar self-restraint, preferring moderated curves and gradated colours to violent and exaggerated ones. The influence of Neoclassical preferences in art shows most clearly in the identification of another type, that of repose, with Divine permanence. Repose suggests a classic monumentality, regularity and solidity; it is 'the "I am" of the Creator opposed to the "I become" of all creatures' *(4.113)*, it includes its necessary contrary, energy, to vitalize the solid form, but the order it imposes lifts that energy above the fretful

59

ephemeral life of man, 'raising the life of sense into the life of faith' *(4.116)*. Ruskin later regretted the emphasis he placed on the necessity for Repose in all art, and in doing so revealed that it was the study of Michelangelo and the ideas of Sir Joshua Reynolds that had induced it*(4.117–18n)*.

Although even the permanence and solidity of Repose required the presence of some vitalizing energy, the concept of order comprehending change is best conveyed by the type of Unity, or Divine comprehensiveness. Unity does not consist in a single quality, but in the interconnection of objects which express God's inherence in all things, as conveyed by the organic cooperation in man and nature. (Again, we are close to ideas of vital beauty.) It takes several forms: unity of subjection, meaning the submission of several things to a common force, as clouds are shaped by the wind; unity of origin, as in the individually various branches of a tree expressing their common source; unity of sequence, our overall recognition of a common bond between a series of things, as in melody and harmony in music; and finally, unity of membership. This is the most interesting form, for it denotes the relationship binding the 'unity of things separately imperfect into a perfect whole'*(4.95)*. Such a unity *can* arise only out of the union of separate and different parts, and it implies that variety is therefore an essential to unity: but, Ruskin adds, only such variety as 'is necessary to secure and extend unity'*(4.96)*, and he coins the phrase 'chordal variety' to mark the limit of permissible change.

The idea that the type of Unity involves the inter-relations of parts turns Ruskin to the problem of Proportion and Symmetry. His desire to show the objective, non-utilitarian nature of beauty causes him to reject the idea that constructive proportion, which enables something to do its work, has anything to do with beauty. Constructive proportion is functional, and therefore appeals to the mind: 'the megatherium is absolutely as well proportioned, in the adaptation of parts to purposes, as the horse or the swan; but by no means as handsome as either' *(4.110)*. But apparent proportion – that is, the feeling of proportion that an object gives us – is non-functional, and therefore an idea of beauty, and vital to the sense of Unity. The relationship of infinitely variable curves which is expressed through their proportionate angles makes up their unity of sequence.

Symmetry is the type of Divine justice: 'in all perfectly beautiful objects, there is found the opposition of one part to another, and a reciprocal balance'*(4.125)*. This is not the same thing as proportion: 'Symmetry is the *opposition* of *equal* quantities to each other; proportion,

is the *connection* of *unequal* quantities with each other.'*(4.125–6)* Symmetry implies arrangement 'contrary to the violence and disorganization of sin'*(4.127)*, but the relationship between the opposite quantities is dynamic, rather than static: 'Absolute equality is not required, still less absolute similarity. A mass of subdued colour may be balanced by a point of a powerful one, and a long and latent line overpowered by a short and conspicuous one.'*(4.125)* When Ruskin came to discuss justice in relation to society in the 1860s, the idea of dynamic symmetry remained a vital part of his argument.

Ruskin's theory of typical beauty can be seen to depend on two potentially opposing principles: Unity and Energy. Both classical and Romantic aesthetics express a desire for totality: how that unity is achieved and what it consists of is the difference between them. In spite of the Neoclassical leanings Ruskin at times displays, Ruskin's Unity is finally that of the Romantics, an organic unity which comprehends variety and perceives the One in an infinitely variable and changing series of forms. This can be seen in his description of Purity, or the type of Divine energy. Purity is a condition of Light, and so partakes of that all-embracing type, but it is also a condition of Life. It is only when particles of matter are together in their pure form that their energy is released. If they are mixed with impurities, or do not cooperate (and all Ruskin's unities imply cooperation), they are incapable of 'vital or energetic action'*(4.129)*. The idea foreshadows later social criticism. In his parallels with cooperation in human, animal and botanical form, Ruskin again comes near to ideas of vital beauty; this need not be seen as a confusion, but as a synthesis of the two processes by which the theoretic faculty perceives the relationship between God and nature, in the beautiful:

It is either the record of conscience, written in things external, or it is a symbolizing of Divine attributes in matter, or it is the felicity of living things, or the perfect fulfillment of their duties and functions. In all cases it is something Divine; either the approving voice of God, the glorious symbol of Him, the evidence of His kind presence, or the obedience to His will by Him induced and supported.*(4.210)*

The importance of the Evangelical phase in Ruskin's career should not be underestimated. Knowing, as we do, that he eventually abandoned his early faith, it is tempting to dismiss his Evangelical theory of beauty as an early attempt to rationalize and integrate the various influences that played upon him as a young man, and then move on to the middle and later period of his life when the material is less organized, his

61

experience of both art and life is greater, and his insights seem more profound. This view has been encouraged by Ruskin himself, who did not publish another volume of *Modern Painters* for ten years, until 1856, by which time he rejected both the literary style and the Evangelical atmosphere of *Modern Painters 2*. In his final years, however, he came to realize the value of what he had been saying.

Evangelical typology is the source of the most important feature of Ruskin's theory and practice: the ability to treat objects both as real and complete in themselves, and as expressions of higher things. He was a materialist and an idealist at the same time. This duality is resolved dialectically, by accepting that objects are both real and symbolic. Even when Ruskin's faith faltered, the types of beauty continued to express higher things, for as 'conditions and modes of being' *(4.128)* they remained visual expressions of the moral qualities needed for the right ordering of human society.

Ruskin's concern to prove that beauty has an objective existence led him to develop an aesthetic which tries to identify the abstract visual qualities in a work of art. To put it more simply, the types of beauty describe those formal qualities which are pleasing regardless of the work's content. A work with no figurative or representational content can be discussed in terms of Ruskin's types. The value of his religious viewpoint was that he accepted the material existence of these forms, as entities independent of man. He did not feel imprisoned in his own subjectivity. Instead he could show that there was a real link between man and nature, in the instinctive response to the visual forms objectively present in the external world. These forms gave delight, and man sought to reproduce them in art.

The connection between nature and art exists at the purely abstract level of a common repertory of visual forms. This was the basis of Ruskin's argument for 'natural' ornament in architecture, by which he meant not the reproduction of certain images of high definition, with fixed meanings as oak leaf or shell, but of the forms which go to make up those images(9.266-7):

Our first constituents of ornament will therefore be abstract lines, that is to say, the most frequent contours of natural objects, transferred to architectural forms, when it is not right or possible to render such forms distinctly imitative. For instance, the line or curve of the edge of a leaf may be accurately given to the edge of a stone, without rendering the stone the least *like* a leaf, or suggestive of a leaf, because the lines of nature are alike in all her works; simpler or richer in combination, but the same in character.

Ruskin illustrates the common repertory of forms with a diagram comparing the curvature of mountain glaciers, trees, plants, and shells (ill. 21). Since such forms have an objective existence, Ruskin was able to explain how irreligious men were capable of producing works of art as beautiful as those of religious men. Since the types of beauty are perceived instinctively and unconsciously, they can also be reproduced unconsciously, without the artist making the moral connection.

Ruskin did make the moral connection, and read the visual forms as symbols of the Divine. It was vital for his theories of the imagination that he should, and it is vital for our understanding of Ruskin to treat him as a symbolic writer, who yet believed in the material existence of these symbols. In this view of nature as real and symbolic two key elements stand out: Life and Light, both expressed by the type of Purity, or Divine energy. In choosing light as the highest expression of God, Ruskin has all the authority of the Bible behind him: 'God is light, and in him is no darkness at all'*(I John 1: 5)*. He was also in the tradition of a long line of thinkers.[5] The order of the creation in Genesis is first the earth without form, then light, the dry land, life; so that light and life are inextricably connected as the two expressions of God which inform the natural world (and of course this is more than metaphor: we could not exist without light). By life he meant a sense of healthy and cooperative energy, which links the physical with the spiritual. Through the theory of typical beauty he had achieved a resolution of Romantic, scientific and Evangelical thought, and he had discovered that, if the theory were applied to painting, landscape art 'might become an instrument of gigantic moral power, and that the demonstration of this high function, and the elevation of some careless sketch or conventional composition into the studied sermon and inspired poem, was an end worthy of my utmost labour'*(3.666)*.

In *Modern Painters 1* Ruskin gave a celebrated piece of advice to young painters. He told them to go to nature 'rejecting nothing, selecting nothing, and scorning nothing; believing all things to be right and good, and rejoicing always in the truth.'*(3.624)* His theory of typical beauty reinforces that advice, by showing that it is in nature that the sources of pleasure in art are to be found. In 1851 he was delighted to discover that a group of young painters seemed to have been carrying out his principles without any personal intervention from him: the Pre-Raphaelite Brotherhood.[6] The finished accuracy of Holman Hunt and Millais was exactly in tune with his own emphasis on the 'facts' of nature.

Ruskin seized on the emergence of the PRB as ammunition for his attacks on the picturesque, and from his very first comment on the Pre-Raphaelites in a letter to *The Times* he stressed the difference between them and the picturesque school: 'They intend to return to early days in this one point only – that, as far as in them lies, they will draw either what they see, or what they suppose might have been the actual facts of the scene they desire to represent, irrespective of any conventional rules of picture-making'*(12.322)*. Whereas the picturesque artist selected a principal subject and left the rest vague, the Pre-Raphaelite made every detail significant, and the very readability of his work made it accessible to everybody, rich or poor: 'The old art of trick and tradition had no language but for the connoisseur; this natural art speaks to all men: around it daily circles of sympathy will enlarge; pictures will become gradually as necessary to domestic life as books'*(14.152)*.

Welcome though this praise was to the group of young painters who were producing realist landscapes, Ruskin's defence contained an important proviso. He praised them because of 'their fidelity to a certain order of truth'; but it was not enough merely to abandon the picturesque mode of vision. The close study of the facts of nature was only a first step in the process of creation; there must be something more if the artist was to perceive the inner laws of landscape. The types of beauty 'are not presented by any very great work of art in a form of pure transcript. They invariably receive the reflection of the mind under whose influence they have passed, and are modified or coloured by its image. This modification is the Work of Imagination'*(4.223)*.

It must have been a bitter disappointment to John Brett to read Ruskin's notice of his landscape of the Val d'Aosta (ill. 22) at the Royal Academy in 1859. Ruskin had suggested the subject to him, and advised him as he painted it. The picture satisfied all Ruskin's criteria of geological and meteorological accuracy, but it was not enough:

it seems to me wholly emotionless. I cannot find from it that the painter loved, or feared, anything in all that wonderful piece of the world. There seems to me no awe of the mountains there – no real love of the chestnuts or the vines. Keenness of eye and fineness of hand as much as you choose; but of emotion, or of intention, nothing traceable.*(14.236)*

These higher requirements of the artist are the subject of the following chapter.

4 Ruskin and the Imagination

'Whole picture-galleries of dreams'

WHEN John Brett discovered that his hard work and technical accuracy simply meant another kind of failure, he might well have asked the question anticipated by Ruskin in *Modern Painters 3*: 'Well, but then, what becomes of all these long dogmatic chapters of yours about giving nothing but the truth, and as much truth as possible?' Ruskin's answer was: 'The chapters are all quite right. "Nothing but the Truth", I say still. "As much Truth as possible", I say still. But truth so presented that it will need the help of the imagination to make it real.'*(5.185)*

The accurate study of fact is only the first stage of the creative process; what really mattered for Ruskin was the artist's *use* of fact. He had always held that it was a narrow achievement merely to create a mimetic version of reality. From the outset he said that there were higher levels of truth, 'of impression as well as of form, – of thought as well as of matter', and these truths might be conveyed completely independently of natural fact, 'by any signs or symbols which have a definite signification in the minds of those to whom they are addressed, although such signs be themselves no image nor likeness of anything'*(3.104)*. The result is a system of three orders of truth: the truth of fact, the truth of thought, and the highest truth, the truth of symbol. The ideas in *Modern Painters* follow this same progression; in this chapter we are concerned with the second and third orders of truth.

Although Ruskin's three orders are marked out in *Modern Painters 1*, the attention to the truth of fact in that volume obscures the other two. The need to defend Turner against specific attacks – that his paintings had imaginative power, but no resemblance to nature whatsoever – demanded this concentration on Turner's meteorological and geological accuracy. In *Modern Painters 2* the position was different:

It is the habit of most observers to regard art as representative of matter, and to look only for the entireness of representation; and it was to this view of art that I limited the arguments of the former sections of the present work, wherein,

having to oppose the conclusions of a criticism entirely based upon the realist system, I was compelled to meet that criticism on its own grounds. But the greater parts of works of art, more especially those devoted to the expression of ideas of beauty, are the results of the agency of the imagination.*(4.165)*

How to define the means by which the higher truths were achieved turned out to be a long and intriguing problem.

There is a further reason why the imagination is neglected in the first volume of *Modern Painters*. When he began, Ruskin was not sure what it was. Nearly eighteen months after *Modern Painters 1* had made its appearance, we find him writing to one of his former tutors at Christ Church, H. G. Liddell, 'can you tell me of any works which it is necessary I should read on a subject which has given me great trouble – the essence and operation of the imagination as it is concerned with art? Who is the best metaphysician who has treated the subject generally, and do you recollect any passages in Plato or other of the Greeks particularly bearing upon it?'*(3.670)* Liddell suggested Aristotle, which may have given him the idea of using *theoria* for the perception of beauty, but Ruskin needed something more than a few quotes from Greek philosophers.[1]

We can see the problem being worked out in his drawings. He was perfectly well aware that somehow Turner penetrated the facts of outward experience and so transformed them, but he was not sure how. In 1841, while in Southern Italy, Ruskin had made a stylish but straightforward drawing of Amalfi (ill. 23). The topographical approach hardly conveys the glory of the scene which he noted in his diary at the time, 'the light behind the mountains, the evening mist doubling their height'*(D1.164)*. On his return to England he was asked to do a more elaborate water-colour based on the sketch. The result, which was not finished until 1844, is a full-scale pastiche of Turner's style (ill. 3). The sunset, moonrise and evening mist in blue, yellow and pink are straining for the poetic effect that these elements could achieve in Turner's hands, but the result is very near caricature. This and other Turnerian fantasies of the period show Ruskin as it were trying to understand Turner from the outside, manipulating the devices, but unable to bring them to life. When in 1848 Clarkson Stanfield (one of the artists dropped in the revised *Modern Painters 1*) showed his picture of Amalfi at the Royal Academy, Ruskin wrote: 'the chief landscape of the year, full of exalted material, and mighty crags, and massy seas, grottoes, precipices and convents, fortress-towers and cloud-capped mountains, and all in vain, merely because that same simple secret has

been despised; because nothing there is painted as it is!'*(4.337)* It was exactly the same dilemma he had been in himself.

The apparent conflict between fact and expression could be resolved, not by metaphysical speculation, but only by a concrete experience, something that depended as much on the evidence of his own eyes as on any intellectual reasoning. Once again, the key event is the tour of Italy in 1845. We have seen how important the tour was in hardening his attitude against the picturesque; it was also the moment of breakthrough for his positive theories of art. As I said earlier, Ruskin did not know a great deal about art history when he began *Modern Painters*, and the purpose of the tour was to fill in the wide gaps in his knowledge. In particular his ignorance of pre-Renaissance painting had been shown up by his reading of the French critic Alexis Rio's *The Poetry of Christian Art*.[2]

Rio took the view that the Italian Renaissance, far from being a great cultural awakening, had destroyed the pure religious art of the medieval Italian Primitives, and had opened the way for decadence and decay. This attitude coincided with Ruskin's own, for he wished to restore the religious basis of art. The conflict between his Protestant views and the Roman Catholic celebrations of Saints and Madonnas was resolved by the fact that these were pre-Reformation as well as pre-Renaissance, when the stream of pure religion was still clear and undivided. At the same time, Rio's condemnation of the Renaissance fitted his own view of art history, for had not the Renaissance led to the despised painters of the seventeenth century, Poussin, Claude and Salvator Rosa? What he thought would be the completion of *Modern Painters* was therefore postponed until he had studied the early Italian schools, and he left for the Continent intending to show that religion 'must be, and always has been, the ground and moving spirit of all great art'*(3.670)*.

The tour opened up more lines of enquiry than he could follow, and ensured that the completion of *Modern Painters* was postponed even further. At Lucca he began his first serious study of architecture and sculpture, and he continued it at Pisa, where he also studied the medieval frescoes in the Campo Santo. The neglect and even active destruction of buildings and works of art made him frantic; he wanted to preserve everything he saw, by drawing it, or making daguerreotypes, and he even carried pieces of church away in his pockets. The picturesque pleasures of decay were far from his mind. At the same time he was becoming more politically aware, and reading Sismondi's *Histoire des républiques italiennes du Moyen-Age* confirmed his view of the Renais-

sance as an end, rather than a beginning.[3] Above all, the new artists that he seemed to discover every day showed how narrow his previous knowledge had been.

Enthusiasm for the new world of Italian Primitive art reached a climax in Florence, before Fra Angelico. He set himself to copy Angelico's *Annunciation and Adoration of the Magi* (ill. 24), though he knew he would never be able to capture the jewel-like quality of the surface: 'The whole background is solid with gold, so wrought up with actual *sculpture* that he gets *real* light, not fictitious, but actual light, to play wherever he wants.'*(L45.102)* If Turner was the master of light in the natural world, here was the symbolic expression of the light within men's souls.

The work in Florence left him exhausted, and he retired to the mountains, aware of the new problem of how to reconcile the expressive truth of Turner with the iconographic truth he saw in the Italian Primitives. From his retreat at Macugnaga he wrote to his father: 'I had got my head perfectly puzzled in Italy with the multitude of new masters and manners and I was getting a little adrift from my own proper beat, and forgetting nature in art – now I am up in the clouds again'*(L45.164)*. Had he stayed in the mountains, he wrote in his autobiography forty years later, he might have written *The Stones of Chamonix* instead of *The Stones of Venice*. However, his geological studies, so important for the defence of Turner, were broken off in order to go to Venice with his former drawing-master, J.D. Harding. He seems to have been unprepared for what was in store: he told his father, 'John and Gentile Bellini are the only people I care about studying here, my opinions about Titian and Veronese are formed, and I have only to glance at their pictures. . . .'*(L45.207)*

Suddenly, he was writing home that he had been 'overwhelmed today by a man whom I never dreamed of'*(L45.210)*. Apparently in an idle moment he and Harding had gone to look at the enormous series of religious pictures painted by Tintoretto to decorate the great halls of the Scuola di San Rocco. He was astonished by the breadth, energy and majesty of Tintoretto's work.

As for *painting*, I think I didn't know what it meant until today – the fellow outlines you your figure with ten strokes, and colours it with as many more. I don't believe it took him ten minutes to invent and paint a whole length. Away he goes, heaping host on host, multitudes that no man can number – never pausing, never repeating himself – clouds, and whirlwinds and fire and infinity of earth and sea, all alike to him – *(L.45.212)*.

His own study of Tintoretto's *Crucifixion* (ill. 25) conveys this sense of energy and movement with a dynamism completely lacking in his earlier picturesque sketches. It was a disturbing experience, the culmination of a long and exciting tour; and, after postponing his return to England in order to make this copy, he was ill nearly all the way home. In later life he never underestimated the value of what had happened, but there is sometimes a note of regret, as though the experience had been too profound, making demands on him which were not his 'own proper work'*(35.372)*. But it was the necessary personal experience enabling him to understand the inner workings of the creative imagination: 'I had seen that day the Art of Man in its full majesty for the first time; and that there was also a strange and precious gift in myself enabling me to recognize it, and therein enobling, not crushing me.'*(4.354)*

Ruskin's positive theory of the imagination is by no means as simple as his negative theory of the picturesque. The ground plan, as laid out in the second half of *Modern Painters 2*, seems clear enough, but his theory raised as many problems as the experience in the Scuola di San Rocco seemed to resolve. It is a little alarming to find him announcing at the beginning of *Modern Painters 3* that he is abandoning any attempt at a systematic approach, on the grounds that he can do better 'by pursuing the different questions . . . just as they occur to us, without too great scrupulousness in marking connections, or insisting on sequences' *(5.18)*. The result is much more expressive of Ruskin's own enquiring imagination, but it does not make the exposition of his constantly developing ideas any easier.

The general terminology, at least, has been established in *Modern Painters 2*. Briefly, the theoretic faculty and the imaginative faculty are both concerned with the same problem, the apprehension and creation of beauty and truth; but they perform their functions differently. The theoretic faculty passively perceives, the imagination actively recreates. Imagination itself operates in three ways, each interacting with the other. First the penetrative imagination sees the object or idea in its entirety, both its external form and its inner essence. Then the action of the associative imagination enables the artist to convey this vision through some medium such as painting. The third faculty, the contemplative imagination, deals with remembered or abstract ideas, and so acts as a kind of metaphor-making faculty. As Ruskin's theory develops, the three kinds of imagination find their correspondence in the three orders of truth. The penetrative imagination deals with external fact and the

inner truth it reveals, the associative imagination expresses the artist's thought, and the contemplative imagination gradually evolves into a theory of symbolism.

All three functions of the imagination, together with the theoretic faculty, combine in the act of seeing – the visual dimension is vital throughout his argument.

All the great men *see* what they paint before they paint it, – see it in a perfectly passive manner, – cannot help seeing it if they would; whether in their mind's eye, or in bodily fact, does not matter; very often the mental vision is, I believe, in men of imagination, clearer than the bodily one; but vision it is, of one kind or another, – the whole scene, character, or incident passing before them as in second sight, whether they will or no.

He quotes the words of Revelation: 'Write the things *which thou hast seen*, and the things which *are.*'(5.114)

The concept of the imagination as a predominantly visual faculty came down to Ruskin through the psychology of Hobbes and Locke, whose works he had read at Oxford, and through the popularization of their views by Addison and Johnson. The eye was regarded as the chief source of information to the brain, and so ideas tended to be treated as visual images. Towards the end of the eighteenth century Romantic theory began to move towards an image of the mind as a container for various emotional states, rather than a picture-book or mirror. The image of the mirror, derived from Plato, was supplanted by one of organic growth, so that the mind, instead of reflecting the outside world (albeit in a rather special way), imposed itself upon it. The link between mind and the outside world was made by the emotions, the vehicle of that 'something far more deeply interfused' described by Wordsworth; the result was an identification between the perceiving subject and its object. Coleridge coined the word 'esemplastic' to describe this unifying process. Ruskin preferred the older visual theory but still had somehow to come to terms with the role of the emotions. This was the problem in his theory of beauty: he insisted that beauty was objective, and yet he had to acknowledge that there was a sympathetic identification between the perceiver and what he saw, particularly as far as vital beauty was concerned. He now found himself in danger of reducing the objectivity of imaginative perception in the same way, by giving too much room for emotional response.

The answer was to try to have things both ways:

There is reciprocal action between the intensity of moral feeling and the power of imagination; for, on the one hand, those who have keenest sympathy

are those who look closest and pierce deepest, and hold securest; and on the other, those who have so pierced and seen the melancholy deeps of things are filled with the most intense passion and gentleness of sympathy*(4.257)*.

Seeing and feeling combine. It was natural that Ruskin should stress the older visual theory. After all, in his own case the eye *was* the chief source of information, both by inclination and training – and any abstract theory would be subordinate to his 'sensual faculty of pleasure in sight, as far as I know unparalleled'*(35.619)*.

Clear seeing, of course, was one of the requirements for the correct apprehension of the facts of nature; indeed, 'the sight is a more important thing than the drawing'*(15.13)*; but there must be no confusion between the expression of a mimetic reality and of a true perception. This was what Tintoretto had taught him in the Scuola di San Rocco; for 'the effect aimed at is not *that of a natural scene*, but *of a perfect picture*' *(11.404)*. The true artist neither falsifies his perception nor tries to reproduce reality. His sight is insight. Tintoretto demonstrates

the distinction of the Imaginative Verity from falsehood on the one hand, and from realism on the other. The power of every picture depends on the penetration of the imagination into the TRUE nature of the thing represented, and the utter scorn of the imagination for all shackles and fetters of mere external fact that stand in the way of its suggestiveness*(4.278)*.

Without the close study of external fact our imaginative process would be false or useless, since we would not know what we are dealing with; but the inner truth is paramount.

This, the penetrative imagination, can be seen at work when a great artist manages to suggest more than he has actually put on his canvas. Appropriately, he turns to Tintoretto's *Crucifixion*, where he finds two masterly examples. To begin with, most Crucifixion scenes (he is thinking of the Renaissance and after) are blasphemous, distorted by their anatomical concentration on the suffering body of Christ. By contrast Tintoretto has made the figure of Christ quite still, depicted at the moment of resignation to this pain. But to express this stillness the rest of the picture is filled with violent action – we can see how Ruskin has tried to convey in his copy the central vertical figure with radiating lines of energetic movement surrounding it. Thus physical agony is expressed by its opposite, repose, one of Ruskin's forms of typical beauty. The penetrative imagination is even better exemplified by the figure on an ass behind and to the left of the Cross. Tintoretto wished to convey not just the brutality of the event itself, but the

rejection of Christ by his people. Therefore, Ruskin points out, the ass is eating withered palm leaves, the palm leaves that had greeted Christ on his triumphal entry to Jerusalem five days before.

To bring the leaves of Palm Sunday to Calvary does not conflict with Ruskin's argument for fact. He insists that the imagination is not creative, merely the arranger of the facts received, operating as a kind of second sight, 'exalting any visible object, by gathering round it, in farther vision, all the facts properly connected with it'*(5.355)*. But although *Modern Painters 1* had established the case for fact against the conventionalized vision of the picturesque, he began to see that the argument for fact was threatened from another quarter. The problem was that the penetrative imagination might be *too* imaginative, – for instance, poets were the worst judges of painting, because their sensitivity was so great that it took only a slight suggestion to set their imaginations racing, with the result that the object itself was lost in the flow of indiscriminate feeling. We have to distinguish between the true appearance of things and their false appearance 'entirely unconnected with any real power or character in the object, and only imputed to it by us'*(5.204)*. If he was to uphold the objectivity of imaginative perception, subjective emotion had to be put in its place.

As I said earlier, Ruskin could not deny that there was an emotional identification between perceiver and perceived: indeed, 'the Imagination is in no small degree dependent on acuteness of moral emotion; in fact, all moral truth can only thus be apprehended – and it is observable, generally, that all true and deep emotion is imaginative, both in conception and expression'*(4.287)*. But there is a difference between sensitivity, which helps us to experience accurately and truthfully the emotions of others, and the egoistical feelings of one's own mind, which seek to impose themselves on everything around them.

To distinguish between true and false appearances induced by the selfish emotions Ruskin invented the term 'the pathetic fallacy'. We are in danger of making a pathetic fallacy whenever we allow our emotions to project themselves on to our surroundings. When in a moment of pain and grief we write of the sea as 'the cruel, crawling foam'*(5.205)*, we are wrong, for foam is not cruel, nor does it crawl, it is simply foam. It is perfectly legitimate to express one thing in terms of another, but it is wrong to confuse them. When Dante describes the spirits of dead men falling 'as dead leaves fall from a bough', this is in Ruskin's view 'the most perfect image possible of their utter lightness, feebleness, passiveness, and scattering agony of despair'*(5.206)*; but with Dante the emotion does not distort; he never loses sight of the

fact that '*these* are souls, and *those* are leaves, he makes no confusion of one with the other'*(5.206)*.

It is here that Ruskin parts company with the Romantic poets. For all that they were concerned with accurate perception free of idealizing emotions, their main interest was in how these perceptions affected their feelings. Their concern is with the natural world, but the world as a set of symbols that will reveal the truth of the poet's inner nature. Coleridge believed that the perceiver and the object of his perception were moulded by the esemplastic imagination into one unity – for Ruskin this seemed an exaltation, not an annihilation of self. He too believed that the natural world contained a set of symbols, but the absolute and universal significance of these symbols was threatened if they were treated as the creation of a subjective mind. That was the problem of his chapter in *Modern Painters 3*, 'The Moral of Landscape'. How can the appreciation of landscape have any moral value at all, if it is merely looked on as a means of gratifying personal feelings?

Ruskin was temperamentally as well as intellectually hostile to what Keats called 'the egoistical sublime'. His religious upbringing instilled self-denial, so that his mind was always directed out towards the greater glories of the universe. 'A poet is great, first in proportion to the strength of his passion, and then, that strength being granted, in proportion to his government of it.'*(5.215)* What was demanded of an artist was a dynamic balance between the opposing stresses of fact and emotional expression, one which would raise his work to the new level of truth.

It must be asked, however, whether or not Ruskin himself was guilty of a pathetic fallacy of another kind, whether or not the grand system of symbols he discovered in the universe was no more than what Henry Ladd calls the 'emotional inreading of moral metaphor'.[4] It was all very well to say that the poet's subjective emotions interfered with his perception of the order of God, but the moral order Ruskin perceived in the external world was a projection of his own religious views. Since he believed in the absolute existence of this order, even when he had abandoned the formal religion on which it was founded, he could not conceive of it as a projection; but, for all that he was intellectually convinced, it was as much a question of faith as of reason.

Assuming, then, that the penetrative imagination has provided the artist with a correct, instantaneous vision of truth, it is the work of the associative imagination to convey it to other people. The word 'asso-

ciative' is an unfortunate choice, for at first glance it suggests a connection with the theory of the association of ideas. By 'associative' Ruskin meant no more than bringing the separate parts of a picture or poem together. The associative imagination does the arranging – but not, as in the case of Claude's *Isaac and Rebecca*, by simply selecting individually pleasing details regardless of their inter-relationship. Unlike the sterile art of classical composition, the shaping imagination creates a living and perfect unity out of imperfect parts. It is a restatement of the theory of the unity of membership in *Modern Painters 2*. This unity can only be seen when the disjointed parts are brought together, and it can only exist in that one form. In achieving it, man comes closest to the creative power of God.

It proved very difficult to explain just how it was that the imagination could create this perfect harmony of imperfect parts. The process worked precisely because there were no rules that it could follow. Ruskin gives a comic description of a picturesque artist trying to draw a tree according to the rules of composition, and failing, because he is afraid of spontaneity. But there is nothing that the imaginative artist dare not do, or that he is obliged to do. A practical demonstration of the interdependence of the separate elements of a picture is given with the aid of a plate from Turner's *Liber Studiorum, Cephalus and Procris* (ill. 26). The reader is asked to cover up each part in turn, and see how in every case the change detracts from the unity of the whole.[5]

The function of the associative imagination extends to the question of the purely formal arrangement of lines, shapes and colours on the canvas. This subject is never tackled seriously in *Modern Painters*, on the grounds that it is too difficult, though he adds: 'Expression, sentiment, truth to nature, are essential: but all these are not enough. I never care to look at a picture again, if it be ill-composed'*(7.204)*. However, his teaching manual *The Elements of Drawing* (1857) does contain an excellent analysis of the general principles on which pictures may be constructed. His point is again that there are no rules. There is just the one principle of bringing all things towards unity, and this applies just as much on the technical, as on the expressive level. He demonstrates his acute visual sensitivity when he writes of the formal qualities of paint.

It is not enough that [lines and colours] truly represent natural objects; but they must fit into certain places, and gather into certain harmonious groups: so that, for instance, the red chimney of a cottage is not merely set in its place as a chimney, but that it may affect, in a certain way pleasurable to the eye, the pieces of green or blue in other parts of the picture*(15.163)*.

Because Ruskin placed such emphasis on the moral significance of paintings, his awareness of their abstract qualities tends to be underestimated. What is important is his desire to unify the two: the 'types' of beauty symbolizing God are also formal qualities of art; conversely, the principles of composition which he discusses in *The Elements of Drawing* carry moral significance. 'There is no moral vice, no moral virtue, which has not its *precise* prototype in the art of painting'*(15.118)*. When he planned a revision of *Modern Painters* in the 1870s he intended to include the section on composition from *The Elements of Drawing*.

Before going on to consider the highest of Ruskin's three orders of truth, the universal system of symbols discoverable in all things, we are now in a position to see how he resolved the conflict between fact and expression. This was the question raised by his two drawings of Amalfi, or his criticism of John Brett's landscape. He tackled the problem in the most practical way possible, by going to the Alps to find the actual spots where Turner had sketched, and comparing this phenomenological reality with Turner's results. In 1843 Turner had produced a second batch of 'delight-drawings' in order to get commissions. Ruskin was especially struck by a sketch of the pass of Faido, on the Italian side of the St Gotthard, where the coach road and the Ticino river run along the bottom of a gorge. He commissioned a finished water-colour and later bought the original sketch. In 1845, in spite of discouraging noises from Turner, he went in search of the actual spot, and made his own drawings (ills 28–30). The results of this research are the basis of his brilliant chapter in *Modern Painters 4*, 'Of Turnerian Topography', which forms a pendant to 'Of the Turnerian Picturesque'.

Here the principles of the imagination are put into practice. 'Painting what we see' now has a much more subtle meaning. If we go to a place and see nothing more than what is there, then we must paint nothing more, and content ourselves to be topographers. But 'if going to the place, we see something quite different from what is there, then we are to paint that – nay we *must* paint that, whether we will or not; it being, for us, the only reality we can get at'*(6.28)*. As topographers we must aim at mimetic reality, but the impression produced by an object seen with the penetrative imagination can never be included within the limits of a picture. The artist must add or subtract in accordance with his insight. In this case the trees in the pass detract from the height of the valley walls, so Turner omits them, to dramatize the dangers of avalanche. The bridge which stands too solidly in the foreground is moved back, in order to concentrate the spectator's eye

on the smashing force of the river. River and road are shown in conflict of the valley floor. The road has bumped and twisted its way all over the St Gotthard pass, so here, on the right, it is made to bump and twist, recalling past and future conditions of the route. To show the perseverance of the road in its struggle with the river, the transport shown is not a powerful *diligence* but a light coach drawn by a pair of ponies. Ruskin gives particular attention to the buttressing of the road on the right, arguing that this is a detail from a sketch made higher up the pass. It had been made thirty years before, yet such is the power of Turner's imaginative vision that this key detail is unconsciously selected from the mass of material retained in his memory.

The sum total of Turner's version of the scene amounts to a kind of 'dream vision'. Obedience to the primary perception of the penetrative imagination meant that no selfish notions of his own powers interfered with communicating the truth of the scene. The associative imagination allowed no modifications according to artificial ideas of composition; only the one unified experience has been conveyed, not as an indulgence of the artist's emotions, but as an expression of the far greater significance of the pass itself. More and more, Ruskin felt that the true force of the imagination

lies in its marvellous insight and foresight, – that it is, instead of a false and deceptive faculty, exactly the most accurate and truth-telling faculty which the human mind possesses; and all the more truth-telling, because in *its* work, the vanity and individualism of the man himself are crushed, and he becomes a mere instrument or mirror, used by a higher power for the reflection to others of a truth which no effort of his could ever have ascertained(6.44).

If *Modern Painters* 1 constitutes Ruskin's argument for fact, then the sections I have cited from *Modern Painters* 2, 3 and 4 constitute his argument for truth in the material world. We now have to consider the final, transcendental truth of the symbolic imagination.

In the last resort, Ruskin would have said that the process of the imagination was incapable of complete explanation. The process was not rational, and all he could do was to try to describe the operation of some of its functions. He asserted repeatedly against those who would impose rules on art that creativity was unteachable; it was a divine gift which could only be damaged or wasted, never improved, while it was often used quite unconsciously by those who had the facility. Towards the end of *Modern Painters* 5, after making an analysis of a Turner drawing in similar terms to the one we have just discussed, he concluded:

'I repeat – the power of mind which accomplishes this, is yet wholly inexplicable to me, as it was when first I defined it in the chapter on imagination associative, in the second volume'*(7.244)*.

The issue we are concerned with is the evolution of Ruskin's symbolism; the difficulty is that this is a two-way process. In one direction, as critic, Ruskin becomes more and more aware of the importance of symbolic expression in art; in the other direction, as it were, as an artist in his own right, he is evolving his own private symbolism, in parallel with the universal system he discovers. His Evangelical training had of course ensured that symbolism was an inherent part of his theories – hence his theory of typical beauty – but it was insufficient to point simply to the existence of God-given types. In his search for a unified theory of art he had to explain how man too could convey the eternal truths of the Creation: he had to say more than just 'there is in every word set down by the imaginative mind an awful under-current of meaning, and evidence and shadow upon it of the deep places out of which it has come'*(4.252)*. This description, suggestive of a journey into the unconscious mind, shows him fumbling for words to convey that special quality of perception which only the truly creative imagination could have.

Of the three chapters on the imagination in *Modern Painters* 2 the third, 'Of Imagination Contemplative', is by far the weakest. The contemplative imagination is concerned with objects that could not be tested by visual perception, either because they were abstract ideas or because they were memories of objects once seen. Such ideas can be conveyed visually in two ways: either by presenting just one aspect of the idea, as an abstract indication of the rest, or symbolically, by substituting a different object altogether to represent the idea. At its simplest level the contemplative imagination acts as a metaphor-making faculty; but its function as originally defined by Ruskin can be applied to the most complex processes of symbolization.

Depriving the subject of material and bodily shape, and regarding such of its qualities only as it chooses for particular purpose, [the imagination] forges these qualities together in such groups and forms as it desires, and gives to their abstract being consistency and reality, by striking them as it were with the die of an image belonging to other matter, which stroke having once received, they pass current at once in the peculiar conjunction and for the peculiar value desired*(4.291)*.

The idea that the imagination can be totally *free* of the limitations imposed on the representation of natural fact opens the way to a com-

pletely abstract or symbolic art; but Ruskin does not for the moment develop the idea in that direction. Instead he is concerned with problems of formal abstraction: how, for instance, a monochrome drawing suggests colour, or how colour dissolves outline. He does not even treat the contemplative imagination as a faculty in its own right, but as a subordinate function of the other two. The full implications of his theory have not been developed.

The problem however remained, and in the third volume of *The Stones of Venice* (1853) he came much nearer to a resolution. The way his ideas evolve is typically Ruskinian, and it is necessary to follow it in some detail. The discussion develops from the grotesque carvings which decorate Venetian and other churches. Concerned with the social as well as the artistic decline he detects in the Venetian Renaissance, he takes one grotesque head on the church of Santa Maria Formosa – 'huge, inhuman, monstrous, – leering in bestial degradation' *(11.145)* – as symptomatic of the city's moral collapse. Since he must distinguish between the grotesques of the Renaissance and the grotesque carvings of the Gothic period, which he considered noble, a general discussion of the grotesque genre ensues. It is an approach, from a different angle, to the same problem of abstraction and symbolism, for grotesques could not be taken as direct representations of anything, but they were not purely decorative objects either.

Ruskin suggests two basic motives for producing any kind of such work: a sense of humour, or a sense of fear, two irrational elements which have legitimate functions in art. Play is a necessary and healthy activity, a relaxation, free from the strict demands of accurate delineation, and a positive virtue in the grotesque: 'its delightfulness ought mainly to *consist in those very imperfections* which mark it for work done in times of rest'*(11.158)*. (Provided, that is, that these imperfections are distinguished from those of the picturesque.) In its playfulness, the grotesque involves a necessary amount of abstraction. When it comes to the grotesque as an expression of fear, then there is a necessary element of symbolism.

Ruskin shows his religious training when he says that the fear that inspires the grotesque is the fear of sin, and the fear of death. As an irrational emotion, fear can distort the normal and relatively ordered functioning of the imaginative faculties, but he also suggests that an irrational element may appear when the mind is overcome by the sheer power of what it is asked to conceive, what he calls 'the failure of the human faculties in the endeavour to grasp the highest truths'*(11.178)*. The result will be a grotesque – a symbol. Almost by accident, Ruskin

has reached the central problem in his analysis: how these higher, un-speakable, overpowering truths are perceived and conveyed. He sees a connection between the 'ungovernableness' of the imagination under the influence of fear, and the whole question of the non-rational and inexplicable working of the creative mind. Not only the grotesque, but 'the noblest forms of imaginative power are also in some sort ungovern-able, and have in them something of the character of dreams; so that the vision, of whatever kind, comes uncalled, and will not submit itself to the seer, but conquers him, and forces him to speak as a prophet, having no power over his words or thoughts'*(11.178)*. Ruskin was saying, in very similar words, the same thing in the conclusion to his analysis of *The Pass of Faido*: the imagination is greater than the man.

To account for the difficulty the mind has in grasping the highest truths, Ruskin is led to set up an experimental model of the mind. True to his visual theory of the imagination, he uses the Platonic image of the mirror. Unlike Romantic ideas of the mind, this traditional image carried none of the overtones of emotional projection which he was so anxious to avoid. The mind must be a mirror, for its purpose was to reflect the greater glory of God, God in this sense as external to man and the universe. But his evangelical training taught him that the image the mind of man received was both dim and distorted, dimmed by selfishness and pride, distorted by the sheer size of what it was called upon to convey. 'The fallen human soul, at its best, must be as a diminishing glass, and that a broken one, to the mighty truths of the universe round it'; therefore, in so far as the artist can see clearly (the visual imagery is consistent throughout his argument), he may perceive these truths clearly; but in so far as his vision 'is narrowed and broken by the inconsistencies of the human capacity, it becomes grotesque' *(11.181)*. This is the rationale not only for symbolism in art, but also for the symbolic interpretation of the natural world, for 'the whole visible creation'*(11.183)* becomes 'a mere perishable symbol of things eternal and true'.

In the light of what has been said about the influence of typology on Ruskin's theories it is significant that he proceeds to build upon his argument by examining the treatment of dreams in the Bible. The ladder in Jacob's dream signified the ministry of angels, but such a conception was too vast for him, so it was presented as a ladder, that is, 'a grotesque'*(11.181)*. We are a long way from the carving on the church of Santa Maria Formosa in Venice, and Ruskin has to admit it himself, for he concedes, 'such forms, however, ought perhaps to have been arranged under a separate head, as Symbolical Grotesque'*(11.182)*.

In comparison with the dense and curiously evolved argument in *The Stones of Venice*, Ruskin handles symbolism with much more confidence in *Modern Painters 3*. There is a much clearer definition of what he now means by a grotesque: 'the expression, in a moment, by a series of symbols thrown together in bold and fearless connection, of truths which it would have taken a long time to express in any verbal way' (*5.132*). Symbolism now has much greater importance in his general scheme of art. Previously his principal divisions had been two: the Purist School, chiefly the early Italian painters, who were morally sound but limited in scope because they worked by abstraction; and the Naturalist School, whose stars were Turner and Tintoretto, which combined realistic depiction with imaginative perception. The Grotesque was added as a third category in its own right, which, since it included painters who worked by personification or allegory as well as those trying to present symbolically the 'highest truths', could include most painters. Allegory and personification had always been treated as legitimate tools for the painter (provided their purpose was sound and their use imaginative rather than conventional); now they fitted into the overall moral system.

The consequence of the development of a rationale for symbolism was that there was now a second argument for the defence of Turner. The artist, because of the greater powers of his imagination – or, if you like, because of his clearer and less distorted mind-mirror – was the man best able to perceive the highest truths symbolized in the natural world. The artist becomes a mediator between God and ordinary man. Frequently the artist is associated with the preacher – and the prophet. In the first edition of *Modern Painters 1* Ruskin's enthusiasm had led him to say that Turner was 'sent as a prophet of God to reveal to men the mysteries of His universe, standing, like the great angel of the Apocalypse, clothed with a cloud, and with a rainbow upon his head, and the sun and stars given into his hand'(*3.254*). (*Blackwood's Magazine* suggested this might be blasphemous and the reference disappeared in later editions.) By linking painting with prophecy Ruskin was building on the theological tradition in which he had been brought up, but in doing so his intention was not to restrict art to some narrow Evangelical doctrine; this was no longer possible, as we shall see. Rather, he wished to justify art as the highest activity possible for man, and enable it to range freely over the multiplicity of truths open to the artist's vision. Art had to become revelation.

In my introduction I quoted Ruskin's description of his work as a tree. With the end of this chapter we come to a natural division in the progress of that work, the conclusion of *Modern Painters* in 1860. This division is not a complete break, but a branching-off point, as themes already inherent become established in their own right, without losing any continuity with the central core of ideas. I have followed the development of his attitude to Turner as one of the linking themes of the first period, and there can be no better example of the organic evolution in Ruskin's writing than the way his analysis of Turner, which began in *Modern Painters 1* firmly rooted in natural fact, ends in *Modern Painters 5* with a discussion of symbolism. The very last works of Turner that he considers are not the landscapes which first fired his enthusiasm, but two allegorical works, *The Goddess of Discord Choosing the Apple of Contention in the Garden of the Hesperides* (ill. 27) and *Apollo and Python* (ill. 5).

The analysis of these paintings reveals both a different Ruskin and a different Turner from those of seventeen years before. A technical reason for Ruskin's developed interpretation was that before writing his concluding volume he had for the first time seen the whole of Turner's work. Turner died in 1851. In his will he left his works to the nation, intending that they should be gathered together in a special Turner Gallery, but the will was confused and his wish has never been carried out. Ruskin resigned as an executor of the will, but in 1857 he secured the job of cataloguing the nineteen thousand-odd Turner drawings lying in the cellars of the National Gallery. This he did in the winter of 1857–58, writing a report and a catalogue for fifty sketches which he selected for display. This opportunity to survey all of Turner's work led him to give a much gloomier picture of Turner's mind than he had done up to now. In *Modern Painters 1* he had spoken of Turner's last works as dark prophecies which admitted the impossibility of achieving his aims; and now, in Ruskin's final pages, pessimism, encapsulated in the title for Turner's poems, 'The Fallacies of Hope', becomes the dominant note. This view of Turner is in accordance with modern opinion; he *was* a pessimist, but the changed and darker world picture that now emerges at the end of *Modern Painters 5* is as much Ruskin's as Turner's.

The choice of these two particular paintings with which to conclude *Modern Painters* shows how significant imaginative symbolism had become for Ruskin, but it is important to see how the underlying themes of natural fact and creative expression still function as orders of truth within the overall structure. *The Garden of the Hesperides* (1806) is an opportunity for Ruskin to exercise his increasing interest in the

Greek myths; and the reader is treated to an elaborate, and at first confusing, account of the mythological sources for the subject of the painting. Ruskin's mythography is both a critical tool and an imaginative creation in its own right. Not only does he compound all the classical mythographers from Homer to Pausanias without distinguishing their value as sources; he also treats Biblical reference, Dante, Spenser, Milton, Shakespeare and sometimes later sources as one continuous body of poetic meaning, as 'a Sacred classic literature'(33.119). His interpretation of myth, though, is consistent with the orders of truth on which all his criticism is founded.

Myth is treated as existing on three levels, 'the root and the two branches'(19.300). On the first level it is an expression of natural phenomena; on the second it is the personification of an idea; and lastly it holds 'the moral significance of the image, which is in all the great myths eternally and beneficently true'(19.300). Ruskin is not particularly concerned whether or not Turner consciously assembled his classical references in *The Garden of the Hesperides* in the precise pattern he detects. As a great prophetic artist, Turner unconsciously partakes of the great tradition of physical and moral imagery. Take for example the smoke-breathing dragon which lies along the crest of the background hills. According to the ancient sources, the garden of the Hesperides was set on the Mediterranean coast of Africa, sheltered by mountains from the hot winds of the Sahara. The dragon, therefore, is the desert wind, the Simoon, marking the limit of vegetation represented by the garden. At the same time the dragon is related, according to Ruskin's mythography, to Medusa, whose face could freeze men to stone. The dragon clutches the mountainside, as stone, and as ice, for if Ruskin 'were merely to draw this dragon as white, instead of dark, and take his claws away, his body would become a representation of a great glacier, so nearly perfect, that I know no published engraving of glacier breaking over a rocky brow so like the truth as this dragon's shoulders would be'(7.402). The dragon is therefore wind and ice, and yet simultaneously Ruskin suggests that its jaws are modelled on those of a Ganges crocodile. This is the truth of natural fact with which Ruskin had begun his defence of Turner.[6]

Although Ruskin is confident that Turner had intended the dragon to represent the hot winds of Africa, Ruskin's point is that 'the moral significance of it lay far deeper'(7.393). The dragon that guards the tree in Hesiod's account of the Garden of the Hesperides is linked with the serpent in the Garden of Eden. As Ruskin traces the mythological connections through Virgil and Dante, the dragon becomes the symbol

of fraud, rage, and gloom(7.401), with final significance as 'the evil spirit of wealth'(7.403). Thus the natural fact of the herpetological accuracy of the dragon's jaws conveys a higher expressive truth. But the coherence between natural fact and symbolic expression is not limited to the internal symbolism of this one picture. A structure whose meaning is 'eternally and beneficently true' must also have external, universal reference. To stress this eternal significance Ruskin calls *The Garden of the Hesperides* a religious picture, and draws from it a particular meaning for his own time: 'Such then is our English painter's first great religious picture; and exponent of our English faith. A sad-coloured work, not executed in Angelico's white and gold; nor in Perugino's crimson and azure; but in a sulphurous hue, as relating to a paradise of smoke. That power, it appears, on the hill-top, is our British Madonna'(7.407–8). The greedy jaws of the dragon are Victorian society's passion for material wealth, his smoke is from the furnaces of Industrial England.

A system of symbols with both particular and universal reference must necessarily also have continuity from one work of art to another. In this case the serpent-dragon of *Apollo and Python* (1811) is the connecting link. Here Ruskin spends less time on the mythological significance of the story and goes straight to the central meaning of the work: the archetype of the conflict of light and dark. None the less the process of revealing this central meaning passes through the same progression of natural fact, individual expression and universal symbol.

Ruskin's analysis of the two paintings is linked by the problem of light. The change between the 'sad-coloured' Hesperides and the flashes of light in the background and sky of the *Apollo* 'is at once the type, and the first expression of a great change which was passing in Turner's mind. A change, which was not clearly manifested in all its results until much later in his life; but in the colouring of this picture are the first signs of it; and in the subject of this picture, its symbol'(7.409). The context of this first hint of Turner's later colour style is taken as an image for the critics' rejection of his later colouristic works. The scarlet in these clouds is defended in the same way as those later works were defended in *Modern Painters 1*, by an appeal to observation: 'One fair dawn or sunset, obediently beheld, would have set them [the critics] right; and shown that Turner was indeed the only true speaker concerning such things that ever yet had appeared in the world.'(7.412) The phrasing echoes the geological defence of Turner seventeen years before.

83

It is significant that colour should play such an important part in Ruskin's final discussion of Turner in *Modern Painters*. Although he had been sensitive to the question of colour throughout the work, he had had difficulty in integrating the problem with the main thread of his argument. Ruskin acknowledges the fact by introducing a footnote of several pages at this point, to try to pull his scattered references together. It seems that the structure of symbolism he was evolving gave him the confidence to deal with the problem. Thus we have a colour as an accurately observed natural fact, as symbolic of the change in Turner, and then as a reverberating image with a multiplicity of meanings. Scarlet is the colour of light passed through the earth's atmosphere; it is the colour of human blood; it is the Hebrew symbol of purification. All light has symbolic value:

as the sunlight, undivided, is the type of the wisdom and righteousness of God, so divided, and softened into colour by means of the firmamental ministry, fitted to every need of man, as to every delight, and becoming one chief source of human beauty, by being made part of the flesh of man; – thus divided, the sunlight is the type of the wisdom of God, becoming sanctification and redemption. Various in work – various in beauty – various in power. Colour is, therefore, in brief terms, the type of love.*(7.418-9)*

Apollo and Python becomes for Ruskin the expression of the theme which more and more comes to dominate his writing. Everywhere he sees evidence of an archetypal conflict, of light against dark, of life against death, of love against sin. Looking at the picture, we can see what led him to that conclusion. The dragon-serpent writhes into the dark diagonal filling one-third of the frame, its wound and one claw along the edge of the dynamic axis that leads straight to the young Apollo, half kneeling in a pool of light, with a penumbra that is nearly a halo around his head. Behind him, on a secondary axis, the gentler curves that sweep upwards from the foliage on the left lead towards a quieter landscape. But the line of the distant ridge of mountains is carried diagonally back into the centre of the picture by the branch that the serpent has smashed. That is my own description. Ruskin concentrates on the moral meaning. 'This is the treasure-destroyer, – where moth and rust doth corrupt – the worm of eternal decay. Apollo's contest with him is the strife of purity with pollution; of life with forgetfulness; of love, with the grave'*(7.420).*

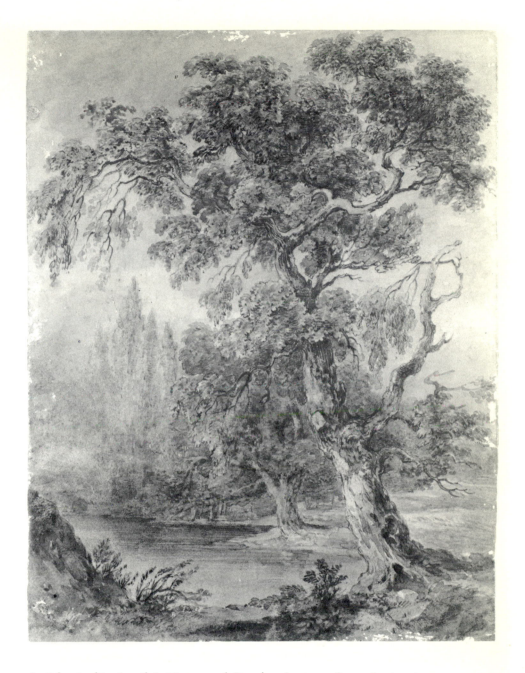

6 *John Ruskin (attrib.)*, Trees and Pond, *1831 or 1832. An imaginary composition in the eighteenth-century drawing-master style of Ruskin's first instructor, Charles Runciman. (For Runciman's teaching see* RFL.258–9, 262–3.) *See p. 36.*

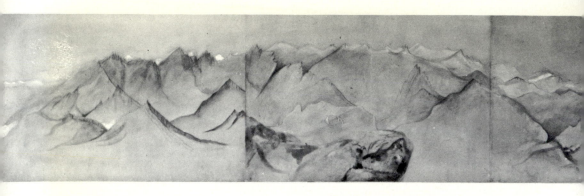

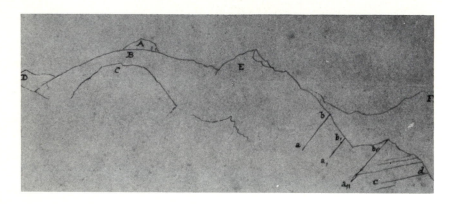

HOW TO LOOK AT MOUNTAINS

7 *John Ruskin,* Panorama of the Alps, *1844. Drawn from the Bel Alp above Brieg (D1.304–5). Ruskin was facing south, so that according to 26.222 the Matterhorn and Simplon are on the right, the Aletsch Alps on the left. See p. 22.*

8 *John Ruskin,* Mont Blanc from St Martin's: studied for rock cleavage only, *?1849. A geological view: Ruskin's key letters mark the principal features of Mont Blanc; 'a–b' indicate cleavage, 'c–d' indicate bedding. See p. 21.*

9 *J.M.W. Turner,* Vignette to Rogers's 'Italy', *1830. The model for illustration 10. See p. 36.*

10 *John Ruskin,* Vignette to 'A Tour on the Continent', *1834. Rogers's* Italy *was Ruskin's first introduction to Turner's work. He imitated the form of Rogers's poem, Turner's illustrations, and even the typeface in the titles. See p. 36.*

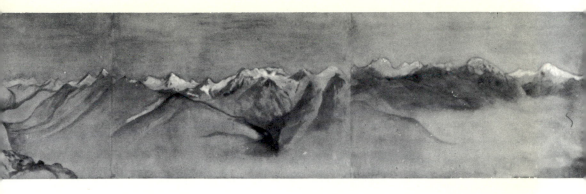

COMO.

I LOVE to sail along the LARIAN Lake
Under the shore—though not to visit PLINY,
To catch him musing in his plane-tree walk,
Or angling from his window:* and, in truth,
Could I recall the ages past, and play
The fool with Time, I should perhaps reserve
My leisure for CATULLUS on *his* Lake,

 * Epist. I. 3. ix. 7.

EHRENBREITSTEIN

Oh warmly down the sunbeams fell,
Along the broad and fierce Moselle,
And on the distant mountain ridge,
And on the city, and the bridge,
So beautiful that stood
Tall tower, and spire, or gloomy part
Were made and shattered in the sport,
Of that impetuous flood,
That on the one side, washed the wall,

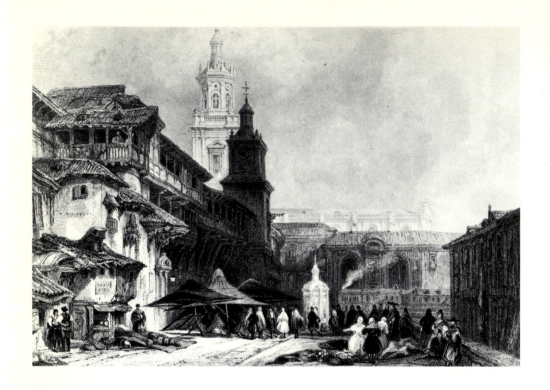

TOURISM AND THE PICTURESQUE

11 David Roberts, Vittoria, *engraving for 'The Tourist in Spain', in* Jennings' Landscape Annual *for 1837. John James Ruskin bought the original drawing in that year.* *See p. 39.*

12–13 John Ruskin, Piazza Santa Maria del Pianto, Rome, *1840. Ruskin's first version based on his drawing on the spot (D1.118), and the version redrawn and lithographed for inclusion in* The Amateur's Portfolio of Sketches *(1844). Compare both versions with Prout's* Forum of Nerva, *illustration 17.* *See p. 38.*

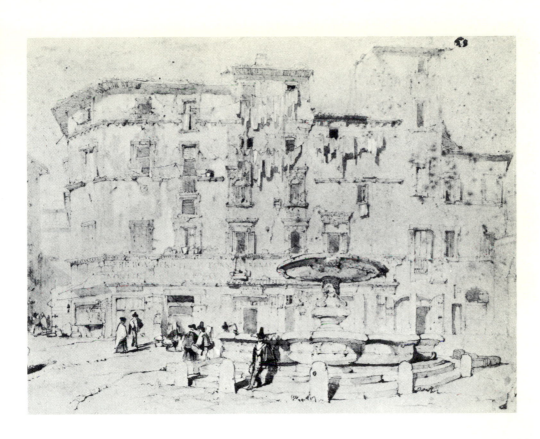

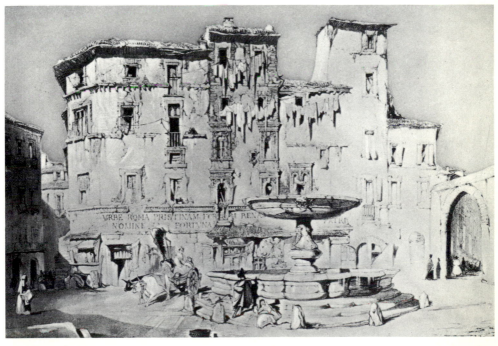

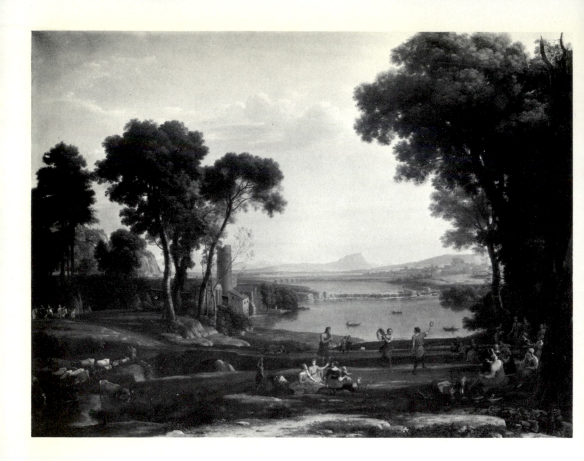

14 Claude Lorrain, The Marriage of Isaac and Rebecca. *The classical landscape, a model for picturesque artists – and for Turner; see facing illustration. Ruskin's violent attack on the painting in 1843 is quoted on pp. 43–44.*

15 J. M. W. Turner, Richmond Bridge. *The first Turner ever bought by the Ruskins, in 1837. The classical elements of the composition show how conventional Ruskin's appreciation of Turner was before the revelation of 1842 (ill. 4). See p. 40.*

16 J. M. W. Turner, Vignette to Rogers's 'Italy', 1830. *In Modern Painters 1, Ruskin calls this plate of Napoleon at the Battle of Marengo (despite the derivative central figure) 'one of the noblest illustrations of mountain character and magnitude existing'(3.444). See p. 44.*

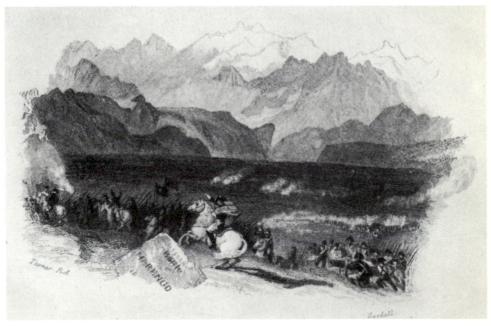

PICTURESQUE ROME

17 *Samuel Prout,* The Forum
of Nerva. *Compare this with
Ruskin's description of Rome
quoted on p. 38, and his own
Rome drawings, illustrations 12
and 13.*

PICTURESQUE BRISTOL

18 *John Ruskin,* St Mary Red-
cliffe, *?1839. An early Ruskin
which mixes the styles of Prout
and Roberts. See p. 37.*

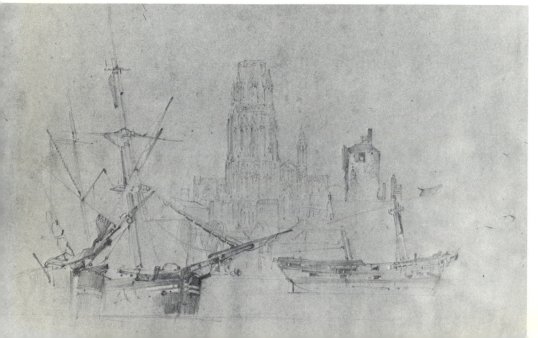

NATURE AND ARCHITECTURE

19 John Ruskin, Design for a Capital for the Oxford Museum, *1856 or 1857. On the right, a study of the natural forms of a plant, possibly a strawberry; on the left, the forms stylized as a design. See also Ruskin's comment on illustration 41. See p. 51.*

NATURE AND ART

20 John Ruskin, The Aspen, under Idealization. *Drawn for* Modern Painters 4 *to illustrate artists' treatment of natural form, from Giotto to his last drawing-master Harding. Compare these with Claude's and Turner's trees in illustrations 14 and 15. See p. 46.*

NATURE THE SOURCE OF DESIGN

21 John Ruskin, Abstract Lines. *Illustration to Volume 1 of* The Stones of Venice *(1851) to demonstrate that architectural ornament should be based on the abstract lines derived from natural shapes. a–b: the curve of glacier near Chamonix; d–c, e–g, i–k: curves in mountain ranges; h: a branch of spruce fir; l–m, q–r, s–t, u–w: leaf shapes; n–o: the lip of a snail shell; p: a worm spiral. See 9.266–9. Ruskin points out that these curves demonstrate the type of Infinity, or Divine Incomprehensibility. See p. 63.*

PRE-RAPHAELITE LANDSCAPE

22 John Brett, Val d'Aosta, *1858. Painted under Ruskin's direction, and in his view a complete failure: 'of emotion, or of intention, nothing traceable' (14.236). See p. 64.*

Amalfi

23 *John Ruskin, Amalfi, 1841. An efficient souvenir sketch of the Italian tour of 1840–41. Compare this on-the-spot drawing* (D1.164) *with the attempt to transform it into a Turnerian water-colour, ill. 3. See* *p. 66.*

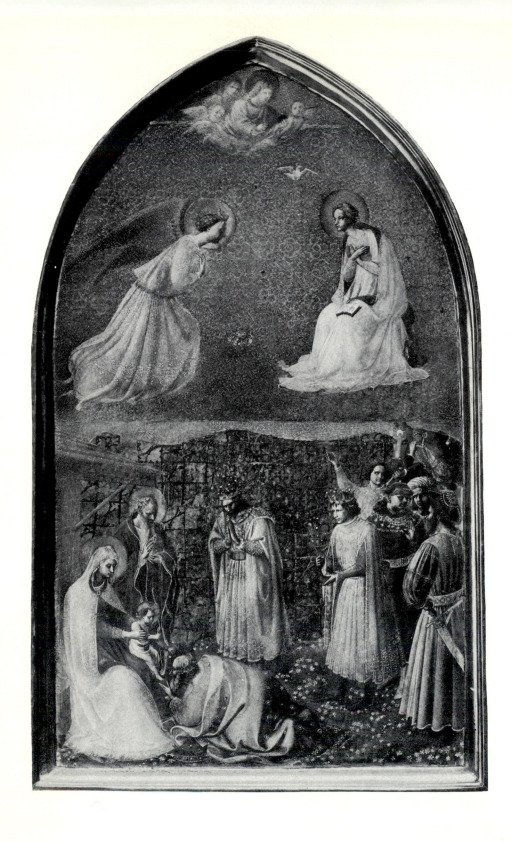

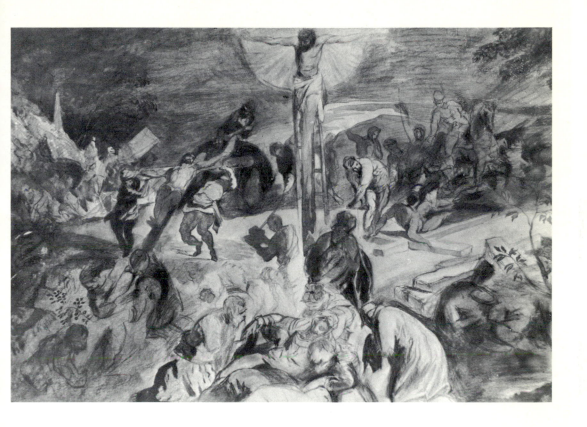

24 *Fra Angelico,* Annunciation and Adoration of the Magi. *In Florence Ruskin made a small copy of the Annunciation scene – 'its effect to me is most divine'(L45.102) – and began to drastically revise his views on Italian art. See p. 68.*

25 *John Ruskin,* Copy of the Central Portion of Tintoretto's 'Crucifixion' in the Scuola di San Rocco, Venice, 1845. *Ruskin told his father to put Tintoretto 'at the top, top, of everything'(L45.212) and his energetic copy shows the emotional effect of Tintoretto's demonstration of the penetrative imagination at work. See p. 69.*

IMAGINATION AND THE ART OF COMPOSITION

26 *J.M.W. Turner,* Cephalus and Procris, *engraving from* Liber Studiorum. *In* Modern Painters 2 *Ruskin demonstrates the operation of the associative imagination by instructing the reader to cover up each part of the plate in turn and observe the dependency of each section on the other. His instructions are quoted in full in note 6 on p. 215. See p. 74.*

27 *J.M.W. Turner,* The Goddess of Discord Choosing the Apple of Contention in the Garden of the Hesperides, 1806 *(detail). In the foreground the Goddess receives the apple from one of the Hesperides, in the background is the dragon Ladon. Ruskin was chiefly interested in the dragon, which he interpreted in mythological, geological and sociological terms. See p. 81.*

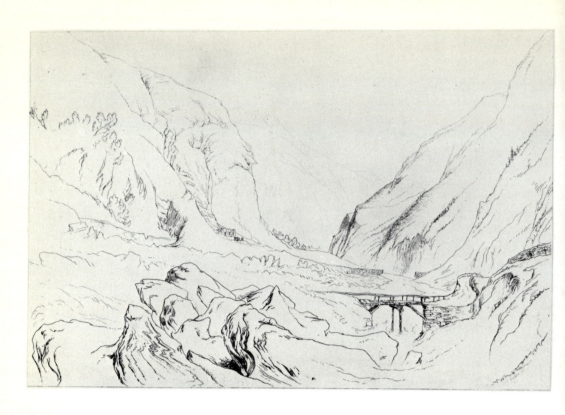

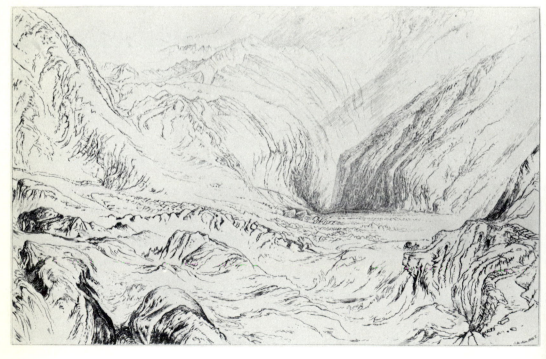

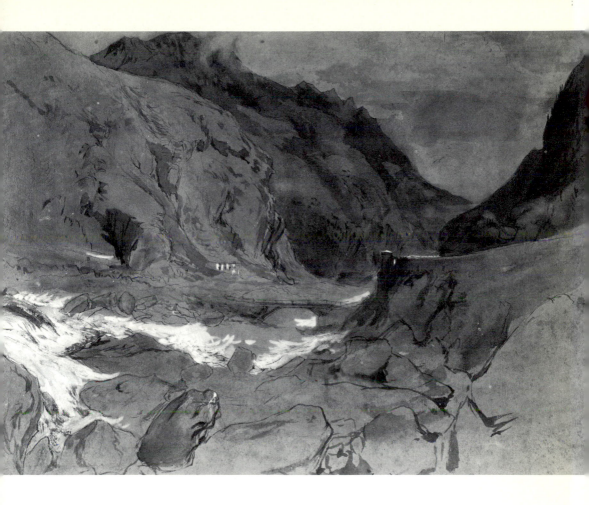

A DEMONSTRATION OF THE WORK OF THE IMAGINATION

28, 29 John Ruskin, The Pass of Faido (1st Simple Topography); *John Ruskin (after Turner),* The Pass of Faido (2nd Turnerian Topography). *Ruskin engraved these plates in* Modern Painters 4 *to demonstrate the difference between a topographical and an imaginative vision. In 1845 he sought out the actual site of Turner's drawing, and made his own sketches (L45.172). See p. 75.*

30 John Ruskin, Pass of Faido, 1845. *Ruskin's on-the-spot drawing shows that his own immediate response to the scene was nearer Turner's than a topographer's (6.34–41). See p. 75.*

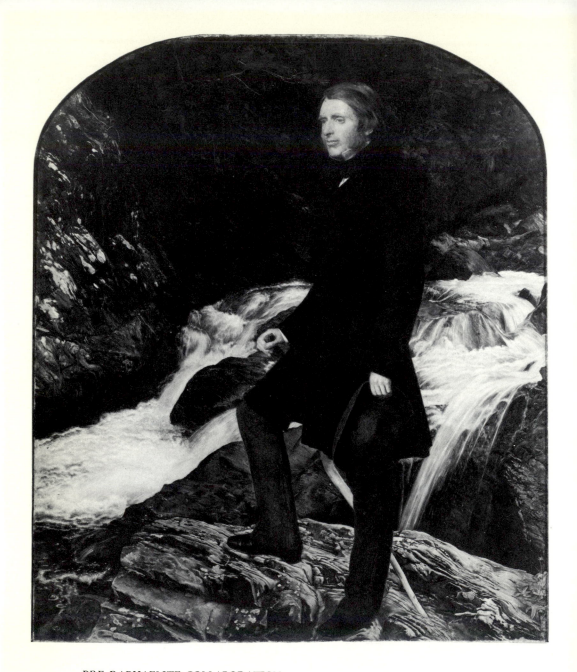

PRE-RAPHAELITE COLLABORATION

31 J.E. Millais, John Ruskin, *1854. Ruskin at thirty-five, begun at Glenfinlas in 1853 and finished in strained circumstances in London in 1854, after Effie had left Ruskin and their marriage had been annulled. The left-hand rock on the far side of the stream is the subject of illustration 32. See p. 121.*

32 John Ruskin, Study of Gneiss Rock at Glenfinlas, *1853. Stimulated by Millais, Ruskin concentrates his geological knowledge into a powerful example of the first order of truth. See p. 121.*

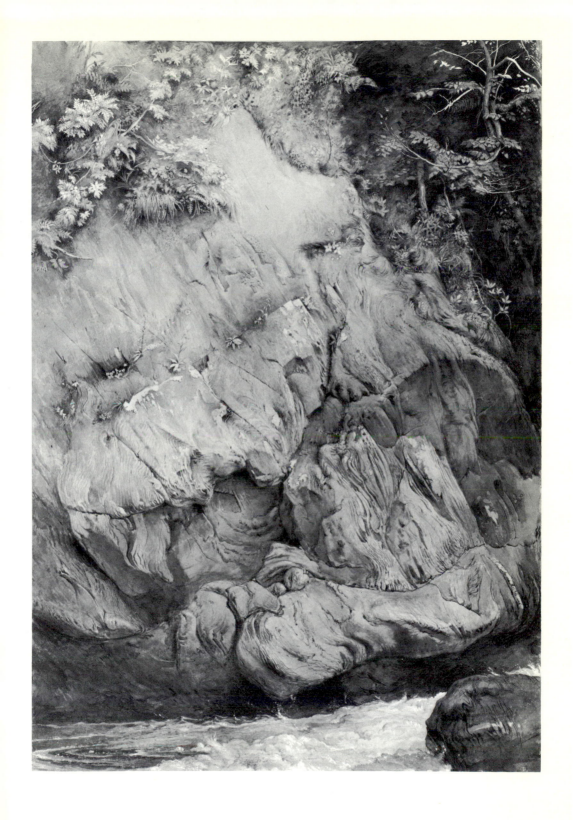

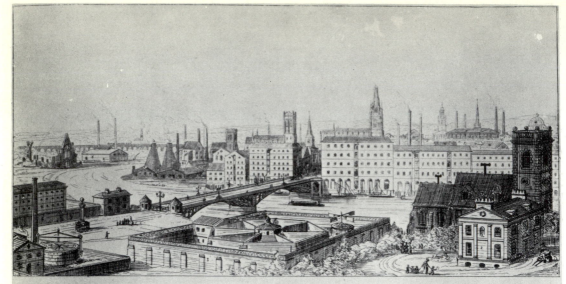

THE SAME TOWN IN 1840.

1. St Michaels Tower, rebuilt in 1750. 2. New Parsonage House & Pleasure Grounds. 3. The New Jail. 4. Gas Works. 5. Lunatic Asylum. 6. Iron Works & Ruins of St Maries Abbey. 7. Mr Evans Chapel. 8. Baptist Chapel. 9. Unitarian Chapel. 10. New Church. 11. New Town Hall & Concert Room. 12. Wesleyan Centenary Chapel. 13. New Christian Society. 14. Quakers Meeting. 15. Socialist Hall of Science.

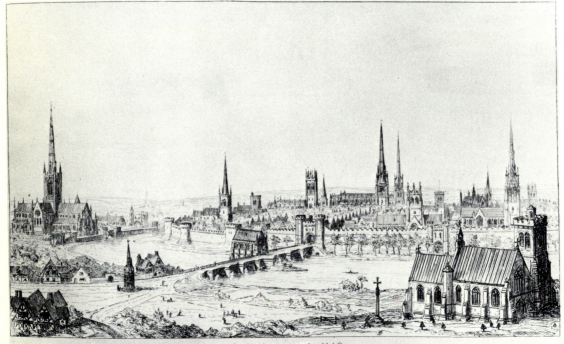

Catholic town in 1440.

1. St Michaels on the Hill. 2. Queens Cross. 3. St Thomas's Chapel. 4. St Maries Abbey. 5. All Saints. 6. St Johns. 7. St Peters. 8. St Alkmonds. 9. St Maries. 10. St Edmunds. 11. Grey Friars. 12. St Cuthberts. 13. Guild hall. 14. Trinity. 15. St Olaves. 16. St Botolphs.

THE NATURE OF GOTHIC

33 a and b Augustus Welby Pugin, illustration to Contrasts. *Medieval Catholic Christian versus nineteenth-century Protestant Utilitarian. Sectarian chapels replace Gothic churches, and an ironworks is built over the ruins of an abbey. Though he rejected Pugin's Roman Catholic slant, Ruskin nonetheless drew the same conclusions about the relationship between the state of architecture and the condition of society. See p. 129.*

34 John Ruskin, Working Study of a Doorhead in the Campiello della Chiesa, San Luca, Venice, *1849 or 1850. The measurements and calculations show the care with which Ruskin studied his material at first hand. A finished version of this subject appears as Plate 13 of* Examples of the Architecture of Venice, *of 1851(11.344–5). See p. 132.*

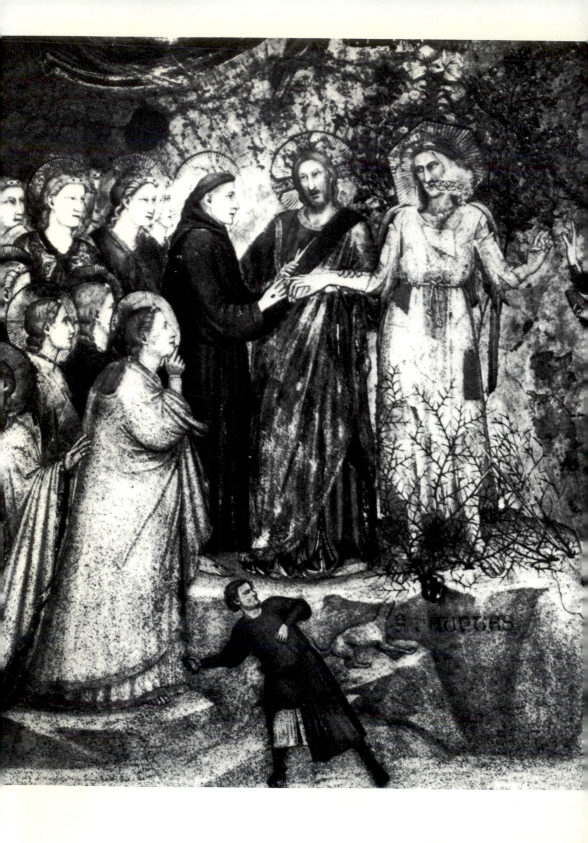

RELIGIOUS ART: CHRISTIAN AND PAGAN

35 *The Master of the Veils, detail from* The Marriage of Poverty and St Francis *(formerly attributed to Giotto) The Lower Church, Assisi. Copying this fresco in 1874, Ruskin reconsidered his views of the early Italian painters. He also began to identify himself with St Francis, and Poverty with Rose La Touche, particularly because of the roses above Poverty's head. See p. 164.*

36 The Greek Type of Athena, *wood engraving by Ruskin's assistant Arthur Burgess from a vase in the British Museum. Made for sale with* Fors Clavigera, *and discussed 20.242–3; Ruskin chose Athena, the Queen of the Air, as the embodiment of the values of life and light. See p. 156.*

37 *John Ruskin,* Copy of Carpaccio's 'Dream of St Ursula', *1877. Ruskin was working on this elaborate copy in Venice two years after the death of Rose La Touche. The gift of a pot of flowers similar to those on the windowsill in the painting reinforced his identification of St Ursula with Rose. He had seen her for the last time when she lay ill in bed. See p. 163.*

38 *Anon., detail from* Harry Told his Mother the Whole Story, *illustration to a story in* The Children's Prize *(1873). Without mentioning Rose by name, Ruskin published a description of the girl lying ill in bed in the same month as he saw Rose for the last time(28.257). Compare this with Ruskin's own drawing of Rose, ill. 39. See p. 162.*

39 *John Ruskin,* Portrait of a Girl's Head on a Pillow, *?1875. It seems almost certain that the girl is Rose, possibly drawn during her final illness. See p. 162.*

40 *John Ruskin,* Study of Wild Rose, *1871. Ruskin attributed his serious illness in 1871 to the difficulty he had with the subject(21.230). See p. 161.*

FOLIAGE EXERCISES FOR THE RUSKIN SCHOOL OF DRAWING

41 A courtyard at Abbeville, *photograph by Ruskin, 1858. Ruskin re-uses a photograph originally taken to illustrate the subject matter of Prout* (14.388) *as a drawing exercise. Ignoring the original picturesque context (p. 48), he selects a detail so that when the student 'has learned to draw these leaves as the photograph represents them, he will know how to admire the imaged leaves carved at the side of them'* (21.294). *See p. 174.*

42 John Ruskin, Sketch of Leafage. *The selected detail sketched with a single wash.*

43 John Ruskin, The Same Leaves, Farther Carried. *The two upper groups only, leaving the highlights blank.*

44 John Ruskin, Completion of the Same Study. *The series of washes is completed by the use of body colour white. 'These three exercises are examples in execution only; and whatever is in them must be got, by the student who copies them, with that quantity of work and no more'(21.295).*

Casa Loredan.

Verona

Knoblochiorum insignia.

Fent Romulidæ suæpisa, fabasą, cicerą,
Allium erit nobis nobiliore loco.

Hoc nostris placuit maioribus, hinc sibi nomen
Sumpsere, & clypei signa vetusta sui.

ippe velut Scorodon per rosida prata virescit,
Serpentesą, fugans pharmaca dira necat.

Sic Martē quicunq, colit virtutis amore,
Et viret, & patriæ pestibus exitio est.

*A reconstruction of part of the Rudi-
mentary Series, a series of examples of
heraldry as simple exercises in drawing
and as symbols of leadership. Two photo-
graphs which should appear between 47
and 48 have been lost. See p. 175.*

45 *J.M.W. Turner*, A Frontispiece
(at Farnley Hall), *1815. 'An example
of Turner's early heraldic work'*
(21.174).

46 *Coat of arms from* Insignia Sacrae
Caesareae Maiestatis, *1629. 'To be
used for early pen-practice'* (21.175).

47 *John Ruskin*, Study of the
Marble Inlaying in the Front of the
Casa Loredan, Venice, *1845. 'I was
always working, not for the sake of the
drawing, but to get accurate knowledge of
some point in the building'* (27.175).

48 *Samuel Prout*, Tomb of Can
Grande, Verona. *'The tomb of the
best knight of Italy, by the modern
English mind, educated in contempt of
the dark ages'* (21.177).

49 *John Ruskin*, The Twelve Heral-
dic Ordinaries. *Originally engraved for
use in the schools of the Guild of St
George. Ruskin later included it in the
heraldry exercises at Oxford. He analyses
the symbolism at 22.280–4. See p. 175.*

50 The Museum of the Guild of St George, *photograph* c. *1876. The earliest known photograph, of the upper room of the cottage at Walkley, Sheffield, shows the crowded conditions and the variegated materials displayed. See. p. 187.*

I have tried to show that Ruskin's symbolic interpretations consistently carry both particular and universal significance; but these symbols do not just operate externally in works of art. They also have continuity on the psychological level. Ruskin could not have made his meaning more plain when he concluded of Turner, 'his work was the true image of his own mind'. But what is true of the artist Turner is also true of the critic Ruskin. On the very same page as his application of the symbolism of the *Apollo* to Turner's life, he writes of himself: 'Once I could speak joyfully about beautiful things, thinking to be understood; – now I cannot any more; for it seems to me that no one regards them.' (7.422) Again we must ask the question raised by the pathetic fallacy – are all these symbols no more than a projection of Ruskin's increasingly unhappy mind?

It is clear that these and other symbols that emerge do have a psychological reference for Ruskin. They are not arbitrarily chosen, but come from the deepest recesses of his mind. However, having said that, I think this should be treated only as adding a further level of understanding. If we do this, we are presented with not only psychological insights, but a superbly coherent structure of imaginative imagery, a structure of imagery that is not limited to a single creative medium, like painting or poetry, but can be applied to any issue confronting the human mind; to history, to philosophy and, as we shall see, to economics. Anything, indeed, in indivisible reality. In an obscure footnote to an obscure article, Ruskin wrote: 'It is a strange habit of wise humanity to speak in enigmas only, so that the highest truths and usefullest laws must be hunted for through whole picture-galleries of dreams which to the vulgar seem dreams only.'(17.208) We may read Ruskin's enigmas as psychological evidence only, but if we do so, we will lose sight of the truths and laws which they conceal.

Ruskin's treatment of myth represents his final theory of the imagination, a theory which comprehends the three orders of truth of *Modern Painters*: the truth of natural fact, the truth of thought, both as impression and expression, and the transcendental truth of symbol. If we wish to add a further level of psychological truth, it can be done without distortion to the scheme. The imagination both perceived truth, and recreated it, so that as Ruskin evolved a theory of symbolism to help him interpret art, he began to apply it in his own writing, to the extent that his later work only becomes comprehensible when we see that he is operating a system of symbols expressed by natural fact.

Ruskin first applied the orders of truth to Turner in *Modern Painters 1*:

in different stages of [Turner's] struggle, sometimes one order of truth, some-times another, has been aimed at or omitted. But from the beginning of his career, he never sacrificed a greater truth to a less. As he advanced, the previous knowledge or attainment was absorbed in what succeeded, or abandoned only if incompatible, and never abandoned without a gain; and his last works presented the sum and perfection of his accumulated knowledge, delivered with the impatience and passion of one who feels too much, and knows too much, and has too little time to say it in, to pause for expression, or ponder over his syllables. There was in them the obscurity, but the truth, of prophecy; the instinctive and burning language which would express less if it uttered more, which is indistinct only by its fulness, and dark with abundant meaning(3.611).

This is a prophetic description of Ruskin's own future development.

5 The Artist and Society

'the Teacher and exemplar of his age'

'ONCE I could speak joyfully about beautiful things, thinking to be understood; – now I cannot any more; for it seems to me that no one regards them.'*(7.422)* This confession in the closing pages of *Modern Painters 5* shows the deep change of mood that had come over Ruskin by 1860; the reason he gives for this change shows that his work was already taking a new direction. The love of nature in *Modern Painters 1* has been replaced by a concern for men; optimism has given way to a darker mood, sometimes of depression and sometimes of anger. The outcome of this sea-change was the expansion of his art criticism into an attempt to account for the whole of man's activity.

There were good reasons for Ruskin to be both depressed and angry. He had undergone great changes between 1843 and 1860; difficulties in his emotional life exacerbated the crises of intellectual thought, and the changes in his critical attitude in turn produced problems in his private relationships, particularly with his parents. The most important changes were in his feelings for nature and in his belief in God. As we saw in Chapter 1, these were mutually supporting ideas, and a change of attitude towards one inevitably placed the other in a different light. Ruskin's doubts in both areas started at the same time. After the heavy theoretical work of *Modern Painters 1* and 2 he suffered a severe reaction, which led to depression and an apparently psychosomatic illness; the emotional and intellectual difficulties of the next decade can be traced back to this near nervous breakdown. The books had given an entrée into fashionable literary society, which must have delighted his ambitious parents, but it soon became clear that a life of breakfasts and balls was not to his taste. Alarmed by his melancholy state, his parents encouraged him to think of marriage. This in turn produced a new difficulty, the disastrous relationship with Effie Gray.

This is not a biography, and I must be brief.[1] Euphemia Gray was the daughter of a family friend; when she was still a young girl Ruskin had written the fairy tale *The King of the Golden River* to entertain her.

(Curiously, the destructive gold and the fruitful paradisical valley which appear in this story also make their way into the later writings on economics.) Ruskin courted Effie with love letters no more and no less passionate than those of other men, and in the spring of 1848 they were married. Something however went wrong: Ruskin never made love to his wife. Either he was completely impotent or there was some physical or emotional difficulty between them that prevented the marriage being consummated. He later denied that he was impotent, and said that there had been something wrong with Effie, so that the moment had been postponed. Eventually it became too late.

In an age that was reticent about sex, the stresses between John and Effie did not at first appear. In 1848, prevented by the political situation on the Continent from going to Italy, they travelled in Normandy. Effie played her part well, but conflict was inevitable between her and Mrs Ruskin over their mutual property, John. Complaints about Effie's attitude and domestic incompetence multiplied, even though John took her away from his parents to Venice in 1849-50 and 1851-52. For her part, Effie had good cause to protest, and reacted by having some form of emotional illness herself. Ruskin was really quite well during the first four years of marriage, perhaps because parental pressure was greater on Effie. Their life in Venice was a civilized solution to their private failure. The city was occupied by the Austrians; and while he had his work all around him, she had a squadron of Austrian officers to escort her to the garrison balls and galas. However, it was clear by the end of 1851 that there was little except the conventions of society keeping them together. Ruskin told his (admittedly hostile) parents that 'the only way is to let her do as she likes – so long as she does not interfere with *me*: and that, she has long ago learned – won't do' *(LV110)*.

Since divorce did not effectively exist, there was little that could be done. The crisis came in 1853. Asked to lecture at Edinburgh (these were to be his first public lectures, and his parents were very worried by the idea), Ruskin decided to prepare his text and take a holiday in Scotland at the same time. Thanks to his association with the Pre-Raphaelites, he had become friendly with John Everett Millais, and Millais and his brother William were invited to come too. Ruskin was doubtless keen to work closely with one of the new school whose cause he had championed. Accommodation was found at Brig o'Turk, in Perthshire, and the holiday became something of a rustic house party. It was not quite the *fête champêtre* intended, for it rained a great deal. The rain and other difficulties meant that the portrait Millais was painting

of Ruskin (ill. 31) had to be finished in London. Ruskin made a study of the rocky bank that forms a background of the picture (ill. 32); the crisp delineation suggests that he was learning from Millais as much as Millais was learning from him.[2] Millais and Effie were thrown into each other's company. In April 1854 she found an excuse to leave London and return to her father's house in Perth. From there she returned her wedding-ring to the Ruskins.

The scandal was splendid, for those not directly involved; Millais said at the time that the two main topics of conversation in society were the Crimean War and Ruskin's marriage.[3] Divorce was possible only by means of an individual act of Parliament or through the Church Courts; Ruskin chose not to defend the action brought against him,[4] and suffered the public humiliation of having the marriage annulled by the Church on the grounds of his 'incurable impotence'.[5] Effie married Millais in June 1855. This time the marriage was a success, but this did not prevent Effie from ensuring, when the time came in 1870, that Ruskin's last chance of happiness would be destroyed.

The private misery of unhappy marriage and the public embarrassment of its annulment must have been bitterly painful, but much more agonizing – and far more significant for him in the long run – was the change in Ruskin's attitude to the original twin sources of his inspiration, nature and God. Simultaneously the certainties that had sustained him began to weaken. This was the origin of the crisis that had produced the breakdown in 1847 which his marriage had at least partly been intended to cure. *Modern Painters 1* and *2* are the monument to an upbringing in natural theology and Evangelical determinism, but almost immediately afterwards a reaction set in: 'All that I had been taught had to be questioned; all that I had trusted, proved.'*(35.431)* His was by no means an isolated case, for many contemporaries were suffering religious doubts that left them bereft of inspiration – and therefore harsher in their intellectual conviction of the need for moral law. The discoveries of the geologists and the arguments of the Biblical critics were gradually eroding the authority of the Bible as the word of God. For Christians like the Evangelicals, whose beliefs were built on this authority, the destruction of the Bible as the indisputable word of God meant the destruction of all faith. The arguments and trials in the 1860s surrounding the publication of *Essays and Reviews* and of Bishop Colenso's *The Pentateuch and the Book of Joshua critically examined* were to reflect the religious crisis of the time.[6] Ruskin had already undergone his test of faith by then, but although he repudiated his earlier Evan-

gelical outlook, he did not immediately publicize his agnosticism.[7] Throughout the 1850s the struggle remained a private one.

The first difficulty was that he could not deny the evidence of his own eyes. At Oxford he seems to have accepted Buckland's natural theology, but Buckland's accommodations with the Bible story could not survive the discoveries of more advanced geologists like Charles Lyell, who regarded the mixing of theological and geological questions as merely a hindrance to both.[8] It was of Lyell's work that Ruskin was thinking when he made the often quoted comment in 1851: 'If only the Geologists would let me alone, I could do very well, but those dreadful Hammers! I hear the clink of them at the end of every cadence of the Bible verses'*(36.115)*. It was the Evangelical crux: either the Bible was completely true, or it was completely untrue; either the world was made in six days, or it was not made by God at all; either the prophecies would be fulfilled, or Christ's teaching was nonsense and the world was empty of meaning. In spite of determined efforts to cling to the earlier certainties, the hold on belief gradually weakened.

Ruskin soon conceded that the Bible might be just 'another history', but there remained the hope that the difficulties of rational belief might be met by an act of faith. In 1848 he was prepared to accept, privately, Pascal's view that since logically it was as impossible to *dis*prove the existence of God as it was to prove it, it was best to wager on there being a God after all. But it was only a temporary answer. During Easter 1852 he passed through his own week of doubt, pain and eventual resolution. It is significant that he had recently written a private commentary on the Book of Job, for Job was the Old Testament prophet who finally found wisdom only after a thunderous reminder from God that He *was* the creator of the world.[9] On Good Friday Ruskin confessed in a letter to his father that he had been 'on the very edge of total infidelity – and utterly incapable of writing in the religious temper in which I used to do'*(LV244)*. To secure himself, he fell back on Evangelical discipline: 'I resolved that at any rate I would act as if the Bible *were* true'*(LV244)* – and this brought consolation. But he knew how far he had already gone. In brighter mood on Easter Sunday, he explained that, when he had written earlier that he had come to the place where 'the two ways met',

I did not mean the difference between religion and no religion; but between Christianity and philosophy: I should never, I trust, have become utterly reckless or immoral, but I might very possibly have become what most of the scientific men of the present day are: They all of them, who are sensible –

believe in God – in *a* God, that is: and have I believe most of them very honourable notions of their duty to God and to man: But not finding the Bible arranged in a scientific manner, or capable of being tried by scientific tests, they give that up – and are fortified in their infidelity by the weaknesses and hypocrisies of so called religious men. . . . The higher class of thinkers, therefore, for the most part have given up the peculiarly Christian doctrines, and indeed nearly all thought of a future life. They philosophize upon this life, reason about death till they look upon it as no evil: and set themselves actively to improve this world and do as much good in it as they can. *(LV246–7)*

Effectively, this was to be his own future position.

The mention of death betrays Ruskin's real worry, for he was struggling with an apparently insoluble doctrinal problem. The Evangelical was taught to fear death, because all but a few were condemned to damnation; but the promise of damnation was also the promise of an after-life for those who were saved. If therefore he rejected Evangelicalism he might not have to fear future damnation, but in doing so he also rejected the possibility of an after-life – and the fear of death remained. The theme of death had been drummed into him ever since he was a child, death irrevocably associated with evil by St Paul: 'sin entered into the world, and death by sin'. During his heart-searching in Venice in 1852 he recalled what a shock it had been the first time he had seen a man on his deathbed*(LV170)*. When Evangelicalism was eventually sloughed off, he was in many ways in no more secure a position, for all that life now held was eventual negation by death, and only grim determination and attention to duty could stave off a sense of futility. 'It is so new to me,' he told Carlyle, 'to do everything expecting only Death'*(36.382)*. It is not surprising, then, that so many of Ruskin's arguments should be expressed in terms of the opposing images of life and death, or that man's conduct should be presented as a choice between them.

The certainty of death can also produce its opposite, the affirmation of life, and it was the positive values of life, and especially art, which finally gave release. The moment came in 1858, and once again it was an experience closely associated with a picture. That summer he had gone to northern Italy, still making geological notes for *Modern Painters*, but the mountains palled, and he went to Turin to study in the Gallery of the Royal Palace. His attention was caught by Veronese's *Solomon and the Queen of Sheba* (ill. 1). Until then he had considered Veronese to be one of the 'sensualists', lost in the fall of Venice, but working on a

careful copy of the painting he gradually changed his view: 'One day when I was working from the beautiful maid of honour in Veronese's picture, I was struck by the Gorgeousness of life which the world seems to be constituted to develop, when it is made the best of.' *(7.xli)*[10] He had reached another turning-point, and this moment of perception became, as time distanced him from it, one of the most significant in his life. Acceptance of the positive values of existence, this 'Gorgeousness' meant escape from a negative religion.

I was still in the bonds of my old Evangelical faith; and, in 1858, it was with me, Protestantism or nothing: the crisis of the whole turn of my thoughts being one Sunday morning, at Turin, when, from before Paul Veronese's Queen of Sheba, and under quite overwhelmed sense of his God-given power, I went away to a Waldensian chapel, where a little squeaking idiot was preaching to an audience of seventeen old women and three louts, that they were the only children of God in Turin; and that all the people in Turin out-side the chapel, and all the people in the world out of sight of Monte Viso, would be damned. I came out of that chapel, in sum of twenty years of thought, a conclusively *un*-converted man.*(29.89)*

So wrote Ruskin in *Fors Clavigera* in 1877; but, as we have seen before in accounts of the key moments of his life, there are other versions of the same story. As George Landow has pointed out,[11] when the moment is described in *Praeterita* in 1888 the crucial moment is no longer located in the plain Protestant chapel, but afterwards, before Veronese's picture:

I walked back into the condemned city, and up into the gallery where Paul Veronese's Solomon and the Queen of Sheba glowed in full afternoon light. The gallery windows being open, there came in with the warm air, floating swells and falls of military music, from the courtyard before the palace, which seemed to me more devotional, in their perfect art, tune, and discipline, than anything I remembered of evangelical hymns. And as the perfect colour and sound gradually asserted their power on me, they seemed finally to fasten me in the old article of Jewish faith, that things done delightfully and rightly were always done by the help and in the Spirit of God.*(35.495-6)*

This later version emphasizes the positive value of the experience rather than the loss of religious faith it involved; it also stresses the power of visual sensation over him. In this case it is almost a synaes-thetic moment, for the music (which he also mentioned to his father at the time in very similar terms) seems as important as the picture. At last, Ruskin had learned that he could accept the sensuality of art and man. He wrote to his friend Charles Eliot Norton, with whom he could

speak frankly: 'I've found out a good deal – more than I can put in a letter – in that six weeks, the main thing in the way of discovery being that, positively, to be a first-rate painter – you *mustn't* be pious; but rather a little wicked, and entirely a man of the world. I had been inclining to this opinion for some years; but I clinched it at Turin.'*(LN1.67)*

An altered view of the artist has important implications for the relationship between the artist and society, but this new view also has a lot to do with Ruskin's loss of 'landscape feeling'. The love of God and the love of nature were so nearly the same thing that it has been a little artificial to discuss them separately. He recognized their interconnection in the Good Friday letter of 1852, confessing nearness to 'total infidelity . . . and exactly in the degree in which this infidelity increased upon me, came a diminution of my *enjoyment* of even what I most admired more especially of natural things'*(LV244)*. The crisis of faith and the loss of landscape feeling played their part in the illness of 1847; indeed the loss of religious inspiration may partly have been the result of the failure by the external world to produce any longer the emotions which confirmed the presence of God.

In an excellent analysis of this change of heart, Francis Townsend concludes that by 1849 'Ruskin's landscape feeling was dead'.[12] True, the zest for nature *in itself* disappears, but it is rather its context which changes. He could no longer feel totally annihilated by the power of God and nature, as he had in 1842, beside the fountain of the Brevent, but landscape retains its value so long as it is associated with man. The shift can be seen by comparing that earlier description quoted on page 31 with a passage in *The Seven Lamps of Architecture* (1849). Whereas before 'to become nothing might be to become more than Man'*(4.364)*, he now records the change in his feelings when the scene was mentally transposed to an uninhabited part of the world: 'The flowers in an instant lost their light, the river its music; the hills became oppressively desolate; a heaviness in the boughs of the darkened forest showed how much of their former power had been dependent upon a life which was not theirs'. That life was not the presence of an unseen Deity, but 'human endurance, valour, and virtue'*(8.223-4)*.

The result of the gradual loss of landscape feeling was a shift to a concern for a man-centred art. *Modern Painters 3* (1856) shows how his responses were changing. In the first two volumes the value of nature is unquestioned, but in the third he dares to ask if the pleasure taken in landscape really is such a good thing. An answer is sought in the history of man's attitude to nature, culminating in the chapter 'The Moral of

Landscape'. The conclusion is that nature does have value, but, as we saw in Chapter 1, the purely poetic response is secondary to other, higher needs. While a passion for nature always works to the good, it is also a sign of weakness, in that it is insufficient simply to worship nature on its own; one must act positively to bring about moral improvement as well. By calling for a 'science of aspects' which involved a harder look at man and his surroundings than the reveries of the poet, he was signalling the change of intellectual position necessary now that his emotional responses were no longer able to sustain his earlier Romantic outlook. 'The Moral of Landscape' represents the half-way stage to a social view of art – which is why its argument is so tortuous. The problem was to decide how far nature could be said to have any independent influence on man. The linked Chapters, 'The Mountain Gloom' and 'The Mountain Glory', in *Modern Painters 4* (1856) are his answer.

Typically, these two chapters are set up like an experiment, a subject for visual observation. The location is the mountain district of the Valais in Switzerland, and its character and appearance is carefully and lovingly described. It is a beautiful passage – which only serves to point the contrast that he wishes to make. It may seem to the visitor that in this region,

> if there be sometimes hardship, there must be at least innocence and peace, and fellowship of the human soul with nature. It is not so. The wild goats that leap along those rocks have as much passion of joy in all that fair work of God as the men that toil among them. Perhaps more.*(6.388)*

Theoretically, the Valais constitutes the best possible environment man could have for the development of his moral and creative faculties – but the experiment shows that the opposite is true. He continues:

> Enter the street of one of those villages, and you will find it foul with that gloomy foulness that is suffered only by torpor, or by anguish of soul. Here, it is torpor – not absolute suffering – not starvation or disease, but darkness of calm enduring; the spring known only as the time of the scythe, and the autumn as the time of the sickle, and the sun only as a warmth, the wind as a chill, and the mountains as a danger. They do not understand so much as the name of beauty, or of knowledge.*(6.388)*

Following this preliminary – but none the less devastating – conclusion, Ruskin suggests some possible reasons why the mountains should produce such gloom among their inhabitants. Significantly, there begins a long meditation on the obsession with death in the region, although he finds the fascination with death that turns white-painted mountain

chapels into charnel houses is the same obsession that makes an opera like *Death and the Cobbler* a success in sea-level Venice. The mountains are no longer praised, but blamed, for he admits that they can sometimes be ugly, and that the harsh physical conditions of mountain life cramp and brutalize the mountaineer's existence. To grim surroundings and an unhealthy climate are added the social and cultural influences of Roman Catholicism, with its bad art, obsession with pain and encouragement of idleness and superstition (all, one must add, very Evangelical Protestant objections). The town of Sion (whose very name the Bible scholar Ruskin could not fail to read as 'high place') is treated as an exemplar of all the ignorance, disease and decay which is possible in mountain country. The description of Sion marks the end of Ruskin's optimism born of natural theology; at last he admits that nature, which he has formerly read only as evidence of the benevolence of God, also warns of his anger: 'It seems one of the most cunning and frequent of self-deceptions to turn the heart away from this warning, and refuse to acknowledge anything in the fair scenes of the natural creation but beneficence.' *(6.414)* He now realizes that his own responsibilities have been avoided for too long by just such a self-deception.

And yet the mountains are not wholly at fault, as the corresponding chapter 'The Mountain Glory' is intended to show. The mood is deliberately changed to celebrate the mountains which 'seem to have been built for the human race, as at once their schools and cathedrals' *(6.425)*. Whatever their occasional ugliness, 'the granite sculpture and floral painting' *(6.426)* of the hills do have a helpful influence on mankind; their beauty plays its part in man's ideas of art and religion. But given its beneficial effect, nature alone cannot save mankind; it can only be effective when man is reformed from within. The people of Sion might yet become happy and virtuous, but certainly not by acquiring the benefits of nineteenth-century society; the one advantage of mountain environment is its isolation from the follies and vanities of the plain.

By 1860, then, Ruskin's attitude to both God and nature had changed; but they remained constant themes. The authority of the Bible as an Evangelical text had been destroyed; but the effect was only to widen its applicability as part of the 'Sacred classic literature' *(33.119)*. The language of the Bible was no longer the exclusive property of one sect; it was not written 'for one nation or one time only, but for all nations and languages, for all places and all centuries' *(16.399)*. Most importantly, the theory of typical beauty evolved from Evangelical typology

127

was strengthened, not abandoned, for it now expanded into a theory of universal symbolism. Nature remained the repository of those types, and God their creator, but a God that worked through man. The process of Ruskin's mind was always towards greater inclusion, to perceive common factors in a greater number of things, to reconcile opposites and extend categories; so that the loss of a restrictive Evangelical faith opened up new areas of thought. Nor did the loss of faith lead to atheism; if it had, then it was a complete hypocrite who wrote the final peroration to *Modern Painters*.

If the proper subject of art is now man, then it takes on a social, rather than a personal, religious significance. The link between Ruskin's aesthetic and social theory was architecture. He started to make notes on architecture on a large scale almost immediately after completing *Modern Painters* 2 in 1846, and for the next decade the subject occupied most of his attention. There are several reasons for this temporary abandonment of the defence of Turner: quite simply there was the desire for a change after the second volume of *Modern Painters*; and, further, he could see that his arguments had raised questions which required fresh thought before they could be resolved in the next volume, with its half-apologetic subtitle, 'Of Many Things'. A forceful reason for calling attention to the beauty of medieval buildings, as he pointed out in the preface to *The Seven Lamps of Architecture* (1849), was that so many were being destroyed 'by the Restorer, or Revolutionist'*(8.3n)*. It is also true that a weakening response to nature made a change of subject matter necessary, although his first notes on architecture had been intended for the continuation of *Modern Painters*, and later, when he fully developed the concept of the close links between architecture and nature, the subject grew back towards the original theme. 'The last part of this book, therefore,' he wrote of *The Stones of Venice* in 1852, 'will be an introduction to the last of *Modern Painters*.'*(10.208n)* He did not know that there were three more volumes to be written before the defence of Turner was ended.

Two external factors also turned Ruskin's thoughts to architecture, and consequently to social questions. Firstly, there was the desire to make a contribution to the controversy surrounding the Gothic Revival. Although the Gothic style was generally accepted as suitable for ecclesiastical building, the driving force for the revival had come from Roman Catholics, or near-Catholics, and thus the purely architectural problem was mixed with a doctrinal one which made it difficult for the true Protestant – such as Ruskin was supposed to be – to fully accept the style. The leading English exponent of the Revival was Augustus

Welby Pugin, who was received into the Catholic Church in 1836, the year of the publication of the first edition of his famous book *Contrasts*. Ruskin was disparaging of Pugin, and claimed that he had only glanced once at his book, but this very disparagement betrays the sympathy he felt for Pugin's view of the moral responsibilities of the architect. More especially, they had a similar view of the Renaissance. The Catholic writer Rio had opened Ruskin's eyes to early Italian painting; and Pugin followed Rio in treating the Renaissance as the expression of the corruption that had overtaken society and the Church. Where Ruskin differed from Pugin, of course, was over Catholicism, and he derided the way people could be 'lured into the Romanist Church by the glitter of it' (9.437). In order to remain free of the taint of Romanism he attacked Pugin unfairly; but he was very close to him. His condemnation of sham, the view of architecture as social history, and the hope for a universal style of building, are all anticipated by Pugin. Ruskin may even have taken over from Pugin the idea of 'contrasts': Pugin's illustration of the difference between a medieval and a modern English town (ill. 33) has its echo in Ruskin's comparison of the Grand Canal in the fourteenth century and Gower Street in the nineteenth (11.4), or Rochdale versus Pisa (16.338–40).[13]

To the doctrinal concern to save the Gothic style for Protestantism was added the genuine fear that the social upheavals of Europe might destroy all Gothic buildings, Catholic and Protestant alike. The revolutions of 1848 affected Ruskin directly;[14] they prevented him from going to Italy that year, while the journey to Normandy that was made instead helped to stimulate his interest in architecture. In October he visited Paris and Rouen, and observations there appear in the *Seven Lamps of Architecture*. Clearly there is sympathy for those who were suffering: 'I am not blind to the distress among their operatives; nor do I deny the nearer and visibly active causes of the movement: the recklessness of villainy in the leaders of revolt, the absence of common moral principle in the upper classes, and of common courage and honesty in the heads of governments.' (8.261) But he was no supporter of revolution. The solution he offered – in a chapter entitled 'The Lamp of Obedience' – was a moral regeneration through work, specifically through building, which would release the creative potential of all engaged upon it, and end the mental and spiritual idleness which he blamed as the main cause of unrest.

The revolutions of 1848 certainly brought a sharpened political awareness, but Ruskin's reaction was conservative. When the political disturbances in France continued to threaten his travel plans in 1851

and 1852 he applauded Napoleon III's *coup d'Etat* and the arrests that followed. Although the implications of the social theories that he himself later evolved were extremely subversive of the established order, he maintained the claim, as he put it humorously in the opening words of *Praeterita*: 'I am, and my father was before me, a violent Tory of the old school'*(35.13)*. (This fell short of approving of the Austrian occupation of Venice, however.) His view of practical politics in the 1850s is probably best summed up by a remark in a letter: 'Effie says, with some justice – that I am a great conservative in France, because there everybody is radical – and a great radical in Austria, because there everybody is conservative.'*(LV60)* In 1871 he referred to himself as a 'Communist . . . reddest also of the red' and as a 'violent Tory' four months later*(27.116, 167)*. To the end of his life he never bothered to vote.

In spite of Ruskin's contempt for practical politics, on the theoretical level, architecture was treated from the start as a 'distinctly political art'*(8.20)*. Architecture conveys

more than any other subject of art, the work of man, and the expression of the average power of man. A picture or poem is often little more than a feeble utterance of man's admiration of something out of himself; but architecture approaches more to a creation of his own, born of his necessities and expressive of his nature. It is also, in some sort, the work of the whole race *(10.213)*.

This does not however demean the other arts, for precisely what is most expressive about a building is its decoration, by painting and sculpture. This is no contradiction, for the individual work is a coherent part of a greater whole, and as such all art, but particularly architecture, expresses social history.

The idea of art as social history does not involve any loss of continuity with the idea of art as a mediator between man and nature. The social history of man can be judged in terms of how well or how badly societies have utilized, through their art, the creative energies available in the natural world. Ruskin's choice of analogies shows the interdependence he perceived between architecture and nature – for they come from the natural sciences, crystallography, geology, zoology, anatomy.[15] Correspondingly, the imagery of architecture was applied to natural science. The three geological eras of the earth, creation, sculpture, and decay, parallel the phases of Venetian history. In turn, the decoration of Venice is subject to the cycle of the seasons: 'Autumn came – the leaves were shed, – and the eye was directed to the extremi-

ties of the delicate branches. *The Renaissance frosts came, and all perished!'* *(11.22)*

The link between nature and building, 'this look of mountain brotherhood between the cathedral and the Alp'*(10.188)*, is a recurring idea, from the early essays *The Poetry of Architecture* onwards; it was the one aspect of the picturesque that was not rejected. Since the natural world is the source of our conception of beauty, it follows that the man-made forms which come closest to those of nature will be the most satisfying. Not that it is simply a question of isolating and imitating a particular natural form; that would be an external process. Rather, all design, in architecture, sculpture, painting, or botany, depends on the law of organic form. The dogtooth decoration does not *imitate* the pyramidic crystal; both are governed by the same inner force. And when architectural decoration begins to pretend that it is no longer subject to the laws of physics – in Ruskin's terms, when it begins to pretend to be what it is not, and loses its truth – then it begins to die. A causal connection becomes apparent between the decline of architecture and the rise of landscape painting. Since buildings no longer acted as a link between man and the creative energies of nature, satisfaction had to be sought elsewhere:

For as long as the Gothic and other fine architectures existed, the love of Nature, which was an essential and peculiar feature of Christianity, found expression and food enough in them ... but when the Heathen architecture [that is, Palladian] came back, this love of nature, still happily existing in some minds, could find no more food there – it turned to landscape painting and has worked gradually up into Turner.*(LV192)*

So the digression into architecture was indeed the preliminary to the rest of *Modern Painters*.

Having established the link between nature and the social art of architecture, Ruskin was led on to apply the law of organic form to society itself. Nature was the model for man-made form, so the organization of natural forms might become a paradigm for society. In the natural world the separate parts united in a single energetic whole, exemplifying the type of Divine purity; similarly the associative imagination of the artist combined the imperfect elements of a painting into the one possible perfect composition. The analogy between nature, art and society was there to be drawn: 'Government and co-operation are in all things and eternally the laws of life. Anarchy and competition, eternally, and in all things, the laws of death.'*(7.207)* Ruskin made this

statement twice, first in his analysis of the rules of composition; later, when he turned to political economy, he saw no reason to alter a word.

The obligation upon art to improve society was a commonplace of nineteenth-century thought – it is only because artists made an attempt at the end of the nineteenth century to free art from this obligation that we now need reminding of it. Where Ruskin differed was in his reversal of the proposition. At first he accepted the standard view that art should act as a source of moral regeneration in society, but during the 1850s we are able to see a gradual shift of emphasis. While still believing that art could restore the broken links between man and nature, he came to see that art was an *expression* of society, an index of its health, not a cure for its corruption. The connection between aesthetic and social theories was implicit when he began the study of architecture; the change from art to sociology, if not to economics, takes place within the three volumes of *The Stones of Venice*.

The first volume, like *The Seven Lamps of Architecture*, is primarily concerned with aesthetic problems, and intended to establish certain principles of form and decoration that would produce a practical living architecture. However, during the research for the second volume, he began to see the far wider implications of the argument. Writing to John James in 1852 he seems aware of a distinction in *subject matter* between what had gone before and what was to follow. *The Seven Lamps of Architecture* and the first volume of *The Stones of Venice* 'have been merely bye play – this *Stones of Venice* being a much more serious [volume] than I anticipated'*(LV181)*.

The seriousness was the result of facing the sociological question posed by the stirring opening lines of the whole work:

Since first the dominion of men was asserted over the ocean, three thrones, of mark beyond all others, have been set upon its sands: the thrones of Tyre, Venice, and England. Of the First of these great powers only the memory remains; of the Second, the ruin; the Third, which inherits their greatness, if it forget their example, may be led through prouder eminence to less pitied destruction.*(9.17)*

The problem – the experiment – Ruskin set himself was this. Architecture was the work of the whole nation, Venice had had fine architecture (ill. 34), and yet Venice fell. The conclusion must be that art, like nature, was incapable of saving mankind.

The proposition is demonstrated in the second volume, in the key chapter on the cathedral of St Mark's. It begins with a series of contrasts,

first between the cathedral close of an English city and the approach to St Mark's through the alleys of Venice; then between the noise and glare of the piazza and the beauty of St Mark's itself. Some of Ruskin's finest prose is used to show that St Mark's is a jewel, the greatest art the city possesses, a precious Bible in stone, but what effect does it have on the people who crowd round it?

You may walk from sunrise to sunset, to and fro, before the gateway of St. Mark's, and you will not see an eye lifted to it, nor a countenance brightened by it. Priest and layman, soldier and civilian, rich and poor, pass it by alike regardlessly. Up to the very recesses of the porches, the meanest tradesmen of the city push their counters: nay, the foundations of its pillars are themselves the seats – not 'of them that sell doves' for sacrifice, but of the vendors of toys and caricatures.*(10.84)*

Even within the cathedral itself, in the cool and the dark, with the sound of the Austrian band in the square shut out at last, the splendour and significance of the images which decorate its wall are unregarded.

The beauty which it possesses is unfelt, the language it uses is forgotten; and in the midst of the city to whose service it has so long been consecrated, and still filled by crowds of the descendants of those to whom it owes its magnificence, it stands, in reality, more desolate than the ruins through which the sheep-walk passes unbroken in our English valleys.*(10.92)*

There is a parallel between the conclusion to the description of St Mark's and the passage on the town of Sion.[16] Sion is surrounded by the beauties of the natural world, and yet no help comes from the hills. St Mark's stands at the heart of Venice, and yet its beauty has in no way prevented the moral decline of the city. Nature, and art the interpreter of nature, are unable to redeem society, therefore the proposition must be reversed: redeem society, and the significance of art and nature may once more be appreciated by mankind. Tintoretto failed to save Venice; could a renewed Venice, that is to say England, save Tintoretto? The importance of art as a moral activity remains; beauty still exists to convey the absolute values upon which a sound society must rest; but if the art of a nation is beautiful, it is because its society is noble, and Victorian art is ugly because Victorian society is ugly. As early as 1847 he had written: 'There has not before appeared a race like that of civilized Europe at this day, thoughtfully unproductive of all art – ambitious – industrious – investigative – reflective, and incapable.' *(12.169)* The opening lines of *The Stones of Venice* were a solemn and explicit warning to the England of his day.

'St Mark's' may show that art could not save the Venetians from their fall – but it does not show how the ruin of their art itself occurred. And here we are back among questions that seem primarily aesthetic rather than sociological. However, when Ruskin comes to examine the reasons for the decline of Venetian Gothic architecture, social conclusions are inescapable. The point is sometimes overlooked that he did not study Venetian architecture because he considered it the *best* form of Gothic – his opinion of Verona was far higher – but because Venice 'exemplifies, in the smallest compass, the most interesting facts of architectural history'*(8.13)*. Venice was a model that would show just that interconnection between aesthetic and social questions which make art a moral activity.

Like Pugin, Ruskin believed that the Renaissance revival of Greek and Roman architecture was not the cause of the fall of the Gothic, but its expression. Gothic was corrupted from within, just as the Church was corrupted by its own members. In his view the decline of religious art led on the one hand to the rejection of art by the Protestant reformers, and on the other made way for a takeover by Paganism which took artists away from faith to fiction, and caused the debasement of all art values. The cause of this collapse must therefore be found within the Gothic period, and must be detectable in the fabric of the buildings themselves. In accordance with his established practice, he relied almost entirely on the observing eye alone, for no historians agreed on the dates of the buildings considered.

Making the same calculations with the same techniques that had been applied to painting, Ruskin came to the same conclusion: that the Gothic had sown the seeds of its own destruction the moment it violated truth. The truth of Gothic tracery was its organic form – not as flowers or leaves – but as *stone*. As the carver refined his skills, however, he discovered that stone could be made to appear to bend or curve, as though it were malleable, and a lie was told. When

the tracery is assumed to be as yielding as a silken cord; when the whole fragility, elasticity, and weight of the material are to the eye, if not in terms, denied, when all the art of the architect is applied to disprove the first conditions of his working, and the first attributes of his materials; *this* is a deliberate treachery*(8.92)*.

The pleasure of flowing tracery is undeniable, but once the builder is distracted from the space he has to fill to the mere means of filling it, then mannerism, with its ensuing degradation, is inevitable. Once free of the laws of physics, tracery could disobey all the laws of organic

form: stone bars could appear to flow through one another, the principal mass of a pillar could look as though it had been poured over the smaller shafts supporting it. For the fourteenth-century builder the display of technical skill became the sole object of architecture.

The question was not now with him, What can I represent? but, How high can I build – how wonderfully can I hang this arch in air, or weave this tracery across the clouds? And the catastrophe was instant and irrevocable. Architecture became in France a mere web of waving lines, – in England a mere grating of perpendicular ones.*(16.283)*

The cause of this collapse was, paradoxically, perfection. Once Art becomes interested only in herself, 'she begins to contemplate that perfection, and to imitate it, and deduce rules and forms from it; and thus to forget her duty and ministry as the interpreter and discoverer of Truth' – clearly Ruskin intends this truth to be both moral and aesthetic – 'by her own fall – so far as she has influence – she accelerates the ruin of the nation by which she is practised'*(16.269)*.

Perfection led to self-regarding mannerism, luxury, vice. The great virtue of the Gothic had been that it had room for imperfection. The medieval carver practised the Christian virtue of humility before the stone, he did his best, to the limit of his capabilities, and so reached a fulfilment of his creative potential that would be impossible in a form of architecture that imposed an absolute standard of execution and a rigid repetition of parts. When Ruskin wrote that the glory of Gothic was that 'every jot and tittle, every point and niche of it, affords room, fuel, and focus for individual fire'*(9.291)*, he meant that the medieval cathedrals expressed just those values of life and energy which he found in nature, and sought to release in society.

The doctrine of the evils of perfection was found in the traceries of Rouen and the pillars of Abbeville – but the sociological conclusions quickly followed. They are drawn in a chapter in the second volume of *The Stones of Venice*, 'The Nature of Gothic', which follows shortly after that on St Mark's. Perfection, it is argued, enslaves the artist, by preventing individual expression. This applies to all manual labour, for in any man 'there are some powers for better things; some tardy imagination, torpid capacity of emotion, tottering steps of thought'*(10.191)*, but they can be utilized only if we are prepared to allow for individual imperfection. Almost imperceptibly Ruskin has ceased to talk about the artist, and begun to discuss the worker. His concern is no longer fifteenth-century Venice, but nineteenth-century England, for the perfectionism of the industrial age has made men again into slaves. The

standard imposed upon the craftsman is not that of nature, but of the machine; if he is to be liberated, he must be allowed to think, instead of made to copy. Even if the results are crude and feeble, 'you have made a man of him for all that. He was only a machine before, an animated tool'*(10.192)*.

Ruskin blames the dehumanization produced by industrial society more than anything else for the political upheavals taking place around him. The cause of social discontent was not really hunger, or envy, but the very system which the Utilitarian economists since Adam Smith had regarded as opening the way to universal happiness. An essential element in the organization of production is the division of labour; but for Ruskin,

> It is not, truly speaking, the labour that is divided; but the men: – Divided into mere segments of men – broken into small fragments and crumbs of life; so that all the little piece of intelligence that is left in a man is not enough to make a pin, or a nail, but exhausts itself in making the point of a pin or the head of a nail.*(10.196)*

This is a conscious reference to Adam Smith's *The Wealth of Nations*, for he too takes pin making as an example of the division of labour.[17] But where Smith sees a system which gives each man but one thing to do as efficient and productive, Ruskin sees the process breaking down the organic unity of life into sterile units of despair.

The analysis of the social conditions of industrialization in 'The Nature of Gothic' has a parallel in another consideration of the conditions of labour in the mid-nineteenth century: Karl Marx's *Economic and Philosophic Manuscripts of 1844*. Here Marx uses the term 'alienation' to describe many of the consequences of industrialization which Ruskin also deplored. Man is alienated from nature; for the product of his labour, his connection with the natural world, is taken from him. His labour is not satisfying in itself, for he does not look upon it as in any way a creation of his own, but rather as an abstract commodity which must be exchanged for the necessities of existence. Since his work does not release any creative potential, man is alienated from his own self, having no means of transforming the external world in accordance with his self-defining instincts. Alienated from himself, man is also alienated from others in the struggle for survival. Without using a single term such as 'alienation', Ruskin makes the same points: the dislocation of man and nature, the status of man reduced to that of a machine, work as slavery when creativity is stifled, man set against man by the laws of competition.[18]

I stress that I am pointing to a parallel, not a connection. Marx's early writings on alienation were not published until 1932. But that there should be a parallel is not surprising: both men were describing the same economic conditions and had read the same theorists, notably Adam Smith and Ricardo, with perhaps a backward glance at Rousseau. Marx's more philosophically expressed analysis throws considerable light on the conclusions that Ruskin was approaching through aesthetic terms. Both believed that the essential relationship was between man and nature, and that the medium of this relationship was work: not simply the economic tasks forced upon man by necessity, but the constant activity by which man transforms his environment at the same time as he is shaped by it. For Ruskin the highest mode of this activity was art, but as 'The Nature of Gothic' shows, he sought to raise all human labour to its most creative level.

Both Ruskin and Marx opposed the utilitarian economics of their day, the 'classical' economics which assumed that egoism was the principal motivation of man, but that the checks and balances of competition would resolve individual conflict for the general good. Both argued that we must transcend egoism by recognizing that our activities are governed by what exists *between* people, and links them, not by an abstraction within ourselves that separates us from others. The radical difference is in how they thought this fellowship could be achieved. Marx predicted a series of revolutions, more or less violent; Ruskin, with his religious upbringing, restricted the possibilities of conversion to each individual, rather than a whole class.

The attack on contemporary working conditions in 'The Nature of Gothic' is only a relatively small portion of the whole chapter; it grows naturally out of a consideration of the conditions of labour needed to produce good architecture, and leads on naturally to the prescription of principles for contemporary design, and to an attack on demands for perfection in all art. Increasingly, however, he saw the life of the worker as an essential link in his argument for a man-centred art. The conclusion to *The Stones of Venice* repeats the thesis that contemporary society demanded above all the perfection and accuracy of

hand-work and head-work; whereas heart-work, which is the *one* work we want, is not only independent of both, but often, in great degree, inconsistent with either. Here, therefore, let me finally and firmly enunciate the great principle to which all that has hitherto been stated is subservient:– that art is valuable or otherwise only as it expresses the personality, activity, and living perception of a good and great human soul.*(11.201)*

He feared that the point might not get across, tersely remarking in 1854 that no one had 'yet made a single comment on what was precisely and accurately the most important chapter in the whole book; namely the description of the nature of Gothic architecture, as involving the liberty of the workman'*(12.101)*. Yet 'The Nature of Gothic' was twice chosen as a manifesto for a new ordering of society, first by the Working Men's College in London, founded by the Christian Socialist F.D. Maurice in 1854, and then by William Morris, who reprinted the chapter at the Kelmscott press in 1892. Morris's admiration for both Ruskin and Marx is one sign of affinity between *The Stones of Venice* and *Das Kapital*.

A developing concern for the ethics of production and consumption found its first expression in concern for the production and consumption of artists. It is in these ironic terms that two lectures on art education given at Manchester in 1857 are couched. Their title, *The Political Economy of Art*, is doubly ironic, for the occasion was the great Manchester Art Treasures Exhibition, held in the city which had given its name to the utilitarian economics he despised. A series of lectures and addresses throughout the 1850s repeats the argument of *The Stones of Venice*, that even with great art a nation can lose its way.

The lectures continally reach out towards a wider context, where the relationship between the artist and society might be defined for once and for all. That meant writing directly about society itself. Criticism of contemporary values was not new; Thomas Carlyle had been denouncing society's wickedness for twenty years, and the development of a personal friendship increased Carlyle's influence upon him. But Ruskin differed from other critics, whether novelists like Dickens or sages like Carlyle, in that he attacked the Utilitarians on their own ground. He was the only one to attempt to write a work of economics.

The opportunity for such a startling change of subject came in 1860, shortly after the publication of the last volume of *Modern Painters*. His publishers had launched a new magazine, *The Cornhill*, edited by Thackeray, and, having obtained his father's grudging consent, he offered them a series of articles on political economy under the general title *Unto this last*. It must be admitted that his knowledge of theoretical economics was limited; one could hardly be more frank than Ruskin himself, who once boasted that he had never read a single work of economics, except Adam Smith's *The Wealth of Nations* twenty years before*(16.10)*. Clearly he made some preparations for *Unto this last* by reading David Ricardo and John Stuart Mill, from whose works

quotations appear, somewhat inaccurately, in the essays.[19] It must also be admitted that, when practical questions of economics are tackled, solutions are close to those of the writers he criticizes. But these limitations do not weaken the essential point of Ruskin's argument, that it was necessary to place the science of economics on an ethical basis. One measure of his success may be the fact that the articles in *The Cornhill* caused such an outrage that they were stopped before the series was complete.

People were angry, because *Unto this last* exposed the blind selfishness which lay beneath the complacent belief that to act in one's own interests was also to act in the interests of society. Jeremy Bentham's proposition that man's actions are governed by the pursuit of pleasure and the avoidance of pain had led the economists to argue that individual selfishness created a natural harmony of interest in society, that this harmony was spontaneous and beneficent, and that the less that was done to interfere with it the better. Ruskin interpreted the classical economists as saying: 'avarice and the desire of progress are constant elements. Let us eliminate the inconstants, and, considering the human being merely as a covetous machine, examine by what laws of labour, purchase, and sale, the greatest accumulative result in wealth is obtainable.'*(17.25)* What was especially alarming was that the economists were happy that affairs should be regulated by a blind process devoid of moral content. The law of supply and demand was in economics the equivalent of the 'balances of expediency'*(17.28)* which governed utilitarian ethics. The rule that when supply exceeds demand, prices fall, and when demand exceeds supply, prices rise, is morally neutral, but its consequences can be horrifying, as anyone who had lived through the economic upheavals of the 1830s and 1840s could see.

The Utilitarians, Ruskin pointed out, applied the law of supply and demand to people as well as products. Adam Smith had seen this as the regulator of population growth, and the Reverend Thomas Malthus had provided a rationale against charity by showing that the poor bred to the limit of their capacity to support children, so that any improvement in their conditions would only lead to a population surplus. As a result, the poor 'are themselves the cause of their own poverty', which must have been very comforting to a rich man.[20] Ruskin satirized this attitude in a letter to the *Daily Telegraph* in 1864, pointing out that the oppressed labourer would conclude that 'the shortest way of dealing with this "darned" supply of labourers will be by knocking some of them down, or otherwise disabling them'*(17.502)*.

In place of the naked competition which seemed the only motivation of nineteenth-century society, Ruskin offered cooperation, social affection and justice. It was simply not true that egoism was our guiding principle, and it certainly did not produce the beneficent results the Utilitarians claimed. Cooperation – that essential quality in art – would end the destructive antagonism of rich and poor, and instead society would be ordered in accordance with the principle of justice. Ruskinian justice is essentially authoritarian: it would bring equity, but not equality, for each would find his place in society according to his merits, the apportionment in accordance with moral law. The type of Divine justice in *Modern Painters* 2 is Symmetry; but 'Absolute equality is not required, still less absolute similarity'*(4.125)*. It is a concept that derives from the Evangelical idea of God, the Hebrew God of the Old Testament, the angry father whose judgment of the sinful and the elect needs no explanation. The angry father could however also love and show compassion, and Ruskin's relations with his own father play their part in his respect for paternalist authority. To the Biblical concept of justice was added that of Plato's *Republic*, where a state founded on mutually cooperating classes was ruled by an elite of benevolent leaders. In the final analysis Ruskin's concept remains unphilosophical, a projection of his conscience, or even an emotional expression of a need for security. But it becomes comprehensible when one realizes that it is the expression, in moral terms, of just those principles of right ordering and cooperation which govern his aesthetic theories.

Having placed the economic argument on an ethical plane, he was able to point to an essential flaw in the economists' case. Adam Smith and David Ricardo recognized that the only real source of value was labour. Capital, as tools or land, was useless without hands to work it; the capitalist made his profit by lending the labourer the wherewithal to live in return for working with his capital. Labour transformed capital by making it fruitful – but the fruits went to the capitalist, not to the labourer. Ruskin accepted that labour was the source of value, as indeed did Marx, but he pointed out that therefore there was a social relationship which must be taken into account. It might appear sound economic sense to buy cheap and sell dear, but whenever we buy cheap goods, 'remember we are stealing somebody's labour. Don't let us mince the matter. I say, in plain Saxon, STEALING – taking from him the proper rewards of his work, and putting it into our own pocket.'*(16.401–2)* It is useless for one man to make himself rich, if he makes two men poor in the process. The economists held that what was good for one man

was good for society; the moral argument was that it was not a question of the acquisition of wealth at all, but *how* it was acquired, and how it was used. And since riches meant power over other people, wealth should be calculated in terms of the value of the people whose work it commands.

But what does that vague word 'value' really mean? Here again there was an error to be shown in the economists' calculations. In practice, value was treated as value in exchange, and it was on the basis of what one could get in exchange for a given article that one calculated its price. Value in exchange was governed by the law of supply and demand, which should in theory bring prices to their lowest practical level. But if supply and demand forced the price of labour down to starvation wages the calculation was futile, and the injustice hurt worker and master alike.

What made your market cheap? Charcoal may be cheap among your roof timbers after a fire, and bricks may be cheap in your streets after an earthquake; but fire and earthquake may not therefore be national benefits. Sell in the dearest? – yes, truly; but what made your market dear? You sold your bread well today; was it to a dying man who gave his last coin for it?*(17.53–4)*

The value of something is not its price, nor its value in exchange, but what prompted us to make an exchange for it in the first place, the fact that we had a use for it, that it was of value *to us*.

Ruskin argues that our calculations should be based not on value in exchange, but value in use, utility. It is no longer a question of the abstract and remorseless law of supply and demand, but the completely human problem of differing capacities and desires: wealth must be of use *for* someone, consumption must do us good, not harm. What governs that use is the principle of justice, and the test of utility; both ideas undermine the basis of orthodox economic thinking and establish a fresh set of values on which to establish a new social philosophy. The essence of that philosophy is that things are valuable only if they 'avail towards life'*(17.84)*, that wealth is 'THE POSSESSION OF THE VALUABLE BY THE VALIANT'*(17.88)*, and that there is but one fact to be remembered in all our economic dealings: 'THERE IS NO WEALTH BUT LIFE.'*(17.105)*

The imagery of *Unto this last* rests upon a fundamental opposition of life and light, and death and darkness, and to a great extent, whatever our opinion of the 'scientific' content, the argument also rests on this antithesis. It does not weaken Ruskin's case to say so, for the practical consequences of nineteenth-century economic policies were death and

disease for the exploited, and quite literally darkness, as he was to point out in his meteorological observations in *The Storm Cloud of the Nineteenth Century* (1884). The positive values of a free, happy, organic and creative society are associated with ideas of life and light. Life, as we have seen, is that force in the natural world which art and architecture should convey to man, and light is one of its purest expressions, a Divine attribute listed in *Modern Painters* 2 as the type of Purity conveyed in Scripture by 'God is light, and in him there is no darkness at all' (*I John 1: 5*). As we have seen, Ruskin was no longer an Evangelical, but he had developed the use of typology into a system of universal symbolization. The opposition of light and darkness is not only an Evangelical type; it is also an archetype, and would be recognized instinctively:

To the Persian, the Greek, and the Christian, the sense of power of the God of Light has been one and the same. That power is not merely in teaching or protecting, but in the enforcement of purity of body, and of equity or justice in the heart; and this observe, not heavenly purity, nor final justice; but now, and here, actual purity in the midst of the world's foulness, – practical justice in the midst of the world's iniquity.(*22.204*)

The archetype is completed by its opposites, death and darkness. The forces of the Devil which had contended for the young Ruskin's Evangelical soul were now perceived as a universal evil working to destroy the potentially paradisical garden of England. What the economists thought of as production was in fact destruction. True wealth had its opposite, 'illth':

One mass of money is the outcome of action which has created, – another, which has annihilated, – ten times as much in the gathering of it; such and such strong hands have been paralyzed, as if they had been numbed by nightshade: so many strong men's courage broken, so many productive operations hindered; this and the other false direction given to labour, and lying image of prosperity set up, on Dura plains dug into seven-times-heated furnaces. That which seems to be wealth may in verity be only the gilded index of far-reaching ruin(*17.53*).

In these passages Ruskin may sound more like a preacher or a prophet than a philosopher, but the imagery was necessary to persuade men to transcend the narrow limits of economics. The use of the archetypal conflict of life and death was not a mere literary device; he could see that men *were* killing each other and destroying the world in the search

for profit. A moral appeal such as this could only be expressed in the strongest imaginative terms.

Unto this last seems such a change of direction that it is often considered as the beginning of the social writings of the 1860s, rather than as the culmination of the art criticism that had gone before. The book is of course both, but I have discussed it before the conclusion to *Modern Painters* because it is the clearest and most obviously socially directed expression of the theme of life and death that runs throughout *Modern Painters* and the architectural writings. The direct attack on economics brings the theme out into the open. But where does the argument for social reform leave the artist? Should he abandon painting and take up economics? Far from it. Like Ruskin, he should be concerned with both.

To begin with, the conclusions drawn from the analysis of industrialization in 'The Nature of Gothic' apply just as much to the artist as to the worker. The artist is after all a worker himself, and every worker should be as far as possible an artist. Later, Ruskin was to lay stress on the origins of art in manual labour to the extent of saying that 'a true artist is only a beautiful development of tailor or carpenter' (27.186). Art, as has been said, was the highest form of that activity in which we are perpetually engaged, the constant interchange between ourselves and our environment which, as Marx pointed out, is for most of us no more than work. Since art is the highest form of work, the artist must be a special kind of person, a special kind of worker, and in as much as art contains the history of the whole race that produces it, the artist will embody in his own personality the distinctive characteristics of the society which produced him.

The idea is close to Carlyle's image of the creative man as hero, a Romantic concept derived from Goethe, and indeed Carlyle said of Goethe that he was 'a clear and universal *Man*' whose sympathy for the ways of all men 'qualify him to stand forth, not only as the literary ornament, but in many respects too as the Teacher and exemplar of his age'.[21] But where Carlyle treats his heroes very much as actors upon history, Ruskin was more concerned to show how artists expressed through their actions the historical conditions that prevailed upon them. He hoped that they would indeed become the teachers of the rest of mankind, but it was as exemplars that he saw them. The most significant example of all was Turner, a product of his time, rejected by society when he sought to influence it, and yet whose rejection showed how important that interaction with society was. And if Turner

typifies for Ruskin the social conditions of art in the first half of the nineteenth century, his handling in *Modern Painters* typifies the changes that took place in Ruskin's own viewpoint. At the beginning Turner is presented as close to a Romantic poet, like Wordsworth; at the end he is nearer to Carlyle.

Artists, then, are the expression of their society, and at the same time give form to their society through their art. It had been part of Ruskin's argument since *Modern Painters 1* that an artist could only work within his local traditions: 'The Madonna of Raffaelle was born on the Urbino mountains, Ghirlandajo's is a Florentine, Bellini's a Venetian; there is not the slightest effort on the part of any of these great men to paint her as a Jewess.'*(3.229)* The changes that come about in art take place for common reasons of national character, and take place simultaneously in accordance with both social and individual developments.

The consequence of the relationship with national character is that the artist has a special moral responsibility to the society he serves. If he is indeed to embody all the noble virtues of his time, he must be noble himself, 'no shallow or petty person can paint. Mere cleverness or special gift never made an artist. It is only perfectness of mind, unity, depth, decision, – the highest qualities, in fine, of the intellect, which will form the imagination.'*(7.249)* But he should exercise these virtues only through the use of his recording eye – and here there is a clear distinction between Ruskin's and Carlyle's heroes: 'It is not his business either to think, to judge, to argue, or to know. His place is neither in the closet, nor on the bench, nor at the bar, nor in the library. They are for other men, and other work . . . the work of his life is to be two-fold only; to see, to feel.'*(11.49)*

It is tempting to conclude from this that Ruskin is saying that in order to be a good painter one must also be a virtuous man, and for a time it appeared that he did hold this view. From an article written in 1847 it seemed that Fra Angelico was his ideal artist, 'a man of (humanly speaking) *perfect* piety – humility, charity and faith'*(12.241)*. But, as we know from the account of Ruskin's 'unconversion', he came to accept the animality of man, and changed his heroes accordingly. What gave him particular trouble (and I do not believe he ever found a satisfactory solution to the problem) was the fact that the flowering of art seemed inevitably to herald the destruction of the society that produced it. One explanation was that as exemplars of their age, artists must necessarily fall with it. The fall itself was manifested in the same way in architecture: the demand for perfection, and the artist's increas-

ing capacity to achieve it, led to a self-regarding interest in skill alone. At first the Renaissance provided a healthy stimulus and an antidote to corrupt Gothic, and produced painters like Michelangelo, Leonardo and Raphael; but inevitably their achievements and the weakening of the religious impulse in society led to a luxurious and vicious mannerism. Painting and sculpture survived the immediate collapse of architecture because they were the individual products of the finest minds. To borrow an idea from Marx: artists like Tintoretto, Titian and Veronese resisted alienation because of the individual nature of their works; but not those who followed. Sadly, it seemed to Ruskin, 'the names of great painters are like passing bells.'*(16.342)* A significant death image.

It was only when the view of the artist as an expression of society had been formulated that Ruskin could come to terms with the sixteenth-century Venetian painters. The preface to *Modern Painters 5* admits that until then they had been treated as 'however powerful, yet partly luxurious and sensual'*(7.9)*. It was not until that moment in the Gallery of Turin before Veronese's *Solomon and the Queen of Sheba* that he was finally able to shrug off the religious prejudice in favour of specifically God-directed art: 'with much consternation, but more delight, I found that I had never got to the roots of the moral power of the Venetians'*(7.6)*. As a result, not the ascetic Fra Angelico but Titian becomes the ideal artist,

wholly realist, universal, and manly. In its breadth and realism, the painter saw that the sensual passion in man was, not only a fact, but a Divine fact; the human creature, though the highest of the animals, was, nevertheless, a perfect animal, and his happiness, health, and nobleness, depended on the due power of every animal passion, as well as the cultivation of every spiritual tendency. *(7.296-7)*

This act of integration is the true theme of Ruskin's own all-important un-conversion before Veronese. He was at last able to explain how it was that the Venetian painters, although without religion, were yet great artists, for

human work must be done honourably and thoroughly, because we are now Men; – whether we ever expect to be angels, or were slugs, being practically no matter. We *are* now Human creatures, and must, at our peril, do Human – that is to say, affectionate, honest, and earnest work. Farther I found, and have always since taught, and do teach, and shall teach, I doubt not, till I die, that in resolving to do our work well, is the only sound foundation of any religion whatsoever.*(29.88)*

The act of integration represented by the moment in the Turin gallery enabled Ruskin at last to try to bring *Modern Painters* to a conclusion. In spite of its occasional discursiveness, the last section is a remarkable synthesis of the recurring themes and ideas of those five volumes. A synthesis, and a resolution, for many of the ideas that had been subjected to a constant dialectical evolution find their final form. There is no better example of this than the return in the opening page to the starting-point of *Modern Painters*, the relationship between man and landscape. 'The Moral of Landscape', the half-way position, questioned the value of actual landscape to man; here the value of landscape painting is finally decided upon. As has been inevitable ever since the antithetical chapters on 'Mountain Gloom' and 'Mountain Glory', the conclusion is that landscape is valuable only in its relation to man.

As is so often the case in Ruskin's later writings, the title of the chapter itself is a poetic image of its contents. Here 'The Dark Mirror' conveys the final conception of a man-centred art. The image of the mirror, so vital to his explanation of the significance of symbolism and the workings of the imagination, reappears as what it always had been, the image of the soul. His original inspirations, nature and the Bible, are finally placed in their right relationship to man, for it is only *through* man that their truths can be perceived. Only in the dark mirror of the soul will we find a true conception of God: 'No other book, nor fragment of book, than that, will you ever find: no velvet-bound missal, nor frankincensed manuscript; nothing hieroglyphic nor cuneiform; papyrus and pyramid are silent on this matter; – nothing in the clouds above nor in the earth beneath.'*(7.261–2)* This commitment to the human soul may leave Ruskin staring into a scarcely penetrable gloom, 'Through the glass, darkly'. But, he continues, 'except through the glass, in nowise'. Against this darkness is set an image of light, as man is shown to illuminate the world around him, for 'all the power of nature depends on subjection to the human soul. Man is the sun of the world; more than the real sun.'*(7.262)*

The end of *Modern Painters 5* involves one last grand view of the cultural history of Europe, a historical analysis which resolves itself into how each period and each school of art came to terms with the concept of death. Death, as we know from the imagery of *Unto this last*, is not merely the final act of life, but its positive antagonist, an essential antagonist, however, for schools of art are strengthened by their struggle, and can only be judged by their victory over it. Thus the school of pre-Renaissance religious painting 'cannot constitute a real school [of landscape], because its first assumption is false, namely, that

the natural world can be represented without the element of death'
(*7.265*). The struggle is most heroic amongst the Venetians, and its
result the most tragic, for they threw away their power over Venice in
the pursuit of pleasure. Through a series of contrasted artists set in their
contrasted landscapes, we arrive at one last great antithesis, Giorgione's
Venice versus Turner's London.

Against the beauty of Venice is set the squalor of London; against
the luxurious but none the less proud religion of Venice is set the almost
complete absence of religion in Turner's city. The ugliness of London
had its compensations, for it caused Turner to know and understand the
poor, but he could not find God there. Only outside the town, among
the Yorkshire hills, could Turner find the beauty which gave rise to
faith – or creative inspiration: 'Loveliness at last. It is here then,
among these deserted vales! Not among men.'(*7.384*)

So Turner chose to paint landscape, where Giorgione, with the
architecture of a beautiful city around him, could still find beauty among
men. Turner 'must be a painter of the strength of nature, there was no
beauty elsewhere than in that; he must paint also the labour and the
sorrow and passing away of men: this was the great human truth visible
to him. Their labour, their sorrow, and their death'(*7.385–6*). And so
Ruskin begins a long meditation on the death of the nineteenth
century, a meditation which finds its issue in the analysis of those two
final Turner canvases, *The Garden of the Hesperides* and *Apollo and Python*.

The last chapter of *Modern Painters 5* is dense with religious refer-
ence, almost as though it were another Book of Revelation. But
Ruskin's concern is that the kingdom of God should come on earth, not
in heaven. The earth is still in chaos, and the spirit of God is still
moving over the face of the waters. Some men see it, most do not, and
the choice is between light and darkness, just as *Apollo and Python* is a
victory of light over darkness. Those who are prepared to receive the
Kingdom of God must choose labour instead of luxury; for Ruskin the
choice was already made. His work was to be a determined effort to
bring the nineteenth century to its senses; he took as his motto
'TODAY', 'for the night cometh, when no man may work'.

6 The Queen of the Air

'The moral significance of the image'

FROM 1860 onwards the oppositions in Ruskin's life and writings became more and more marked. I do not mean the petty contradictions that his critics were always pointing out, but the major oppositions between theory and practice, between the ideal and reality, and finally between sanity and madness. A major tension existed in his attitude to the relationship between art and society. The attack on conventional economics in 1860 did not resolve the problem of the contradictory need for a good art to make society noble, and for a good society to produce a great art. It was as though he had to start all over again. He confessed

the disappointment of discovered uselessness, having come to see the great fact that great Art is of no real use to anybody but the next great Artist, that it is wholly invisible to people in general – for the present – and that to get anybody to see it, one must begin at the other end, with moral education of the people, and physical, and so I've to turn myself quite upside down, and I'm half broken-backed and can't manage it(36.348).

He was already aware in 1860 of the personal limitations that at times would make his efforts seem ludicrous, or pathetic.

The way to resolve the internal conflict of irreconcilables was to release the tension between them through action. The opposing forces could be held in balance in the act of turning ideas into practice. That was the paradox and resolution of art. He wrote, quoting himself:

'So far from art's being immoral, little else except art is moral.' I have now farther to tell you, that little else, except art, is wise; that all knowledge, unaccompanied by a habit of useful action, is too likely to become deceitful, and that every habit of useful action must resolve itself into some elementary practice of manual labour.(20.264)

Ruskin meant just that: that all art began as some physical action, and that all manual labour, if rightly directed, could be as fulfilling as art:

148

'To succeed to my own satisfaction in a manual piece of work, is life, – to me, as to all men'*(28.206)*. This was the need for the 'moral education of the people, and physical' that is the foundation of his programme of action.

The early 1860s were the lowest point of Ruskin's career. Nervous exhaustion after completing *Modern Painters* and *Unto this last* brought on the usual depression, compounded this time by the public's rejection of his economic ideas. The articles for *Unto this last* were stopped by *The Cornhill* while he still had four more chapters planned, and his next series of articles on economics, *Munera Pulveris* (1862–63), this time for *Fraser's Magazine*, suffered the same fate. *Unto this last*, which was reprinted in book form in 1862 (although the opportunity to complete his scheme was not taken), got no sympathy from the public, selling only 898 copies during the next ten years*(17.xxxii)*. The reviewers turned against the formerly popular art critic. The *Saturday Review* called his articles 'feminine nonsense', 'pious as well as silly'. The *Manchester Review* among others found him subversive: 'It is not against political economy, but against society that he has written.'[1] The public reaction reinforced his father's displeasure; John James's attitude had made him disguise the full extent of his social revolt during the 1850s; the apparent failure of *Unto this last* and *Munera Pulveris* caused the reimposition of parental censorship.

Relations between John and his ageing parents were deteriorating anyway. The change in his religious views put a barrier between them, and their control over his life became more and more irksome. In 1861 he wrote to his friend Charles Norton about the 'almost unendurable solitude in my own home, only made more painful to me by parental love which did not and never could help me'*(36.356)*. The answer was to go abroad, rejecting England and avoiding parents. On 14 May 1862: 'Tomorrow I leave England for Switzerland; and whether I stay in Switzerland or elsewhere, to England I shall seldom return. I must find a home – '*(LN1.127)*. Home-seeking turned out to be an impractical scheme for building a house in the Alps.

For refreshment he returned to geology and took up classical studies again. The normal high output of work dropped back; the only significant products of these 'exile' years were the articles that became *Munera Pulveris*. The problem was solved by the death of John James on 3 March 1864. The responsibilities he had to assume called him home, and the death of his father made it no longer necessary to stay abroad. He was freed in several ways: an inheritance of £120,000, together

with various properties, and pictures valued at £10,000, gave him almost unlimited power to carry out his schemes; the removal of his father's censorship allowed him to give unrestricted expression to his ideas.

The result was a burst of activity: books, articles, lectures, letters to the press. The ending of his father's editorial control may have caused him to abandon large-structured works like *Modern Painters* (finished off under pressure from John James, and even then not properly completed); but writing was becoming a continuous activity without any need for a specific form. The lecture, bringing personal contact with an audience and limitations of time, suited his arguments best, and these became the basic unit for his books during the 1860s. As Ruskin took over responsibility for his own publishing, he was free to send material to the printers and keep it standing in type until a suitable place was found for it. By the 1880s part-publication was the standard form in which his works appeared. His publications became a running commentary on his actions, finding its most convenient form in the monthly public letters of *Fors Clavigera* which began in 1871.

In spite of the widely different forms his writing took, it all related to a central core of ideas constantly linked and repeated, and consistently expressed in a coherent language of imagery. The essential message remained the same:

The Science of Political Economy *is* a Lie, – wholly and to the very root (as hitherto taught). It is also the Damnedest, – that is to say, the most utterly and to the lowest pit condemned of God and his Angels – that the Devil, or the Betrayer of Men, has yet invented. . . . To this 'science' and to this alone (the professed and organised pursuit of Money) is owing *All* the evil of modern days. . . . It is *the* Death incarnate of Modernism, and the so-called science of its pursuit is the most cretinous, speechless, paralysing plague that has yet touched the brains of mankind.*(17.lxxxii)*

Munera Pulveris began as an attempt to construct a political economy based on the new definitions made in *Unto this last*. The first two articles try to contain the runaway energy of his prose within a careful framework of numberings and section headings. But he was unable to sustain the effort to keep his associative, all-embracing world-view restricted to a narrow focus.

Such being the general plan of the inquiry before us, I shall not limit myself to any consecutive following of it, having hardly any good hope of being able to complete so laborious a work as it must prove to me; but from time to time,

as I have leisure, shall endeavour to carry forward this part or that, as may be immediately possible; indicating always with accuracy the place which the particular essay will or should take in the completed system.*(17.162–3)*

The confidence with which he rejects system, while all the time claiming that he could use it if he tried, is ominous.

Munera Pulveris certainly breaks down as a system. The third article is almost taken over by a footnote, as an image from *Unto this last* sets off a meditation on his recent reading: Homer, the Greek tragedians, Plato, Dante, Chaucer, Shakespeare, Goethe, Milton, Spenser, Herbert and Bacon, the whole held together by the patterns and associations he perceived. Such apparent digression pleased the editor of *Fraser's Magazine*, but not the publisher, who eventually stepped in, and his second attempt to change the economic thinking of his time, like the first, was brought short. When the articles were finally published in book form nine years later, they were introduced as 'the preface of the intended work'*(17.143)*, a work never to be completed.

Although Ruskin failed in rational terms to construct a political economy in *Munera Pulveris* based on the definitions of *Unto this last*, he did none the less take the argument a stage further. As he saw it, the fundamental problem of economics was the conflict between all those things which could be summed up as availing towards life, and all those things which meant destruction and death. To produce a positive programme from this analysis he had to find a means to resolve the conflict on the side of life. This mediating power was the principle of Justice, as outlined in *Unto this last*; but now Ruskin found a way to give the abstract principle a visual form: the image of kingship. This idea evolves from a footnote in *Unto this last*, where the important distinction is first drawn between Ruskinian justice and common-law justice, or equity. Ruskinian justice, righteousness, refers to an absolute standard of right and wrong; equity is no more than a balancing of interests. Thus, 'Righteousness, is King's justice, and Equity Judge's justice.' *(17.59n)* It is an absolute standard conveyed in the Bible, and the Biblical phrase 'sun of justice'*(17.59)* which triggered off this definition of kingship, made the essential connection in Ruskin's mind between this new idea and the scheme of light and dark.

Kingship dominates the latter half of *Munera Pulveris*. Those ideas of government which he had intended to convey through the ordered system of his opening pages burst out in a flower of associations. The principles governing charity

lead us into the discussion of the principles of government in general, and

especially of that of the poor by the rich, discovering how the Graciousness joined with the Greatness, or Love with Majestas, is the true Dei Gratia, or Divine Right, of every form and manner of King; *i.e.* specifically of the thrones, dominations, princedoms, virtues, and powers of the earth: – of the thrones, stable, or 'ruling', literally right doing powers ('rex eris, recte si facies') – of the dominations – lordly, edifying, dominant and harmonious powers; chiefly domestic, over the 'built thing', domus, or house; and inherently two-fold, Dominus and Domina; Lord and Lady . . . *(17.229)*.

The sentence continues, virtually no more than a series of rapid notes, for another seven lines, but the sketch contains all the elements of the image he needed to convey the absolute standard of justice that resolved the conflict of good and evil.

Kingship would not only hold back the bad, but act positively for good. 'Critic law' assigns rewards and punishments according to a man's worth (his true, not economic value); in its capacity as reward-giver, Critic law 'becomes truly Kingly, instead of Draconic . . . that is, it becomes the law of man and of life, instead of the worm and of death – both of these laws [of reward and punishment] being set in changeless poise one against another, and the enforcement of both being the eternal function of the lawgiver.'*(17.242–3)* Not surprisingly a stern kind of justice is proposed: 'The essential thing for all creatures is to be made to do right; how they are made to do it – by pleasant promises, or hard necessities, pathetic oratory, or the whip – is comparatively immaterial.'*(17.255)*

Kingship, while deriving its authority from eternal powers, is an essentially human agency, and has no specifically institutional form. Right education brings responsibility and authority, 'a power over the ill-guided and illiterate, which is, according to the measure of it, in the truest sense, *kingly'(18.109)*. The prudent peasant who is able to overcome a natural disaster and help his foolish neighbours without exploiting them 'has been throughout their true Lord and King'*(17.267)*. The organization of the masons who built the Gothic cathedrals expresses the same values of humility and justice. Ruskin was even prepared to appeal to the merchants of Bradford, whose commercial ethics he despised, as kings*(18.454)*. Moral leadership, from whatever source, would judge, guide, and substitute cooperation for competition. There is 'only one pure kind of kingship; an inevitable and eternal kind, crowned or not; the kingship, namely, which consists in a stronger moral state, and a truer thoughtful state, than that of others; enabling therefore, to guide, or to raise them'*(18.110)*.

It is not hard to find reasons for this choice of image. Ruskin's Evangelical background had always made him think in terms of God as a judging power; and the loss of formal belief did not remove the idea of a spiritual force which could judge and punish. It satisfied Ruskin's need for a sense of stability:

Observe that word 'State'; we have got into a loose way of using it. It means literally the standing and stability of a thing; and you have the full force of it in the derived word 'statue' – the 'immovable thing.' A king's majesty or 'state', then, and the right of his kingdom to be called a state, depends on the movelessness of both: – without tremor, without quiver of balance; established and enthroned upon a foundation of eternal law which nothing can alter, nor overthrow.*(18.110)*

Historically, Ruskin explained his Toryism as 'a most sincere love of kings, and dislike of everybody who attempted to disobey them' *(27.168)*, learnt from Homer and Sir Walter Scott. The Doges of Venice formed his ideal of an 'elective monarchy'*(9.19–23)*, and his analysis of the rise and fall of Venice in *St Mark's Rest* of 1877–84, a paradigm for the history of all states, revolves around the rise and corruption of kingly authority*(24.258)*. One group who most certainly did *not* contribute to his image of kingship were the contemporary rulers of the earth. Napoleon III, once admired, is severely criticized during the Franco-Prussian war for being 'a shadow of a King'*(27.172)*, 'a feeble Pan's pipe, or Charon's boatswain's whistle, instead of a true king'*(27.579)*.

Kingship fights on the side of good, and it is in this sense that Ruskin's views on war must be understood. At times he sounds a militant imperialist, praising the nobility earned in battle and the strength of nations raised in struggle, but this war is on the imaginative plane and has nothing to do with the actual wars of the nineteenth century. Modern war, 'scientific war, – chemical and mechanic war' *(18.472)*, was no more than the perfection of the methods of waste and destruction created by the capitalists. 'All unjust war being supportable, if not by pillage of the enemy, only by loans from capitalists, these loans are repaid by subsequent taxation of the people, who appear to have no will in the matter, the capitalists' will being the primary root of the war'*(17.104n)*. True, Ruskin wound up his inaugural lecture at Oxford in 1870 with an appeal to the youth of England to go forth and conquer the earth that sounds like an imperialist hymn (Cecil Rhodes found it an inspiration),[2] but his imagery shows that he was thinking in terms of a moral rather than economic dominion. 'Will you, youths

of England, make your country again a royal throne of kings; a sceptred isle, for all the world a source of light?'*(20.41)*

Kings and light point out once more the connection between the new image and the established theme of life against death, for in the moral war between good and bad, kingship will cause the light to push back the darkness. In the conclusion to *Sesame and Lilies* (1865), the imagery of the Resurrection is used to show how the conflict will be resolved; in the same way he appeals to the Arthurian legend of a tomb of sleeping kings who will return to life when the call is given to restore England to rights.

Kingship, as it evolves from a footnote in *Unto this last* through *Munera Pulveris* to *Sesame and Lilies*, is the resolution of the original struggle, but Ruskin's creative imagination does not stop there. The image of kingship divides into two parts, just as *Sesame and Lilies* is divided into two lectures. The title of the first lecture, 'Of Kings' Treasuries', displays one side of the ideal of government; the second, 'Of Queens' Gardens', reveals the other.

Kingship is associated with war and judgment; Queenship tempers masculine leadership with feminine compassion: 'it is a *guiding*, not a determining, function'*(18.121)*. The view of women portrayed by Ruskin in 'Of Queens' Gardens' is a decidedly Victorian one,[3] but that does not stop him appealing to women to take up their responsibilities and restore the polluted garden of England to its proper beauty. Women, by failing to act as guides to men, are as responsible as men for the wrongs that are done: 'There is not a war in the world, no, nor an injustice, but you women are answerable for it.'*(18.140)* The beauty of woman's private pleasure-garden is contrasted with the destruction around it: 'Outside of that little rose-covered wall, the wild grass, to the horizon, is torn up by the agony of men, and beat level by the drift of their life-blood.'*(18.141)*

As the themes of kingship and queenship evolve they develop beyond the immediately 'political' context until they represent vital spiritual values. Queenship is at its most developed in a book whose title is, again, an image of the whole, *The Queen of the Air* (1869). This short work is in many ways the most typical – and the most delightful – of Ruskin's late works. His own attitude towards it was predictably contradictory: he presented it as 'desultory memoranda on a most noble subject'*(19.291)* and yet also thought it 'the best I ever wrote'*(37.86)*. The text is made up from six different sources, plus some unpublished fragments, and was never properly edited.[4] 'This work has grown under my hands so'*(36.563)*, he complained, shortly before abandoning the

half-corrected text to the printers. The ostensible subject was 'a study of the Greek myths of cloud and storm'*(19.284)*, but Ruskin moves from mythology to botany to art criticism, economics, moral philosophy and colour theory, before returning to Greek art. In the process Ruskin retains a firm grip on the reality of the physical world, and at the same time moves far beyond it into mystical realms of thought.

The Queen of the Air is about myth, but the real subject is the imagination, Ruskin's own imaginative process which transformed the physical facts of the world into symbols. It is the operation of those three orders of truth discussed in Chapter 3 – the truth of natural fact, the truth of thought and the truth of symbol – but the third, symbolic, level is much more extended and much more overt. The imaginative process is now also working in two directions at once: at the same time as interpreting the 'Greek myths of Cloud and Storm', using the critical techniques which revealed the meaning of Turner's *Apollo and Python*, Ruskin was also creating a new poetic structure, his own personal mythology, derived from those physical phenomena to which he attributed the source of myths.[5] The myth-making goes back even further, beyond the discovery of the symbolic imagination necessary to understand Turner, to his original inspiration, the beauty of the natural world. In 'all the most beautiful and enduring myths, we shall find, not only a literal story of a real person, – not only a parallel imagery of moral principle, – but an underlying worship of natural phenomena, out of which both have sprung, and in which both remain forever rooted'*(19.300)*.

The three orders of truth of *Modern Painters* become 'these three structural parts' of myth, 'the root and two branches: – the root, in physical existence, in sun, or sky, or cloud, or sea; then the personal incarnation of that; becoming a trusted and companionable deity . . . and lastly, the moral significance of the image, which is in all the great myths eternally and beneficently true'*(19.300)*.

It is important to remember that the stress on the physical as well as the moral significance of the image meant that Ruskin always returned to reality and real things, however mystical some of his flights might seem. The study of Plato led him to think of the world as a temporal expression of something absolute and eternal, but his Evangelical training was a valuable corrective to pure Idealism. The Evangelicals, while not denying that the world was a symbol of God's will, maintained that it was also his physical creation, and therefore really existed.[6] As a result Ruskin does not treat myth as a form of allegory (in the sense that one thing is taken simply to stand for another

with no more real existence than an algebraic term) but as an expression of the interchange between phenomenal reality and eternity.

The sum of all is, that over the entire surface of the earth and its waters, as influenced by the power of the air under solar light, there is developed a series of changing forms, in clouds, plants, and animals, all of which have reference in their action, or nature, to the human intelligence that perceives them; and on which, in their aspects of horror and beauty, and their qualities of good and evil, there is engraved a series of myths, or words of the forming power, which, according to the true passion and energy of the human race, they have been enabled to read into religion. And this forming power has been by all nations partly confused with the breath of air through which it acts, and partly understood as a creative wisdom, proceeding from the Supreme Deity; but entering into and inspiring all intelligences that work in harmony with Him. And whatever intellectual results may be in modern days obtained by regarding this effluence only as a motion or vibration, every formative human art hitherto, and the best states of human happiness and order, have depended on the apprehension of its mystery (which is certain), and of its personality which is probable.*(19.378)*

This 'forming power', be it scientifically interpreted as oxygen, or spiritually read as the life force, is identified (ill. 36) as Athena,

physically the queen of the air; having supreme power both over its blessings of calm, and wrath of storm; and spiritually, she is the queen of the breath of man, first by the bodily breathing which is life to his blood, and strength to his arm in battle, and then of mental breathing, or inspiration, which is his moral health and habitual wisdom; wisdom of conduct and of the heart, as opposed to the wisdom of imagination and the brain; moral, as distinct from intellectual; inspired, as distinct from illuminated*(19.305)*.

These oppositions show Athena taking her place beside the masculine image of kingship, exercising her particular virtues of 'Justice, or noble passion, and Fortitude, or noble patience'*(19.307)*. Athena is 'the queen of maidenhood – stainless as the air of heaven'*(19.307)*, and Ruskin draws a specific parallel with the Christian Madonna*(19.347)*. But even beyond the king-queen relationship there are oppositions within the symbol which represent a further stage of evolution. 'In her justice, which is the dominant virtue, she wears two robes, one of light and one of darkness'*(19.306)*: Athena represents compassion, but also passionate anger, and her Gorgon shield has the power of death. Death has its own Queen, Proserpine, 'the Queen of Fate – not merely of death, but of the gloom which closes over and ends, not beauty only, but sin'*(19.304)*.

Athena takes her place in the structure of Ruskin's imagery as 'the Spirit of Life'*(19.346)*, whether as a physical force in the earth or air, or as wisdom in mankind. The specific image of Athena is dissolved into the air with which he associates her, he discusses her presence as breath, as fire, as heat, and the emphasis on the scientific aspects of hearing and plant-growth shows that concern for natural fact which prevents his assertions becoming merely fanciful allegory. Having derived the myth of Athena from the attitude of the Greeks to their blue skies and shown her place in his symbolism, Ruskin then traces Athena back to natural phenomena, to animals, flowers, and finally to colour itself – where another kind of abstraction begins. Two creatures in particular are associated with her, the bird and the snake. The bird, he writes, *is* Athena as it is the air, 'the wild form of the cloud closed into the perfect form of the bird's wings', and it becomes 'through twenty centuries, the symbol of Divine help'*(19.360-1)*; thus the bird is a natural fact, a visual expression of Athena's spirit, and a religious hieroglyph.

The serpent is a counter-image to the bird, and yet there is even a duality within the nature of the serpent, for Ruskin was well aware that the snake was a symbol of purification in Greek mythology, as well as a symbol of evil. The Greek purification myth has been overlaid by that of the snake of the Garden of Eden, and Ruskin in general takes the serpent in its evil form. But though he recognizes the archetype, he questions the association of death with what his descriptions and paintings show he believed to be a beautiful creature.[7] 'Why that horror? . . . There is more poison in an ill-kept drain, – in a pool of dish-washings at a cottage door, – than in the deadliest asp of Nile. Every back-yard which you look down into from the railway, as it carries you out by Vauxhall or Deptford, holds its coiled serpent.' *(19.362)* Ruskin was fascinated by snakes – and he seems to have recognized their psychological significance. James Fergusson's *Tree and Serpent Worship*, which he used in his research, hints at the connection of snakes with phallic worship,[8] and the serpent dreams which he noted in his diary around this time are plainly erotic. He himself commented that these dreams were 'partly mental evil taking that form'*(D2.685)*.

Athena manifests herself through animals and plants, and also without form at all, as pure colour. Colour is associated, as could be expected, with light and sight. 'We have first to note the meaning of the principle epithet applied to Athena, "Glaukopis", "with eyes full of light". . . . As far as I can trace the colour perception of the Greeks, I find it all founded primarily in the degree of connection between

colour and light.'*(19.379)* Athena's robes are light blue and dark blue, the light blue representing luminosity rather than pigmented colour, the dark, the dark side of her character. Nine different shades of red are to be discovered in the generalized 'purple' of Homer, 'so that the word is really a liquid prism, and stream of opal'*(19.380)*.

Colour, particularly in the form of jewels, takes on a spiritual quality as a contemplative object, foreshadowing the system of colour symbolism he was to develop linking geology, heraldry and botany. Turner's 'colour beginnings' had finally set Ruskin on the path of art criticism, and now pure colour was celebrated in its own right:

If you think carefully of the meaning and character which is now enough illustrated for you in each of these colours; and remember that the crocus-colour and the purple were both of them developments, in opposite directions, of the great central idea of fire-colour, or scarlet, you will see that this form of the creative spirit of the earth is conceived as robed in the blue, and purple, and scarlet, the white, and the gold, which have been recognized for the sacred chord of colours*(19.383–4)*.

Athena's colours are the 'blue, and purple, and scarlet' called for by God from Moses in Exodus 25 : 4, the blue associated iconographically with the Madonna, and the colours of the dawn.

Queenship becomes one more resonating chord of associations in Ruskin's writings – from the description of Venice as 'the Sea-Queen' *(24.233)*, to sculpture as the 'queenliest of arts'*(20.263)*, or as a feminine element in his episcopal system for the Guild of St George: 'a queenly power . . . with Norman caps for mitres, and for symbol of authority instead of the crozier . . . the broom'*(28.513)*. But the passion with which he describes the Queen of the Air as the unifying source of wisdom and beauty shows the menace he felt from another grimmer image – a new theme, and a symptom of Ruskin's coming madness.

The natural phenomena transformed by the Greek myths into the Harpies and the Sirens are not under the control of Athena. There is a 'sense of provocation and apparent bitterness of purpose' in the foul south winds and squalls which Ruskin personalizes as the Harpies; explaining their 'mental' meaning, he hardly disguises his emotions confronted by the frustration of his message going unheard: 'they are the gusts of vexatious, fretful, lawless passion, vain and over-shadowing, discontented and lamenting, meagre and insane, – spirits of wasted energy, and wandering disease, and unappeased famine, and unsatisfied

hope'*(19.314)*. The emotional pressure is intense, heightened by the private pain revealed in his reading of the Siren myth: they are 'the great constant desires – the infinite sicknesses of heart – which, rightly placed, give life, and, wrongly placed, waste it away'*(19.315)*.

There is a note of despair in Ruskin's preface to *The Queen of the Air* which shows his attitude to nature changing yet again.

I have seen strange evil brought upon every scene that I best loved, or tried to make beloved by others. The light which once flushed those pale summits with its rose at dawn, and purple at sunset, is now umbered and faint; the air which once inlaid the clefts of all their golden crags with azure is now defiled with languid coils of smoke, belched from worse than volcanic fires. . . . The light, the air, the waters, all defiled!*(19.293)*

The serpentine coils of smoke blew up into a black cloud, which, driven by a Harpy's wind, began to blot out Ruskin's perception of God in Nature. At first the cloud is associated with disappointment and failure, the theme of a lecture given in Dublin in May 1868, 'The Mystery of Life and its Arts'. The central image is the cloud, which is deliberately associated with the clouds that occupied so much space in *Modern Painters*. Now there is another kind of cloud, 'the bright cloud of which it is written – "What is your life? It is even as a vapour that appeareth for a little time, and then vanisheth away." '*(18.146)* Ruskin's own answer is that his life to date had been a disappointment (there were strong personal reasons for him to think so, as we shall see): 'It became to me not a painted cloud but a terrible and impenetrable one: not a mirage, which vanished as I drew near, but a pillar of darkness.'*(18.151)* He confesses what he considered were his failures with Turner, with architecture, with his inability to change men's hearts, or find any comfort in the work of those who had gone before him. Symbolically, when a new edition of the Kingship and Queenship lectures of *Sesame and Lilies* was published in 1871, Ruskin added 'The Mystery of Life and its Arts', as though its gathering clouds threatened the themes of leadership of the other two.

The dark cloud is more than a sign of the loss of faith in nature; this new form of Mountain Gloom is an active force of evil. Increasingly it is a sign of Ruskin's psychological state. In the summer of 1871 he was severely ill with some kind of nervous disorder and suffering terrible dreams*(22.444–7)*. Shortly afterwards he announced in *Fors Clavigera* that he had perceived a change in nature. All that year the sky had been covered with 'a dry black veil, which no ray of sunshine can pierce . . . and it is a new thing to me, and a very dreadful one'*(27.132–3)*.

This is the plague wind that blows with increasing intensity through Ruskin's mind, and his description of it is a surreal combination of the facts of industrial pollution and mental instability. The cloud

looks partly as if it were made of poisonous smoke; very possibly it may be: there are at least two hundred furnace chimneys in a square of two miles on every side of me. But mere smoke would not blow to and fro in that wild way. It looks more to me as if it were made of dead men's souls – such of them as are not gone yet, where they have to go, and may be flitting hither and thither, doubting, themselves, of the fittest place for them. . . . You may laugh, if you like. I don't believe any one of you would like to live in a room with a murdered man in the cupboard, however well preserved chemically; – even with a sunflower growing out at the top of his head.*(27.133)*

The structure of symbolism is almost complete. Death is opposed by kingship and queenship; queenship is the creative spirit of life and light informing all nature, but nature is threatened by a black plague wind that would blot out the light if it could. Ruskin was to be thrown between these opposing images with increasing violence, until at the end he was writing a pellucid, crystalline autobiography between bursts of violent madness.

The stress revealed by Ruskin's plague-wind obsession was not entirely due to his sense of public failure. The frustration was also deeply personal: for ten years his delicate mental balance had been disturbed by a disastrous love affair. As with his marriage, there is no space to go into detail, but the public and personal themes become so intertwined that some explanation must be given. In 1858 Ruskin was asked by Mrs John La Touche, an Anglo-Irish woman of good family and some literary pretensions, to give drawing lessons to her children. The youngest daughter, Rose, was then nine and a half*(35.525)*. By 1861 Ruskin was clearly infatuated with this symbol of innocence; it is as though his affections, frozen in adolescence by the trauma of Adèle Domecq, and only briefly warmed by his wife, suddenly started to flow again. Rose could hardly have been a worse choice. The family was Irish Protestant, the father being an Evangelical (Ruskin made the mistake of confessing his religious doubts to Mrs La Touche in 1861) *(34.662)*; Rose herself was mentally unstable. By 1863 he was well aware of the difficulties. He told his friend Charles Eliot Norton about his

pet, Rosie . . . she canonized me once, but mourns over my present state of mind, which she has managed to find out somehow . . . she has been scolding

me frightfully, and says, 'How could one love you, if you were a Pagan?' She was a marvellous little thing when she was younger, but . . . there came on some over excitement of the brain, causing occasional loss of consciousness, and now she often seems only half herself, as if partly dreaming*(LN1.138)*.

The result was an agonizing pattern of brief sunny interludes of happiness together followed by long periods of increasing pain.

At Christmas 1863 Rose was ill, 'driven mad by religion',[9] an illness which continued throughout 1864. Ruskin's obsession only grew worse, and in February 1866 he proposed marriage. Rose did not refuse; instead she asked him to wait three years for an answer. The La Touche parents were alarmed and tried to separate them. In 1867 Rose was so violently ill that she had to be strapped to her bed. The following year Ruskin's hopes of seeing her in Dublin when he gave his lecture 'The Mystery of Life and its Arts' were dashed when she failed to appear, the private disappointment only serving to reinforce the public despair of the lecture. The La Touches made legal enquiries about Ruskin's first marriage. He protested, 'I will take her for Wife – for Child, – for Queen – for any Shape of fellow-spirit that her soul can wear, if only she will be loyal to me with her love. But if not – let her go her way, and stain every stone of it with my blood upon her feet, for ever. Mine will be shorter – the Night is Far Spent.'*(LMT139)*

In 1870 there was another reconciliation, followed by another interference from Rose's parents. The La Touches were afraid that if Ruskin did remarry, and there was a child, then his divorce from Effie on the grounds of impotence would be null and void, and therefore he and Rose would be married bigamously. Mrs La Touche again sought the advice of Effie, now Mrs Millais, who had first been contacted two years before. Effie was merciless: 'His conduct can only be excused on the score of madness. . . . His conduct to me was impure in the highest degree. . . . From his peculiar nature he is utterly incapable of making a woman happy. He is quite unnatural and in that one thing all the rest is embraced.'[10] Eventually Effie's opinion was passed on to Rose. Ruskin fought back with legal and medical opinion but the strain was intense. It was after painting a spray of roses (ill. 40) that he collapsed with the plague-wind sickness of 1871.[11]

The tragedy dragged on, with more ecstatic moments of happiness, followed by greater desperation, as Rose became more and more ill. Ruskin's feelings had to come out in his work, sometimes as an almost direct confession, sometimes disguised in word-play around Rose's name. In February 1875, the month he saw Rose for the last time, he

published this: 'Being very fond of pretty little girls (not, by any means, excluding pretty – tall ones) I choose for my own reading a pamphlet which has a picture of a beautiful little girl with long hair, lying very ill in bed.'(28.257) The illustration bears a strong resemblance to a drawing by Ruskin of what is probably Rose on her sickbed (ills 38–39). But whereas the girl in the children's story recovered, Rose died on 26 May 1875. Ruskin 'was away into the meadows, to see buttercup and clover and bean blossom, when the news came that the little story of my wild Rose was ended, and the hawthorn blossoms, this year, would fall – over her.'(37.168)

Death, however, was not the end of the story. One of his friends, who had acted as confidante and go-between, Mrs Cowper-Temple, followed the contemporary fashion for spiritualism.[12] Ruskin had taken part in séances in 1863 and 1864 without becoming committed to the movement, but his references to Athena as 'effluence' or 'vibration' in *The Queen of the Air*(19.378) do have strong spiritualist overtones. Mrs Cowper-Temple's house, Broadlands, had been one of the few places where he and Rose had been able to meet. Six months after Rose died, in December 1875, he was again at Broadlands, and more than one spiritualist lady was in the party. Through one of them, Mrs Ackworth, he became convinced that Rose was still in touch. In a letter written shortly after he left Broadlands he described the following conversation, held in the very room where he and Rose had been so happy.

[R:] 'Have you seen any spirits lately?'

'There was one close beside you as you were talking of women, last night', said Mrs Ackworth.

'What like?' said I

'Young – very tall and graceful and fair – she was stooping down over you, almost speaking into your ear – as if trying to stop you.'

R: 'Why to stop me? could you guess?'

Mrs A: 'she seemed pained by what you were saying.'

R: 'Pained – or displeased? as if what I said was wrong?'

Mrs A: 'Pained, as if she had been wrong herself and was reproaching herself. She put her hand to her head she does that very often.'

R: 'Very often! then have you seen her before?'

Mrs A: 'Yes, she came into the room with Mrs Temple the other day; and I asked Mrs Temple who it could be. [Mrs Cowper-Temple did not know, and asked if the girl had been married or not.]

Mrs A: ' . . . afterwards I asked the girl herself if she had been married and she said – No.'

R: 'You asked her! How?'

Mrs A: 'I was able to ask that, but she cannot speak much, yet – she has not been long in the spirit world – I think – probably not a year.'

R: 'No – not a year. She died in May.'

Mrs A: 'You know who it is then? – '

R: 'Yes, well enough – and how Mrs Temple didn't I can't think –'

Then people came into the room.[13]

The experience seems to have cheered Ruskin and given him hope, but it was a dangerous way to deal with grief. In the following year, 1876, he was in Venice, and as the anniversary of the Broadlands 'teachings' *(D3.927)* approached he hoped that this time Rose would speak to him directly. He was studying Carpaccio, whose cycle of paintings illustrating the St Ursula legend had first caught his attention in 1869. The story of St Ursula relates how a king's daughter is betrothed to the pagan son of the King of England. St Ursula will marry the prince after she has made a three years' pilgrimage, during which time he will have become a Christian. St Ursula, however, dies a virgin when she and her attendants are martyred. The 'Pagan' Ruskin had been told to wait three years for Rose's answer to his proposal of marriage; Rose had died a virgin. It is not surprising that Rose and St Ursula became identified in his mind. Locked in a room at the Venetian Academy he copied *St Ursula's Dream* – again, a young girl lying in bed (ill. 37).

On 24 December events coincided to convince him that St Ursula had sent him a message from Rose. One of 'St Ursula's flowers', a sprig of dried vervain, arrived from England, and in another packet came a letter from Mrs La Touche to Joan Severn.[14] As a response to what he felt were Rose's promptings, he decided to forgive Mrs La Touche for what she had done. On his return from the Academy that night he found a pot of carnations like those on St Ursula's window-sill in his room*(D3.921–2)*. It seemed to be a sign of approval from Rose. These 'teachings', whose real nature can only be guessed at from the diary entries, continued into January 1877.

The 'most overwhelming evidence of the other state of the world' *(D3.876)* presented by these experiences convinced Ruskin of the possibility of there being a life beyond the grave after all. He sought to explain the gradual change in a fragment of autobiography written for *Fors Clavigera*. The spiritual happenings are specifically linked to a change in his views on art; together they were the two 'vital causes' of the renewed religious tone in his work. The first was that ' "such things

have befallen me" personally, which have taught me much, but of which I need not at present speak; the second, that in the work I did at Assisi in 1874, I discovered a fallacy which had underlain all my art teaching . . . since the year 1858'(29.86).

The personal events alluded to are the communications from Rose La Touche; the change in his view of art had begun two years before. From his unconversion at Turin in 1858 until he started work in the cathedral of St Francis at Assisi in 1874 he had believed that the worldly painters – Titian, Tintoretto, Veronese – had more to say to men because they accepted life as it was, without reference to other worlds. Their technical superiority over Giotto, Cimabue and Angelico in rendering physical fact reinforced a preference for those who acknowledged that 'we are now Men; – whether we ever expect to be angels, or ever were slugs, being practically no matter'(29.88). But the study of Cimabue and Giotto in Assisi changed his ideas on early Italian art. One picture in particular caught his attention, a fresco in the lower church then attributed to Giotto, *The Marriage of Poverty and St Francis* (ill. 35). Rose was still alive in 1874, and does not seem to have been far from his thoughts. Giotto is 'so confoundedly personal to me. One of the things I want to do myself is his Lady Poverty, and she has her head in a thicket of pale red and deep red roses, and just on the wall next her there's "Penitence" driving away Love, and Death, at least AMOR and MORS. Giotto always put KARITAS for real love'(37.109).

Clearly, the personal significance of the painting colours Ruskin's perception of it, but the conversion to religious painting was none the less genuine. He was perfectly capable of explaining the change of view in critical terms:

I found that all Giotto's 'weaknesses' (so-called) were merely absences of material science. He did not know, and could not, in his day, so much of perspective as Titian, – so much of the laws of light and shade, or so much of technical composition. But I found he was in the make of him, and contents, a very much stronger and greater man than Titian; that the things I had fancied easy in his work, because they were so unpretending and simple, were nevertheless entirely inimitable(29.91).

He now saw a complete continuity in Western art, from the Greeks to Cimabue and Giotto and the Venetians, broken only by the corruption of the Renaissance(15.345), and still present in Velázquez, Reynolds, Gainsborough and Turner(29.89). When Ruskin came to lecture on art at Oxford in the 1870s, the period 1300–1500 has far greater importance than before. The distinction was now between 'worshippers

of Worldly visible Truth', the second order of truth of *Modern Painters*, and 'worshippers . . . of a visionary one' *(29.89)*, that higher imaginative truth that transcends the facts of art, and (in Ruskin's case at least) dissolves the distinction between personal and universal significance. All great artists become 'the Sign-painters of God' *(22.392n)*.

Ruskin's critical theories come full circle – or become complete. Lecturing on *Modern Painters* in 1877 he described it as an Aladdin's palace which had been left with one window unfilled; now he knew what should go there. In his middle years he had regretted the Evangelical tone of *Modern Painters* 2, but now,

Looking back, I find that, though all its Turner work was right and good, the essential business of the book was quite beyond that, and one I had never thought of. I had been as a faithful scribe, writing words I knew not the force of or final intent. I find now the main value of the book to be exactly in that systematic scheme of it which I had despised, and in the very adoption of insistence upon the Greek term Theoria, instead of sight or perception, in which I had thought myself perhaps uselessly or affectedly refined.*(22.512)*

Freed of conventional religion, Ruskin was yet able to reunite himself with the spiritual sources of energy institutionalized in religion; faith was again possible, and art confirmed the holiness of man and nature.

Before, faith had led him to art; now art led him back to faith. At Easter 1875 he wrote a long meditation on the Eighth Psalm.

The entire purport of the Psalm is that the Name, or *knowledge*, of God was admirable to David, and the power and kingship of God, recognizable to him, through the power and kingship of man. . . . And that final purport of the Psalm is evermore infallibly true, – namely, that when men rule the earth rightly, and feel the power of their own souls over it, and its creatures, as a beneficent and authoritative one, they recognise the power of higher spirits also; and the Name of God becomes 'hallowed' to them.*(28.328)*

The image of kingship, created to give form to ideas of human government, now drew him back to ideas of the Divine.

It is tragic that Ruskin's return to the sense of faith should have been achieved at such cost, and that it finally proved impossible to keep the oppositions between private and public obsessions in balance. It does not seem to matter how strongly they pulled against each other, as long as the stress was even, but in the end the personal strain became unendurable: '*Mere* overwork or worry might have soon ended me, but it would not have driven me crazy. I went crazy about St Ursula and the

other saints, – chiefly young-lady saints, – and I rather suppose I had offended the less pretty Fors Atropos, till she lost her temper.' *(LN2.148–9)* The black plague wind continued to disturb him, and the manic tone in his writing becomes more frequent, sometimes bursting out in a scream of anger at

the daily more bestial English mob, – railroad born and bred, which drags itself about the black world it has withered under its breath, in one eternal grind and shriek, – gobbling, – staring, – chattering, – giggling, – trampling out every vestige of national honour and domestic peace, wherever it sets the staggering hoof of it; incapable of reading, of hearing, of thinking, of looking, – capable only of greed for money, lust for food, pride of dress, and the prurient itch of momentary curiosity for the politics last announced by the newsmonger, and the religion last rolled by the chemist into electuary for the dead.*(22.469–70)*

To divert himself from this vision of hell he invented fantastical schemes for Rose-Queens, or devised costumes for the members of his utopia, but even here he could not disguise the state of his mind: 'You think I jest, still, do you? Anything but that; only if I took off my Harlequin's mask for a moment, you would say I was simply mad.' *(28.513)*

In the end, he did go mad. At Christmas 1877, the second anniversary of Broadlands, he wrote in his diary: 'My star-letter was sent to me again last night, for which I am thankful; but very lifeless compared to this time last year.'*(D3.970)* At the end of February his mind gave way completely, and the final cycle of opposites, of sanity and madness, began.

7 Action

'To dress the earth, and keep it'

RUSKIN'S first bout of madness, though violent, did not last very long. By April 1878 he was able to write letters again, and he resumed production of books, articles, and lectures, and continued with his programme of action. He did not finally withdraw from public life until 1889. The last years left to him for work were broken by attacks of mania, and his proliferating schemes and projects were left confused and incomplete. But to the last an underlying coherence remains, carried by the structure of Ruskin's imagery. These images are not only to be read in terms of literary or psychological significance; for Ruskin they were perfectly real. He was a materialist; for him meaning began in matter, and could only be properly expressed in matter. He saw an image in external reality, and read it iconographically, but he also took the symbol and tried to express its significance in a visible and tactile form, not just in pictures, but in things – buildings, institutions, and restored land. It was insufficient to create an image of kingship; it must also be translated into action, where the 'moral significance of the image' could be seen in practice.

Ruskin had long believed that action was the necessary outcome of thought. In the 1850s he had taught drawing at the Working Men's College in London, and there had been his involvement with the building of the Natural History Museum in Oxford. In 1854 he wrote that he was 'rolling projects over and over' in his head. He wanted to lecture workmen and craftsmen and schoolteachers and young men and women in general. He wanted to have prayer books handwritten again (having had the liturgy rewritten), and 'explode printing, and gunpowder – the great curses of the age'. He wanted to lend out Turner engravings and have thirteenth-century missals copied, and found Art Galleries and schools: 'And as all this is merely by the way, while I go on with my usual work about Turner, and collect materials for a great work I mean to write on politics – founded on the thirteenth century – I shall have plenty to do when I get home.'*(36.175–6)* He was joking,

but what is remarkable is that he did eventually manage to do all these things.

The schemes, projects and buildings were the final expression of his arguments. The concentration on the physical in the later part of Ruskin's life, the attempt to make his theories concrete in practice, is a continuation of the visual arguments which he had always used. But the argument was no longer held static in the picture frame; it was material, three-dimensional, it was 'life', because it depended on people and land, not inanimate objects. Where Carlyle preached, Ruskin acted. Ruskin's favourite image of clear, sparkling streams as a symbol of the purified waters of life did not stay a literary idea on the printed page: he paid to have a stream cleaned at Carshalton in Surrey, as a memorial to his mother.

Some of the projects seemed absurd: employing street cleaners in St Giles in London, setting up two retired servants in a shop to sell tea at honest prices. The road-building project for Oxford undergraduates at Hinksey has been treated as a joke, and not as the serious propaganda exercise it really was.[1] Other work was more successful: the help given to Octavia Hill's housing scheme, for example, or his almost single-handed revolutionizing of the system of bookselling. He also worked hard at other people's projects – the committee to defend Governor Eyre in 1866, the Mansion House Committee to aid Paris during the Franco-Prussian war. When his artistic principles were challenged at law, by Whistler's suit for libel in 1877, he was delighted by the prospect of a court-room drama which would enable him 'to assert some principles of art economy which I've never got into the public's head, by writing, but may get sent all over the world vividly in a newspaper report or two'*(29.xxii)*.

Ruskin felt a pressing need to be known by works as well as faith. His conscience was tried by the contrast between his own wealth and comfort and the miseries of industrial Britain. There was also the need for distraction from personal unhappiness, to release pain and frustrated emotion. As the contradictions in his private life became more extreme, work was one way of staving off madness. But action brought with it its own opposition, the contrast between what was aimed for and what was achieved. Two themes are in perpetual counterpoint: his view of himself as a man of action, and his desire to be free of responsibilities. In 1874 he described 'the intensely practical and matter-of-fact character of my own mind as opposed to the loquacious and speculative disposition, not only of the British public, but of all my quondam friends. I am left utterly stranded, and alone, in life, and thought'*(28.14)*. And

yet later: 'I can only do what seems to me necessary, none else coming forward to do it. For my own part, I entirely hate the whole business; I dislike having either power or responsibility; am ashamed to ask for money, and plagued in spending it.'(28.22) This view of himself as a man alone and misunderstood contributed to the desire to speak through action. After outlining one of his more elaborate and impractical schemes for a utopian society, he concluded, 'the day has come for me therefore to cease speaking, and begin doing, as best I may'(28.425-6).

Not, however, that he ever actually gave in to the temptation 'to try and do what seems to me rational, silently; and to speak no more' (27.353). His output was prodigious, but the concentration on action also led to dissipation of energy. This is true of both schemes and writings: there were too many projects, too many decisions to be made; and since, in the end, Ruskin's programme depended on a complete re-ordering of the system of knowledge, there were too many books to be written. But it would be a mistake to expect him to operate in a manner he specifically rejected. His own attitude to the success or failure of the schemes will become clear. And, in however distorted a form, his two most important projects survive: the Ruskin School of Drawing at Oxford, and the Guild of St George.

In 1869 Ruskin was elected the first Slade Professor of Art at Oxford University. This was a new appointment, made under a bequest from Felix Slade, who had left money to found Professorships in Fine Art at Oxford, Cambridge, and University College, London. Ruskin's appointment was a belated recognition of the position he had built up independently of any institution, and it undoubtedly helped to give form and purpose to his work. His attitude was, as it had always been, that 'the teaching of Art . . . is the teaching of all things'(29.86), and from his inaugural lectures in 1871 onwards he did not fail to set his specific art criticism in its social context. He might sometimes lull his audience with the vagaries of thirteenth-century Italian history – but then he would shock them by describing Oxford as a 'dunghill'(22.206), or accuse each of his gentlemen listeners of readiness 'to kill any quantity of children by disease to increase his rents, as unconcernedly as he will eat any quantity of mutton'(23.144). A sense of social mission gave him the courage to claim: 'I am, I believe, the only person here in Oxford who says he has got something entirely definite to teach.'(22.507)

The function of the Professorship as Ruskin saw it was to establish 'a practical and critical school of fine art for English gentlemen: practical, so that, if they draw at all, they may draw rightly; and critical,

so that, being first directed to such works of existing art as will best reward their study, they may afterwards make their patronage of living artists delightful to themselves'(20.27). The critical aspect was catered for in the Professor's lectures, the practical by the foundation of a drawing school. With this two-edged attack he hoped to awaken the interest of Oxford undergraduates 'in a study which they have hitherto found unattractive, and imagined to be useless'(20.193).

The Ruskin School of Drawing was intended as a practical criticism of art education in Britain.[2] There were at that time two kinds of instruction available to the would-be professional: a fine art training in the Royal Academy school, or a design training in the government schools run by the Department of Science and Art. Outside the public institutions there existed private academies for amateurs, future drawing masters, and those who wanted to prepare for the Academy School; and Mechanics' Institutes for artisans, or the more ambitious Working Men's Colleges, such as the one in London where Ruskin had taught. Ruskin had long protested at the classicism of the cast room and life class of the Royal Academy; in the Edinburgh lectures of 1854 he had given a graphic account of the Pre-Raphaelites' reception by their fellow Academy pupils when they tried to bring fresh ideas of truth to nature into their work(12.155-7). In 1863 he gave evidence before a commission investigating the Royal Academy. Asked to estimate the influence of the Academy School on the art of the country he replied: 'Nearly nugatory: exceedingly painful in this respect, that the teaching of the Academy separates, as the whole idea of the country separates, the notion of art-education from other education'. This was the key point, that art must not be an exclusive but an inclusive activity; and he sketched a scheme for the commissioners, treating art training in the context of a complete liberal education, 'corresponding wholly to the university education'(14.479-80). The Slade Professorship was the ideal opportunity to unite art, science and liberal studies.

Ruskin's chief target, however, was the government design schools, known as the South Kensington system because of the location of the central school. He had been campaigning against the government schools since the 1850s, when he had attacked the concept of a separate industrial training in *The Two Paths*. Far more than the Academy, he felt that the government scheme, because of its wider influence on popular taste, had 'corrupted the system of art-teaching all over England into a state of abortion and falsehood from which it will take twenty years to recover'(29.154). Art training had first been instituted at public expense in 1837 with the purely financial motive of breaking the

monopoly of the Continental designs used by British manufacturers. In 1852 a civil servant, Henry Cole, who had made his reputation through his work as a Commissioner for the Great Exhibition of 1851, began a reorganization and massive expansion of the design schools. The course was run on strictly utilitarian lines, and adapted to teach schoolchildren and general students as well as designers and engineers. The system fed upon itself, since many of the pupils became art teachers in the proliferating provincial art schools. The course was numbingly rigid: 'straight lines', said Cole, 'are a national want.'[3] Drawing was treated as though it could be learned like the alphabet, beginning with geometrical shapes on the diagrammatic flat, and then slowly advancing through painstaking copies of specially printed examples, to limited light and shade drawings of casts of ornament and sculpture. All progress was by competitive examination.

Ruskin objected to the government scheme for the same reasons as he objected to the fine art training of the Academy; it made no effort to involve the student in anything more than a technical method. Further, it not only separated the students from a general education; it separated the designer from the artist. Discussing his own proposals he consciously called all creative workers – 'potters, weavers, metal and glass workers, sculptors and painters' – artisans(*21.xx*). Since good design could only be produced by artists working in a noble society, the South Kensington system was training in a vacuum, cut off from art, and oblivious of the social context and moral obligations of design. In *The Two Paths* he had warned that good design was impossible 'so long as you don't surround your men with happy influences and beautiful things'(*16.341*). What was true of design was true of all art, and the constant theme of the Oxford lectures became

you cannot, without the realities, have the pictures. *You cannot have a landscape by Turner, without a country for him to paint; you cannot have a portrait by Titian, without a man to be portrayed.* . . . I can get no soul to believe that the beginning of art *is in getting our country clean, and our people beautiful.*(*20.107*)

A government design school had been using part of the Oxford University Galleries (now incorporated in the Ashmolean Museum) since 1865. In September 1871 Ruskin announced that, having watched it at work for two years, he had become 'finally convinced that it fell short of its objects in more than one particular: and I have, therefore, obtained permission to found a separate Mastership of Drawing' (*27.159*). The University accepted his endowment of £5,000 and allowed him to take over the West Wing of the University Galleries.

The government art master, Alexander MacDonald, became first Ruskin Master of Drawing. This appointment may seem curious in the light of Ruskin's views on South Kensington, but MacDonald, though government trained, had clashed with Cole during the 'art-teachers' revolt' in 1863–64, and gave evidence of the restrictive conditions at South Kensington to a Parliamentary enquiry.[4] Although driven down into the basement, the government course was continued as an evening class by MacDonald, and Ruskin was gracious enough to welcome the presence of this 'elementary school for artisans', although he stressed that he was 'not responsible for any methods of art-education relating to manufactures'*(21.165).*

Ruskin's school was a criticism of the Royal Academy and South Kensington, but it was not intended to do the work of either. Most emphatically its original purpose was not to produce artists. As its name indicates, it was a school of *drawing,* intended to sharpen the visual faculties of any student, as part of his general education. If Ruskin's scheme has any precedent, it is in the tradition of the late eighteenth-century and early nineteenth-century drawing masters such as had first taught Ruskin himself. But its purpose was more than either teaching an elegant pastime for gentlemen, or supplying a useful skill in technical drawing; he believed that visual perception *in itself* was as important as any of our intellectual faculties: 'The facts which an elementary knowledge of drawing enables a man to observe and note are often of as much importance to him as those which he can describe in words or calculate in numbers.'*(16.450)* The concentrated coordination of eye and hand caused a completely different kind of understanding, the sort of understanding that his own practice of drawing had led him to. By drawing, students 'actually obtained a power of the eye and a power of the mind wholly different from that known to any other discipline, and which could only be known by the experienced student – he only could know how the eye gained physical power by attention to delicate details.'*(16.440)* A perception so trained could at the very least take the student to the first order of truth, the truth of natural fact, and, though that was all that Ruskin hoped to achieve, by implication the right training of the eye and mind could lead him to discover the greater glories of the symbolic imagination.

Because Ruskin's practical aim was limited, it is not surprising that the technical exercises he set were so basic. He had already produced two books of technical instruction, *The Elements of Drawing* (1857) and *The Elements of Perspective* (1859). He now produced a third, *The Laws of Fésole* (1877–78), for use both at Oxford and in the projected

schools of the Guild of St George. Some of the first steps were 'niggling' *(15.36)*, as he admitted, and as limited as those made at South Kensington, but whereas the government design student was kept pinned to the flat surface of the drawing-board, Ruskin wanted to apply the accuracy, once learned, to natural objects. He tried to steer his students between the twin errors of drawing things 'mechanically and symmetrically together', as at South Kensington, and the picturesque 'dash and scrabble for effect, without obedience to any law'*(15.344)*. The emphasis on careful copying may seem rigid and unenterprising now, but for Ruskin it was a method of practical criticism of the most basic kind, and one that he had used all his life. Students were encouraged to make precise copies from the examples in the teaching collection, without necessarily going on to a complete course of draughtsmanship: 'It is of greater importance that you should learn to distinguish what is entirely excellent, than to produce what is partially so'*(21.71)*.

The plan was for a 'grammar-school of art' with two classes, one for the exclusive use of undergraduates, the other a general class, or 'lower school', for the use of 'young people residing in Oxford or its neighbourhood'*(21.xx)*. Each had its own room and its own collection of teaching examples. These, whose surviving component parts are still in the University Galleries (in the Print Room of the Ashmolean), are the last direct link we have with Ruskin's purely visual argument. The collection is Ruskinian in a way that no book or individual drawing can be; sadly, like most Ruskinian schemes, though the intention is clear, the practical result is a seemingly incoherent jumble.

In all, there were four separate collections, each example in a sliding frame, kept in cabinets similar to those he had originally designed to hold the Turner sketches catalogued for the National Gallery. The Standard Series was planned as four hundred examples representing the best art of the Western tradition: Greek sculpture and arts, Gothic sculpture and arts, the schools of painting in general, and modern works. In fact only fifty examples were ever arranged, and the system became muddled with the Reference Series, whose basic purpose was to serve as an accumulating collection of the examples referred to by Ruskin in his lectures. Considering the wide range of topics covered by the lectures it is not surprising that it had a much looser arrangement. Although the old masters were illustrated with the intention of improving the student's judgment, they were not designed to teach the history of art. That was a matter for the History Schools: 'I would no more involve the art-schools in the study of the history of art than the surgical schools in that of the history of surgery'*(16.451)*.

The actual technical instruction was supported by two further series, an Educational Series for the undergraduates and a Rudimentary Series for the general class. The Educational Series began with exercises in flower drawing, then worked through Greek design, Gothic art and architecture, then landscape, zoology, ornament, etching and engraving, followed by sections on foliage, and clouds, rocks and water. The Rudimentary Series was more basic, beginning with heraldry (as did *The Laws of Fésole*), Greek and Gothic design and then on to landscape, birds, plants and trees. Notes and instructions were supplied with the catalogues of each series.

When Ruskin finally presented his collection to the University in 1875, the deed of gift required that 'The Master of Drawing shall make, and shall at all times keep perfect and complete, one or more catalogue or catalogues of the Ruskin Art Collection',[5] but it was wishful thinking to expect that the scheme would stay in order. None of the collections was ever complete, nor were the examples very rigidly arranged. Ruskin was operating similar schemes with the Museum of the Guild of St George, and Whitelands College in Chelsea, and he had contacts with a dozen other schools. The result was that examples tended to circulate round England. The Oxford collection suffered particularly in 1887 when Ruskin withdrew at least 111 drawings after falling out with the University, leaving the collections in a muddle that has remained to this day. Regrettably, the Ruskin collection has not been kept separate from the University's general holdings. The examples are no longer in their original frames and the cabinets have been sold. The requirements of space and security have necessitated this, but it is unfortunate that the original sequences, which form such an important part of the argument, have been broken up (ills 41–44).[6]

The examples themselves come from a bewildering variety of sources, in widely different forms. The two most important groups are drawings by Turner and Ruskin himself; Ruskin had already made a gift of some of his best Turner water-colours to the University in 1861, and these were included in the Deed of Gift of the whole teaching collection in 1875. Twenty-seven Turner sketches and water-colours are listed, plus a large number of engravings and *Liber Studiorum* plates.[7] From 1879 to 1906 the Drawing School also had Turner water-colours on loan from the National Gallery. Ruskin's own drawings come from all stages of his career, early vignettes in the style of Turner's for Rogers's *Italy*, Proutish architectural drawings, leaves torn out of notebooks, copies of other paintings, and demonstration studies specially done for the school. There are fourteen drawings by Prout, plus litho-

graphs, eight by William Hunt, eight by Burne-Jones, Dürer engravings and woodcuts, and leaves from illuminated MSS. Besides the original drawings and engravings there are reproductions of the old masters in every medium available at the time: individual copies commissioned by Ruskin from the artists he employed specifically for this purpose, Arundel Society chromo-lithographs, engravings, and black-and-white photographs. There is also an important collection of architectural photographs. Finally there is a miscellaneous assortment of plates cut out of books like Gould's *Birds*, Sowerby's *Botany*, Hornemann's *Icones Florae danicae*, and Lenormant and De Witte's *Elite des monuments céramographiques*.

Since this was a teaching collection, it did not matter to Ruskin very much whether the example he chose was a Turner drawing or a photograph; the only value was its visual context. See, for instance, the reconstruction of the second section on heraldry in the Rudimentary Series*(21.174–7)* (ills 45–48): a Turner, seventeenth-century woodcuts, a Ruskin drawing of 1845, two photographs, and a Prout. The juxtapositions are sometimes surprising, and were meant to be. The student, 'Having had his attention directed in the last thirteen pieces to the simplicity of Greek outlines and the parallel simplicity of Greek execution and of modern processes rightly founded on it [three photographs, seven Ruskin studies of ceramics, a study of Greek sculpture by the Drawing Master, MacDonald, and two William Hunts], he will, I hope, be at first considerably startled and shocked by the petty, crinkly, winkly, knobby and bumpy forms of Albert Dürer'*(21.184)*, and a series of Dürer engravings follows. These jumps and juxtapositions are the visual equivalent of the jumps and juxtapositions in *Fors Clavigera*, and the juxtapositions he perceived in life.

It was consistent both with Ruskin's belief in the value of drawing for learning and with his insistence that art should have some object greater than itself that his examples were chosen with a double purpose; for beyond being practical exercises they were intended to have further value by being presented as two series, 'one illustrative of history, the other of natural science'*(20.35)*. The sheet illustrating the quarterings of a shield, specially printed for the Drawing School, is an exercise in straight lines and curves, but he also used it in a lecture, 'The Heraldic Ordinaries' (ill. 49), where the quarterings are read as symbols in a broad scheme of moral history*(22.280–4)*. The use made of botany typifies the multiform nature of Ruskin's mind. The flower paintings in the Rudimentary Series are elementary exercises in outline and flat wash, but simultaneously they are intended to be lessons in botany and

mythology: not orthodox botany and mythology, but an imaginative re-creation in terms of the symbolism of *The Queen of the Air*.

It would be easy to dismiss the late scientific writings as foolish and irrelevant ramblings written as a distraction from pain and incipient madness – but Ruskin's intentions become much clearer in the context of the Drawing School. True, there is an element of play in the fanciful renaming of plants and reordering of ornithology. But the writings are important not just because his private obsessions force their way through, but because they demonstrate how consistent his interpretation of reality was. The flower exercises in the Drawing School are one more example of the operation of the orders of truth: at the level of fact they are studies in accurate delineation, at another level the amaryllis, the iris, the asphodel and the lily have symbolic meaning, as Christ's lily of the field, the Christian fleur-de-lys, the Greek flower of immortality and the Annunciation lily. Moving beyond interpretation into an actual re-ordering of botanical terms, Ruskin names them 'Drosididae' – Dewflowers, which he associates with the rush plant, and from which he says they are developed. 'I do not mean that they are developed in the Darwinian sense, but developed in *conception* . . . great orders of plants and living creatures are formed in subtle variations upon one appointed type'(21.242).

If we treat Ruskin's science in orthodox terms, then it is no more than a hopeless rear-guard action against Darwinism. The character of science was changing as the descriptive and classificatory methods Ruskin had been brought up with gave way to experiment and analysis; Darwin's theory was a dramatic example of the process by which the scientific world picture had gradually broken with the religious. Ruskin still tried to maintain the certainties of the eighteenth century: 'In the earlier and happier days of Linnaeus, de Saussure, von Humboldt, and the multitude of quiet workers on whose secure foundation the fantastic expatiations of modern science depend for whatever good or stability there is in them, natural religion was always a part of natural science' (26.338–9).

After all the twists and turns in Ruskin's religious belief, it is clear that he was not returning to the natural theology of William Buckland; but he was being consistent with the view of nature which he now realized had been the key idea in *Modern Painters* 2.[8] Such a 'natural theological' view cannot be separated from the means with which he approached nature, that is, his own perception. He had defined the difference between himself and the scientist long before in *The Stones of*

Venice: 'The thoughtful man is gone far away to seek; but the perceiving man must sit still, and open his heart to receive. The thoughtful man is knitting and sharpening himself into a two-edged sword, wherewith to pierce. The perceiving man is stretching himself into a four cornered sheet, wherewith to catch.'*(11.52)* This distinction between analysis and contemplation shows an attitude that seems more Eastern than Western.

Ruskin's late writings on botany, ornithology and geology are based on a re-ordering of knowledge designed to show the connections between things, rather than the differences, and synthesizing separate branches of knowledge into 'grammars' for the schools of the Guild of St George. His original idea had been to link up the various observations of the natural world in *Modern Painters*; but fresh studies gradually took over. Geology was covered by *Deucalion*, which appeared in parts spasmodically between 1875 and 1883. Ornithology, *Love's Meinie*, was produced between 1873 and 1881, and botany, *Proserpina*, between 1875 and 1886. None of these series was ever completed. He argued that 'no existing scientific classification can possibly be permanent' *(26.418)*, and therefore proposed his own. This involved renaming individual and family groups of birds and plants according to their habits and external characteristics, but the names themselves referred to their mythological and literary associations. The system depended 'on its incorporation with the teaching of my new elements of drawing, of which the first vital principle is that man is intended to *observe* with his eyes, and mind; not with microscope and knife'*(25.xxx)*.

This was the 'science of aspects' of *Modern Painters*, now interwoven with his later mythopoetic outlook. Myth gave the natural fact a moral context, unifying the physical image with its eternal significance; myth gave a validity which the divisive analytical speculations of material science could not. 'The feeblest myth is better than the strongest theory: the one recording a natural impression on the imaginations of great men, and of unpretending multitudes; the other, an unnatural exertion of the wits of little men'*(26.99)*. Theory was dangerously close to the introspection he had always shied away from.

In spite of polemical outbursts against scientists, Ruskin's true relationship with them was more subtle, and he hoped that they could work in parallel, not in opposition. (For their part, official bodies like the Geological Society, the British Museum and the British Institution were happy to accept his scientific contributions.) The educational system proposed for the Guild of St George was intended as a balance of art and science, and in preparing his scientific 'grammars', he in-

tended to 'accept every aid that sensible and earnest men of science can spare me, towards the task of popular education'(28.647). The same parallel was to exist at Oxford: 'Admit that, in order to draw a tree, you should have a knowledge of botany: Do you expect me to teach you botany here? Whatever I want you to know of it I shall send you to your Professor of Botany and to the Botanic Gardens, to learn.'(22.232) Science was permitted on the premises of the Drawing School; he intended to have 'some simple and readable accounts of the structure of things which we have to draw continually. Such scientific accounts will not usually much help us to draw them, but will make the drawing, when done, far more valuable to us'(22.214). His plans for an elementary school in 1884 included a 'sufficient laboratory'(29.484).

The 'science of aspects' was the true subject to be learnt at the Drawing School, and in the end this and the unacceptable analytical science were bound to conflict. 'This faculty of sight, disciplined and pure, is the only proper faculty which the graphic artist is to use in his enquiries into nature'(22.209), but the analytical scientist probed and dissected, and here Ruskin felt psychologically as well as intellectually threatened. Consistent with his principles of form in *Modern Painters 2*, he argued that art was concerned only with external appearances:

The study of anatomy generally, whether of plants, animals, or man, is an impediment to graphic art . . . in the treatment and conception of the human form, the habit of contemplating its anatomical structure is not only a hindrance, but a degradation; and farther yet, that even the study of the external form of the human body, more exposed than it may be healthily and decently in daily life, has been essentially destructive to every school of art in which it has been practised.(22.222)

Ruskin's psychological prejudices are plainly at work, and his fear of penetrating the surface of things (perhaps a sexual fear), whether expressed as a horror of introspection or of the anatomist's knife, leads him to argue that 'the artist has no concern with invisible structures, organic or inorganic'(22.241), coming close to contradicting the organicism of his architectural theories.

Ruskin's psychological objections to analytical science, identified primarily with anatomy, are linked to his horror of death, symbolic or actual. He could not object to the sciences of healing and helping, but he fought

against the curiosity of science, leading us to call virtually nothing gained but what is new discovery . . . the insolence of science, in claiming for itself a

separate function of the human mind which in its perfection is one and in-
divisible, in the image of its Creator, and of the perversion of science, in
hoping to discover by the analysis of death, what can only be discovered by
the worship of life(22.529).

Ruskin feared that anatomy could destroy the student's healthy love of
life: 'Cut dead bodies to pieces till you are satisfied; then come to me,
and I'll make shift to teach you to draw even then – though your eyes
and memory will be full of horrible things which Heaven never meant
you so much as a glance at.'(22.232)

Horror of anatomy also came out in his critical judgments; com-
paring Michelangelo unfavourably with Tintoretto (and profoundly
upsetting the University, which was very proud of its collection of
Michelangelo drawings), he blamed Tintoretto's downfall on the
influence of Michelangelo's study of anatomy(22.407–8). When he
resigned from his second period as Slade Professor of Fine Art in 1885,
he gave as his reason the decision to permit vivisection in the University
laboratories.

Ruskin's scientific method should be treated as an alternative theory
of knowledge: the number of facts to be known is small (since we can
only know a small number of facts); the purpose of new discoveries is
to reinforce what was already known, bringing things together and
illustrating their similarities, not their differences. Ideally, all know-
ledge could be brought together into one great pattern, the sort of
pattern he tried to create in the lecture 'The Iris of the Earth' (1876).
This was Ruskin's synthesizing process in action, as he drew on colour
theory, etymology, history and mineralogy to illustrate 'the symbolic
use of the colours of precious stones in heraldry'(26.165). In the *Laws of
Fésole* the system also includes botany and astrology(15.424–31). The
object of this theory of knowledge was moral, and in that sense it was
practical, in that it availed towards life. Knowledge no longer com-
partmentalized into subjects or disciplines could truly become an end
in itself, for through it we may unify the physical and spiritual ex-
pressions of our existence.

On 1 January 1874, Ruskin sat down to write an account of a lecture he
had given at Oxford the previous November on Florentine Art. He told
how, just before going into the University Galleries to give the lecture,
he was disturbed by coming across a small ragged girl playing with a
top: 'She was a *very* nice little girl; and rejoiced wholly in her whip, and
top; but could not inflict the reviving chastisement with all the activity

that was in her, because she had on a large and dilapidated pair of woman's shoes, which projected the full length of her own little foot behind it and before'*(28.14)*. Passing on into the University Galleries, he gave his lecture.

But all the time I was speaking, I knew that nothing spoken about art, either by myself or other people, could be of the least use to anybody there. For their primary business, and mine, was with art in Oxford, now; not with art in Florence, then; and art in Oxford now was absolutely dependent on our power of solving the question – which I knew that my audience would not even allow to be proposed for solution – 'Why have our little girls large shoes?'*(28.14)*

More than thirty years before, Ruskin had been forced to reconsider his approach to art because of the realization that he had treated a half-starved girl 'more as picturesque than as real'*(L45.142)*; now he was using a ragged girl to make English society ask itself the same question about the relationship between art and social reality.

Such a campaign had to be fought outside as well as inside Oxford. At times his duties there seemed a hindrance to his social work; and he was not above using his obligations to Oxford as an excuse for the chaotic manner in which he carried it out; but the question, 'Why have our little girls large shoes?', firmly ties the two aspects of his campaign together. At Oxford he would address the future leadership of the country; in a series of monthly public letters he would address the public at large, letters that had to be written for one good reason at least: 'that you may make no mistake as to the real economical results of Art teaching'*(27.18)*.

This was the scheme of *Fors Clavigera*, published by Ruskin every month from January 1871 until the series was broken by his collapse in 1878, and then produced intermittently between 1880 and 1884. He had first experimented with the form in *Time and Tide* (1867), subtitled *Twenty-five Letters to a Working Man of Sunderland*, when a series of letters addressed to the cork-cutter Thomas Dixon had been reprinted first in newspapers and then as a book. In *Fors Clavigera* Ruskin addressed himself to all 'the workmen and labourers of Great Britain', although it is clear that he meant anyone who worked with head or hands (in the same way as Carlyle and F. D. Maurice appear in Ford Madox Brown's painting *Work*). The choice of title was satirizable like so many of his others, but Ruskin protested, 'I am not fantastic in these titles, as is often said; but try shortly to mark my chief purpose in the book by them.'*(22.315)* *Fors* was chance, guided by the hidden hand of Fate. *Clavigera* meant that chance carried a club, a nail or a key – my own

interpretation is 'Chance, the fate that hits the nail upon the head', but the title contains a multiplicity of meanings.[9] One source of the image was an Etruscan mirror case he had seen some time in the 1860s depicting Atropos, the Greek Fate, about to drive a nail into a beam with a hammer, and so becoming 'the symbol of unalterably determined, or fixed, fate'(27.xix). The hammer and nail also had a Biblical association, not with the instruments of the Passion, but with the Jael of the Old Testament, who murdered Sisera by driving a tent nail through his head. This half-hidden association of Fors with death was the closing image of the last letter before he went mad in 1878(29.379).

The title and form of *Fors Clavigera* were a justification of his method, the all-embracing view that gave complete freedom to work from the broadest generalities to the minutest of particulars, or draw from the most trivial incident a lesson of universal significance. The theme of *Fors Clavigera* was itself and its author, free of any limitations of predetermined form or subject matter. Its shape was a product of chance: 'By the adoption of the title "Fors", I meant (among other meanings) to indicate this desultory and accidental character of the work'(29.315).

But the juxtapositions chosen by chance were in reality no accident; they demonstrated the inner workings of Fate, and each was a lesson of the utmost significance. *Fors Clavigera* was structured by the sensibility of its author and by what he saw and felt from day to day. It is both a journal and the beginnings of an autobiography; material used in *Praeterita* first appears here. The letters were a means of recording the progress of projects, and the place to plan new ones. Above all, they were a means of avoiding the dead hand of analytical system, which must exclude for the sake of artificial clarity: '*Fors is a letter*, and written as a letter should be written, frankly, and as the mood, or topic chances, so far as I finish and retouch it, which of late I have done more and more, it ceases to be what it should be, and becomes a serious treatise, which I never meant to undertake'(29.197). The letters also allowed Ruskin more than one voice, though his readers had to be reminded of the 'passages of evident irony'(28.650) in which his more Swiftian attacks appear. He could be gentle or whimsical, funny, instructive, admonitory, or he could release gouts of black anger.

The social criticism in *Fors Clavigera* is more disordered and more violent than in earlier works, and attacks a wider range of targets, but it never loses touch with the theme of exploitation and destruction of which the modern city becomes the most powerful symbol. London, its skies blacked by smoke, feeds off the countryside, producing nothing; the relationship between town and country is

more fantastic and wonderful than any dream. Hyde Park, in the season, is the great rotatory form of the vast squirrel-cage; round and round it go the idle company, in their reversed streams, urging themselves to their necessary exercise. . . . Then they retire into their boxes, with due quantity of straw; the Belgravian and Piccadillian streets outside the railings being, when one sees clearly, nothing but the squirrel's box at the side of his wires(28.136).

London (which of course had greatly expanded in Ruskin's lifetime) is a physical expression of the system by which the idle rich live off the noble poor: 'All social evils and religious errors arise out of the pillage of the labourer by the idler: . . . first by the landlords; then, under their direction, by the three chief so-called gentlemanly "professions", of soldier, lawyer, and priest; and, lastly, by the merchant and usurer' (29.294-5).

Exploitation enables the rich to make wars for which the poor pay with their lives and labour. The fundamental elements of profit in the capitalist system, rent and interest, are denounced as 'stealing'(28.670), and Ruskin's condemnations of usury, to which all capitalist transactions are finally reduced, become more and more extreme. The lawyers and the Church play their part in this grand system of waste; the clergy 'teach a false gospel for hire'(28.363), and the bishops betray their religion, 'first by simony, and secondly, and chiefly, by lying for God with one mouth, and contending for their own personal interests as a professional body, as if it were the cause of Christ'(28.514). An economic system based on exploitation means not simply the over-production of useless goods, but 'over-*destruction*'(28.695), the waste of lives and resources that could be put to more creative uses than supplying London,

this fermenting mass of unhappy human beings, – news-mongers, novel-mongers, picture-mongers, poison drink-mongers, lust and death-mongers; the whole smoking mass of it one vast dead-marine storeshop, – accumulation of wreck of the Dead Sea, with every activity in it, a form of putrefaction (28.137).

The Guild of St George was Ruskin's counter-image of harmony and plenty. From the very beginning of *Fors Clavigera* he talked of the practical reforms this society would carry out. The Guild existed *as an image*, as a moral contrast to the city of dreadful night in which people were living; and Ruskin would have had it exist in reality, just as London all too painfully already existed. The Guild was to be organized as the exact opposite of capitalist society. Its main occupation was to be

agriculture and education, and, as part of the educational work, the preservation and accumulation of beautiful objects. Its organization was strictly hierarchical, based on elective monarchy in the manner of the Doges of Venice. An aristocracy of members would elect a master who would be in sole charge of the running of the Guild, the appointment of officers, and the admission of members, but who could be deposed by a majority vote(28.649). The Master was to be assisted by Marshals; below them came landlords, land agents, tenantry, tradesmen, and hired labourers; while outside the Guild there would be an 'irregular cavalry' of friends(28.424). In contrast to the bishops of the Church of England there would be an episcopal system by which Bishops of the Guild oversaw and were responsible for the moral and physical welfare of every member – and acted as a kind of police force in financial matters(28.513–14).

Not all members of the Guild would work full time on the Guild's schemes, for it was not intended to be a retreat from the world, but rather 'a band of delivering knights'(28.538). Ruskin had originally wanted to call it the St George's Company, after the mercenary companies that fought in Italy in the sixteenth century, but a Company that specifically did not make money was unacceptable to the Board of Trade (28.628–9). There were to be three classes of members of the Guild: 'Companions Servant' who worked mainly for the Guild, with some private interests; 'Companions Militant' who worked full time, such as agricultural workers; and 'Companions Consular' who gave one-tenth of their income to the Guild, but carried on with their normal occupations following St George's principles(28.539). Besides the Guild itself there was perhaps to be another inner grouping, the Company of Mont Rose(27.296).

Because the destructive capitalist system created nothing but a National Debt, it was the purpose of the Guild to establish a 'National Store'.

The possession of such a store by the nation would signify, that there were no taxes to pay; that everybody had clothes enough, and some stuff laid by for next year; that everybody had food enough, and plenty of salted pork, pickled walnuts, potted shrimps, or other conserves, in the cupboard; that everybody had jewels enough, and some of the biggest laid by, in treasuries and museums; and, of persons caring for such things, that everybody had as many books and pictures as they could read or look at; with quantities of the highest quality besides, in easily accessible public libraries and galleries(28.641).

Since labour was the only source of value, the National Store could only

183

be accumulated by manual labour on the land, and not just on good land, but by bringing into cultivation land that lay idle or waste. This concern to improve the land was a socialized restatement of the nature-worship of *Modern Painters*, which 'taught the claim of all lower nature on the hearts of men; of the rock, and wave, and herb, as a part of their necessary spirit life; in all that I now bid you to do, to dress the earth and keep it, I am fulfilling what I then began'*(29.137)*. The steam engine, symbol of destructive resource-consuming energy, was forbidden on St George's land, except for rail communication and heavy water-pumps; although the adaptation of machinery to the natural energies of wind and water, producing electricity, was to be encouraged. Finally, since rent was capitalistic usury, the rents on St George's farms would be reduced with every improvement made by the tenant, and the whole of it applied directly or indirectly to the benefit of the tenants.

Land and farms meant people, and so a comprehensive system of education was necessary. The children of the Guild's labourers or Companions Militant would be taught in

agricultural schools, inland, and naval schools by the sea, the indispensable first condition of such education being that the boys learn either to ride or to sail; the girls to spin, weave, and sew, and at a proper age to cook all ordinary food exquisitely; the youth of both sexes to be disciplined daily in the strictest practice of vocal music; and for morality, to be taught gentleness to all brute creatures, – finished courtesy to each other, – to speak truth with rigid care, and to obey orders with the precision of slaves*(27.143)*.

The children would be taught with the aid of teaching examples such as those in use at Oxford, and with grammars of natural science, history, music and literature.

The educational system extended into the Companions' homes, for each was to have a *Bibliotheca Pastorum*, a cottage library of standard volumes edited and published by the Guild*(28.20)*. There would also be a standard collection of works of art available in reproduction for each house. The final expression of the National Store would be a series of Museums and Parks for delight and study. The theme of the Guild was peace and justice, which flowed from God through the kingly authority in man and down to the very last creature, 'and so out of the true earthly kingdom, in fulness of time, shall come the heavenly kingdom'*(29.295)*. It is an echo of the conclusion to *Modern Painters*.

Such is the Guild of St George as it might be in its ideal state; Ruskin never made such a summary. As I said, the Guild is a counter-theme to

capitalism in *Fors Clavigera*; his ideas about its organization were liable to change according to the needs of the argument. For instance, at one stage he says that all boys and girls will have to learn Latin; at another, to stress the need for purely visual learning, he suggests it may not be necessary for them to be able to read at all. Schemes for the Guild are woven into and out of other subjects, and appear almost accidentally. Apart from a generalized 'statement of creed and resolution'(28.419–20), and the articles under which the Guild had finally been registered with the Board of Trade, there were no guidelines for the Companions to follow – except the whole body of Ruskin's work: 'For the defence of our principles, the entire series of Letters must be studied; and that with quiet attention, for not a word of them has been written but with purpose'(28.650). And that threw the reader back to the projected image.

The Guild's practical existence was very different from the empires he at times envisaged. Although he announced its foundation in 1871 and started a St George's Fund with £7,000 of his own money, the Guild did not come into existence legally until 1878, or have its first official meeting until 1879, when Ruskin was too ill to attend. The original membership of the Guild lists only thirty-two names(30.86), and none of them gave one-tenth of his income. After seven years' work the land holdings of the Guild consisted of twenty acres of woodland at Bewdley in Worcestershire, a group of eight cottages at Barmouth in Wales, thirteen acres of land at Totley, near Sheffield, three-quarters of an acre at Cloughton near Scarborough, and a small cottage with some adjoining land at Walkley, also near Sheffield, which held the one museum of the Guild of St George. There was little cultivation, and there were no schools.

The one point where the ideal and the actual did meet was in the Guild Museum. In November 1875 a small stone cottage and a plot of land were bought at Walkley. This was to be the Guild's first educational museum, 'arranged first for workers in iron, and extended into illustration of the natural history of the neighbourhood of Sheffield, and more especially of the geology and flora of Derbyshire'(28.395). The 'poetic' reason for choosing Sheffield was the association of agriculture (the purpose of the Guild) with ploughing, ploughing with steel (and also sculpture): steel being the main industry of Sheffield. The practical reason was that a former pupil at the London Working Men's College, Henry Swan, lived in Walkley and invited Ruskin to meet a group of local working men interested in his ideas. His reception encouraged him to plant 'the germ of a museum'. While the agricultural

projects hardly prospered, Ruskin's individual talents were suited to establishing a museum. Museums had in fact been a long-standing interest, going back to his hopes for the curatorship of a 'Turner Gallery' showing the Turner bequest*(13.xxvii–xxix)*. He had put his energies into helping the foundation of the Oxford Natural History Museum, had criticized the administration of the National Gallery, and had attacked the exhibition policy at the Crystal Palace. The teaching collection at Oxford was a parallel scheme to the educational purpose of the Guild. The Guild museum was to be the three-dimensional manifestation of his arguments: 'the consummation of all that hitherto has been endeavoured in my writings, must be found in the completion of the design of the St. George's Museum'*(30.51)*.

The design was never to be completed, but its purposes are clear from what was done. This was not to be a great museum, the grand expression of the National Store, but a local educational institution. Such museums were not for entertainment, but they were for recreation, so that

persons who have a mind to use them can obtain so much relief from the work, or exert so much abstinence from the dissipation, of the outside world, as may enable them to devote a certain portion of secluded laborious and reverent life to the attainment of the Divine Wisdom, which the Greeks supposed to be the gift of Apollo, or of the Sun, and which the Christian knows to be the gift of Christ*(28.450)*

Since the Museum was to serve Sheffield he planned to create a school of metalwork, but this was later abandoned, with some bitterness *(30.70)*, and the flora and geology of Derbyshire were absorbed into the general natural science studies.

Like the teaching collection at Oxford, the Museum synthesized art, science and history. Sculpture was to be given prominence, as 'the foundation and school of painting', and because casts were more effective than copies of paintings; but the casts were to be integrated with the display of relevant drawings and prints, and would also act as instructional examples such 'as may best teach the ordinary workman the use of his chisel'.*(30.55–6)* The choice of paintings and prints related to themes of national history and literature, as did the display of books and illuminated manuscripts. A collection of minerals acted as an introduction to natural science, and at the same time, like the examples of botany and zoology, led back into the world of art. Ruskin's scheme for a new building for the Museum in 1881 envisaged a two-storey structure seventy feet long with an apsidal end, and a front porch like

the door of the baptistry at Pisa.[10] The building was to be faced with marble. Originally Ruskin suggested Derbyshire marble, but the architect pointed out that it would not stand the weather, so Italian marbles were considered instead. Each floor was to have a gallery and a study room, a Public Library and students' reading room on the ground floor, an art gallery and jewel-room above. Other plans included a separate curator's house (also faced with marble) and a hostel and an inn for visitors.

The Guild Museum was multiform and multipurpose: it was a collection of beautiful objects, whether painting, drawing, illumination or minerals, so linking art and nature; it was illustrative of cultural and moral history; and it was a school of drawing and painting, an education for the hand and eye. It was also a synthesis of word and image, for each item in the collection, book, painting, sculpture or mineral, related to the publications of the Guild of St George.[11] The examples of Venetian art and architecture commissioned from Ruskin's copyists carried out the obligation of the Guild to record and preserve the art of the past, and had their literary context in *St Mark's Rest* and the *Guide to the Principal Pictures in the Academy at Venice*. Similar studies and examples linked Florentine artists with *Mornings in Florence*; the Cathedral and streets of Amiens reflected *The Bible of Amiens*. These guidebooks in turn related to Ruskin's work at Oxford, and the scheme for a series of local histories *Our Fathers Have Told Us*. Behind all these was the idea of a cultural history first explored in *The Stones of Venice*. The natural science collection related to *Deucalion, Proserpina,* and *Love's Meinie,* and complemented the studies of landscape that made it natural to include studies from Turner that stretched back to *Modern Painters*. Man's relationship with his surroundings found its political context in the translation from Xenophon's *Economist* for the Guild Library, and its visual context in *The Laws of Fésole*. The aphorisms of *The Laws of Fésole* and the musical discipline of *Rock Honeycomb* and *The Elements of English Prosody* conveyed the educational aims of the Guild for which the Museum was a visual focus.

Again, the reality falls short of the ideal. The collection of the Guild was built up in a haphazard manner, as at the Drawing School, and only the mineral collection and some of the pictures were actually catalogued by Ruskin. The upper room (ill. 50) of the cottage in which the collection was originally kept (the curator lived in the same building) was too small for all the exhibits to be kept there, even after a gallery was added in 1884. Part of the material was kept elsewhere, or joined the floating collection circulating between Oxford, Sheffield and

other points of call. Ruskin's gradual loss of control of his affairs affected the Guild like everything else, and the Museum, like the Guild, was held in suspended animation between his collapse in 1889 and his death in 1900. On the other hand, the Museum did attract people's interest, and Sheffield Corporation were sufficiently interested to be prepared to give £5,000 towards building a new museum in 1882. The proposal fell through because of a lack of further finance and Ruskin's refusal to relinquish full control of the collection. In 1890 the Museum was finally re-opened in larger premises on Corporation property at Meersbrook Park, when Ruskin was no longer in a position to object. This gave more room for display, but the arrangement of the rooms only dimly reflected his original ideas. The collection, like that of the Drawing School, is now dismantled, although Reading University, to which the Guild has loaned the collection, is taking steps towards its restoration.

I have characterized the later period of Ruskin's life as one of increasing oppositions, and nowhere is that opposition more extreme than within the scheme for the Guild of St George. On the one hand he was 'thinking out my system on a scale which shall be fit for wide European work'*(28.424)*, and on the other he was proposing to promote this scheme with the aid of 'about thirty persons – none of them rich, several of them sick, and the leader of them, at all events, not likely to live long'*(28.638)*. I have tried to show that image and reality were unified, because they expressed the same moral argument; but there remains a disparity between the utopian dreams and the pathetic results achieved.

No one knew Ruskin's limitations better than himself. He was truly 'the most practical of men' because his ideas issued in practice, in physical action, but he freely admitted that he saw himself only as a 'makeshift Master' until some better leader came along*(29.197)*. The fact that no one did step forward dramatized his position and almost made a virtue of his weaknesses: 'Such as I am, to my amazement, I stand – so far as I can discern – alone in conviction, in hope, and in resolution, in the wilderness of this modern world'*(28.425)*. The multiplicity of his self-imposed duties was a further excuse for practical failure. It was not wholly his fault, he wrote in 1887, that the programme outlined in his inaugural lectures at Oxford remained unfulfilled, for he had been distracted by other interests, especially the Guild, which had caused his Oxford friends to distrust him*(20.13–14)*. But his obligations to Oxford likewise excused him from concentrating

on Guild work. The mind whose all-embracing view made it possible to conceive such important schemes was also a threat to them, since the need to show the relevance of everything to everything else distracted him into a series of seeming irrelevances.

Was then Ruskin serious about the Guild? He curtly told the readers of *Fors Clavigera* in 1875:

If those of my readers who have been under the impression that I wanted them to join me in establishing some model institution or colony, will look to the third paragraph of Letter I [in which he proposes a National Store], they will see that, so far from intending or undertaking any such thing, I meant to put my whole strength into my Oxford teaching; and, for my own part, to get rid of begging letters and live in peace(28.236).

And yet the gift of £7,000 and the time and money devoted to the Museum, plus his complaints of having to stand alone, show that he did intend the Guild to survive, as indeed it does. The problem is one of method, the sort of problem he encountered when writing his drawing lessons in *The Laws of Fésole*.

I had intended to write it separately for the use of schools; but after repeated endeavours to arrange it in a popular form, find that it will not so shape itself availably, but must consist of such broad statements of principle as my now enlarged experience enables me to make; with references to the parts of my other books in which they are defended or illustrated(28.407).

So it was that *Fors Clavigera* 'contains not a plan or scheme, but a principle and tendency'(28.227).

As a principle, the Guild of St George exists on every page of *Fors Clavigera*, in the Museum, and in every muddled and unfinished scheme; its justification is to be found in the whole body of Ruskin's work, because it is the summation of that work. But even as a principle its exact constitution or description was unnecessary, since its purpose was action and its medium, people: 'The ultimate success or failure of the design will not in the least depend on the terms of our constitution, but on the quantity of living honesty and pity which can be found, to be constituted.'(28.436) The translations from Plato's *Laws* which appear in *Fors Clavigera* link Ruskin's designs with those of Socrates, who gave practical advice to the dictators Dionysius II and Hermias,[12] but whose projected Republic was 'impossible even in his own day'(29.242). It was in this context that Ruskin could say that his advice was 'not, in any wise, intended as counsel adapted to the present state of the public mind, but it is the assertion of the code of Eternal Laws, which the

public mind *must* eventually submit itself to, or die'*(29.198)*. As a principle the Guild of St George had to be greater than himself: 'it would be a poor design indeed, for the bettering of the world, which any man could see either quite round the outside, or quite into the inside of'*(28.235)*.

The reason for the apparent failure of the Guild is Ruskin's fundamentally religious, as opposed to political attitude: 'I do not, and cannot, set myself up for a political leader'*(29.197)*. Political change is brought about by short-term inducement and compromise, and only touches the conditions, not the motivations, of men. The change that Ruskin tried to effect involved genuine conversion, brought about by persuasion or example, and it was essentially as an example that the Guild was intended. He did not care if it only started in 'two or three poor men's gardens. So much, at least, I can buy myself, and give them. If no help come, I have done and said what I could, and there will be an end.'*(27.96)* Ruskin's belief in his cause is religious because it is based on faith, and faith can allow no compromise.

In spite of all his warnings of revolution, Ruskin could not finally advocate it. His model of society is authoritarian, but based on love and moral righteousness, not force. A religious attitude meant that he could not impose change through political action; instead, it had to be brought about by evangelical conversion, hence the emphasis on education, a secular equivalent to missionary work. His example, and his image, was St George:

It is enough for us that a young soldier, in early days of Christianity, put off his armour, and gave up his soul to his Captain, Christ: and that his death did so impress the hearts of all Christian men who heard of it, that gradually he became to them the leader of a sacred soldiership, which conquers more than its mortal enemies, and prevails against the poison, and the shadow, of Pride, and Death.*(27.481)*

Ruskin could only hope that his own life would do the same.

8 On Seeing What Ruskin Meant

'Because men have said so many contradictory things about Ruskin, it has been concluded that he was himself contradictory.'

'HE BECAME, ultimately, his own subject.'[1] John Rosenberg's comment on the gradual entanglement of Ruskin's private obsessions with his public work states a fundamental problem. An approach to Ruskin's ideas via the mind that made them – and Rosenberg's is the best example of the method – greatly increases our understanding, but there is a danger of reducing vital critical concepts to mere manifestations of a diseased brain. In 1933 R.H. Wilenski opened up a new approach to Ruskin when he wrote: 'There is hardly a page of his writings which can be properly apprehended until it is collated with the condition of his mind and the circumstances of his life not only at the general period within which the book falls, but on the actual day on which that particular page was written.'[2] The difficulty with this approach is that the study of Ruskin becomes simply a problem of biography, and at worst completely ignores the overt content of what he was saying. It does not seem to help very much to say that 'Ruskin associated Gothic architecture with sexual potency, and came to admire Gothic largely because it represented this quality', or that Ruskin liked mountains because they reminded him of his mother.[3]

Ultimately, of course, Ruskin *was* his own subject – his last work was his autobiography. The images I have pointed to do have psychological significance. Kingship and Queenship may well be explicable in terms of the Jungian *animus* and *anima*, and quite obviously relate to his parents; the storm-cloud and plague-wind might seem explicable totally in terms of psychological stress, were it not for the fact that the skies of England were indeed getting darker because of pollution. Alternatively, is it not possible that what has been seen as psychological needs finding their expression in his work could be a reverse process, and that his work imposed itself on his life rather than the other way round? Thus Rose La Touche could be the projection on to real life of the ideal he

sought. There was, after all, more than one Rose: Adèle Domecq, Effie Gray before he married her, a fisherman's daughter at Boulogne, and all the pupils of Winnington School. Twelve years after Rose's death, in 1887, Ruskin began a tender relationship with a young art student, Kathleen Olander. *Mark Alston*, a *roman à clef* by Jessica Sykes, suggests that there was an emotional link between herself and Ruskin.[4]

John Rosenberg has himself pointed out the danger of reducing Ruskin's books 'to mere biographical or psychological "evidence", thus eroding their importance as independent works of mind'.[5] It is as works of mind, comprehending all the cultural and social influences at work as well as the psychological stresses, that Ruskin's writings must be treated. I have tried to show that there is a consistency in his critical ideas, *as* critical ideas, throughout his life: even in the last years when they are expressed through eccentric and obsessional private themes. To begin at the level of personality, and work towards the theories, is moving in the wrong direction, and it is not the direction in which his ideas developed. The storm cloud, for instance, is present at the level of argument in 'Mountain Gloom' and 'Mountain Glory' and in *Unto this last*; only later does it turn into an obsession. His grip on reality was such that even when he was mad he was able to recognize the horrors of these attacks *as* fantasies, and clearly distinguish between them and normal life. For a time he was able to survive shattering bouts of madness, and then go back to work.

Ruskin did not regard the existence of personal psychological dispositions as anything more than another factor to be understood in the totality of an artist's work: 'Certain merits of art (as energy, for instance) are pleasant only to certain temperaments; and certain tendencies of art (as, for instance, to religious sentiment) can only be sympathized with by one order of minds.'(16.451) Of Turner he said: 'his work was the true image of his own mind'(7.422). So, too, was Ruskin's, and that all-consuming mental appetite, which at times overwhelms the line of argument in a wealth of details and associations, is the distinctive quality that makes reading him rewarding. It is precisely his refusal to distinguish between the normally accepted divisions and compartments of thought – aesthetic, ethical, social, economic, philosophical and personal – that is the source of his most important insights. As Kenneth Clark has said, 'We should read Ruskin for the very quality of his mind which, when abused, makes him unreadable.'[6]

If we accept, then, that there are strong psychological undertones in

Ruskin's work, but do not stop our investigations there, the fact remains that from a purely literary point of view Ruskin's imagery is obsessive. This led Marcel Proust (for whom studying and translating Ruskin was an important step in his development) to accuse Ruskin of 'fetishism'. Comparing him with the Symbolist painter Gustave Moreau, a surprising but perceptive comparison, Proust detected an 'adoration of the symbol for the symbol's sake'. At first Proust considered this a useful consequence of the close study of Christian art, 'a form of fetishism not likely to do harm to minds like theirs, which, fundamentally, were so deeply attached to the feeling symbolized that they could pass from one symbol to another without finding any obstacle in mere surface differences'.[7] But he developed this concept of Ruskin's 'iconolatry' into a potentially damaging criticism.

Proust accused Ruskin of insincerity. Quoting him against himself on the dangers of idolatry, 'the serving with the best of our hearts and minds, some dear or sad fantasy which we have made for ourselves' (20.66), Proust finds this idolatry at the root of Ruskin's work. The object of his idolatry was beauty, which he felt obliged to sacrifice to duty, but could not. The result was a perpetual struggle between idolatry and sincerity, fought over every page of his books, and within his psyche. In Proust's words:

It is in those hidden regions that the imagination receives the record of things seen, that intelligence stores up the influence of ideas, that memory is impressed by the impact of thought. By very reason of the choice which a man's essential nature is compelled to make of these things, it performs, incessantly, an act of self-assertion, and so is for ever determining the bent of its spiritual and moral life. It was in these regions, I feel, that Ruskin never wholly ceased to commit the sin of idolatry. At the very moment that he was preaching sincerity, he lacked it. It was not what he said that was insincere, but the manner of his saying. The doctrines he professed were moral, not aesthetic, yet he chose them for their beauty. And because he did not want to present them formally as things of beauty, but as statements of truth, he was forced to lie to himself about the reasons that had led him to adopt them.[8]

Proust's cynicism shows the extent to which the unified moral vision of mid-nineteenth century thinkers like Ruskin had broken down by the beginning of the twentieth century. Proust cannot believe that Ruskin genuinely saw beauty as a gift from God, and the forms of beauty as examples of the right ordering of society. It is true that Ruskin chose ideas for their beauty, but there is no contradiction with morality, since he regarded beauty as an expression of moral truth. Proust, influenced

by the *décadence*, confuses beauty and truth; Ruskin in *Modern Painters 2* dismissed this as 'asserting that propositions are matter, and matter propositions'*(4.66)*. Beauty was the result of truth, the by-product of more important activities, be they worshipping God, or harmonizing man's relationships. He vehemently resisted the doctrine of art for art's sake – or beauty for beauty's sake, which Proust claims was his secret motivation. This was not the resistance of a man who loves what he fears, but of a man who wished to preserve the truth of what he saw from distortion.

Proust was harsh because he needed to break away from the influence of Ruskin, and because he recognized the obsession with imagery in himself. His accusation of idolatry was a valuable insight; but where Proust saw only the pathetic worship of empty images, Ruskin had faith that the values he venerated in image form could guide human conduct.

The difficulty of Ruskin's idolatry is that it takes a particularly visual form. Another French writer, Robert de la Sizeranne, noticed: 'Occupied always with visual sensations, Ruskin passes without transition from the red of vermilion to the red colour of blood – because in colour there is no transition. His images, as successively he calls them up, warp and destroy his argument.'[9] More recent critics have also pointed to an over-reliance on the visual dimension. 'Ruskin's wildest extravagances in economics contain a hardcore of perception not at first noticeable. The perception is the consequence of *seeing* the evidence with the same naïve, unspoiled eye which he turned upon the Val d'Aosta; the extravagance is the consequence of pushing the analogy too far.'[10] One writer goes so far as to dismiss the visual element in Ruskin's arguments as a weakness: 'He had, in fact, a visile mind, and nothing is harder to convey in words than the processes of a logic that moves from one picture to another. . . . Ruskin, indeed, lacked the fundamental qualities of mind needed for making a system or a synthesis.'[11]

This book has tried to show that it is through the visual imagination, and the images thrown up by it, that Ruskin becomes accessible, and that the visual dimension is not his weakness, but his strength. The images are the constructs of his argument, they do more than 'convey' what he is saying: they are what he is saying. At times the technique is taken to extreme, so that a visual reading is the only way we can trace the line of argument, for instance in the montage of images which concludes 'Of Kings' Treasuries', or in *Unto this last* and *The Queen of the Air*. The images have the power to transcend superficial muddles and contradictions, and this too Proust has noticed: 'The manifold but

constant obsessions of his thought are what ensure his books a unity more real than the unity of construction – which admittedly is generally lacking.'[12]

This 'more real' unity is supplied by Ruskin's visual imagination. If we are to be concerned with the study of his mental processes, then the operation of his vision will be as important as that of his reason. The tension in Ruskin's work between verbal construction and visual image can be reduced to a conflict between word and picture, a conflict which began as early as his illustrations to his first stories and poems. His education was biased against the picture: the training in draughts-manship, however fruitful, was designed to go so far and no farther; his literary education fostered hopes that he would be Poet Laureate or Archbishop of Canterbury. In fact he made no claims for himself either as a creative writer or as a creative painter. But there is a conflict between his literary training as a critic, and his experience as an ana-lytical draughtsman. It is remarkable how well in practice the two disciplines managed to blend.

The bias of the critical tradition was against images as such. Following Sir Joshua Reynolds, Ruskin began with a literary attitude to art: 'Painting . . . is nothing but a noble and expressive language, invaluable as the vehicle of thought, but by itself nothing.'(3.87) Using the argument of *'ut pictura poesis'*, he sought to raise the status of landscape painting to that of literature and landscape poetry. His dis-cussions of the imagination and fancy, of the pathetic fallacy, have their origins in literature; in *Modern Painters 3* his history of the appreciation of landscape is based on literary evidence. Since techniques of illustra-tion were crude and expensive (originally *Modern Painters* was to have none at all), even the visual aspects of his arguments had to be ex-pressed through the medium of words. But the power of purely visual sensation could not be ignored. In 1849, that is after the somewhat separate work of *Modern Painters 1* and *2* was behind him, Ruskin visited the Louvre in Paris. Before Veronese's vast *Marriage at Cana* he experienced emotions as intense as those he had felt before Tintoretto in the Scuola di San Rocco in 1845:

I felt as if I had been plunged into a sea of wine of thought, and must drink to drowning. But the first distinct impression which fixed itself on one was that of the entire superiority of Painting to Literature as a test, expression, and record of human intellect, and of the enormously greater quantity of Intellect which might be forced into a picture, – and read there – compared with what might be expressed in words. I felt this strongly as I stood before

the Paul Veronese. I felt assured that more of Man, more of awful and inconceivable intellect, went into the making of that picture than of a thousand poems.*(D2.437)*

This was the direction in which he was to move, not by any means excluding the word, but linking it with the picture, so that in the end his arguments were actions entirely, Museums and the Guild of St George.

In spite of the biases of Ruskin's education, the picture asserted itself over the word. Not so surprising, when one considers that he noted his youthful 'sensual faculty of pleasure in sight, as far as I know unparalleled'*(35.619)*. Throughout his life he was worried about his eyesight – and enjoyed very good vision. He makes many references to his eyes being weak or bad, but chiefly because he had tired them in drawing; only in moments of depression, in 1847, in 1867, in 1873, does he seriously consider that his eyes will fail. And in 1880, in a good mood, he noted 'Eyes wonderfully strong'*(D3.993)*. R.H. Wilenski has suggested that he was 'fascinated and frightened by spots of light surrounded with darkness. Such phenomena affected him in morbid moments with a kind of horror.'[13] Thus, as an example, Wilenski claims that it was the floating sparks of colour in Whistler's *Nocturne in Black and Gold: The Falling Rocket* which caused his libellous outburst. It is difficult to accept this; there were other good reasons for attacking Whistler, or Rembrandt, whom Wilenski also mentions as a victim of Ruskin's subconscious fear. The closing words of *Praeterita*, which Wilenski quotes against him, show rapt attention, not morbid horror: *'How* they shone! . . . the fireflies everywhere in sky and cloud rising and falling, mixed with the lightning, and more intense than the stars.'*(35.562)*

Sight was always associated with spiritual insight, and all the rich imagery of the Bible was available as confirmation: 'Have you ever considered how much literal truth there is in the words – "The light of the body is the eye. If therefore the eye be evil" – and the rest? . . . to be evil-eyed, is not that worse than to have no eyes? and instead of being only in darkness, to have darkness in *us*, portable, perfect, and eternal?'*(22.199)*. In *Fors Clavigera* for August 1872 he meditates on Luke 10: 23: 'Blessed are the eyes which see the things that ye see' *(27.341)*, and in *St Mark's Rest* he notes that several Doges of Venice who had been deposed were afterwards blinded as the city's 'practical law against leaders whom she had found spiritually blind: "These, at least, shall guide no more." '*(24.269)* His fascination with the serpent

symbol was partly that 'The word "Dragon" means "the Seeing Creature" . . . here was a creeping thing that *saw!*'(27.483)

Spiritual insight could be so strong that it was independent of light: 'Darkness to the spirit means only seeing nothing for its own fault. Have you ever felt the dimness of the bodily eye in extreme sickness? – so also of the spiritual eyes in sickness or weakness of heart. . . . This faculty of seeing Him or the higher creatures, which to mortal eyes are invisible, we properly call "imagination" '(22.527). Sight, insight, and imagination are all part of the same visual dimension.

Ruskin was aware of the philosophical and Biblical traditions of the importance of sight. Locke's psychology treated it as the highest perceptual faculty, and both Plato and Aristotle, in spite of their prejudice against the 'deceptive' art of painting, emphasize the connection between vision and wisdom. Ruskin refers to Plato's analogy of the shadows in the cave: 'respecting the sun and intellectual sight, you will see how intimately this physical love of light was connected with their philosophy, in its search, as blind and captive, for better knowledge'(20.152–3). For Ruskin, sight was a great deal more than the passive reception of visual stimuli, it was 'an absolutely spiritual phenomenon; accurately, and only, to be so defined; and the "Let there be light", is as much, when you understand it, the ordering of intelligence, as the ordering of vision'(22.195).

Since sight was 'the ordering of intelligence', Ruskin's purely visual perception inevitably had a direct effect on his intellectual arguments. This was certainly the case in his breakthrough from the picturesque vision, and the discovery of the penetrative imagination; but in the perceptual field the most significant change is the gradual acknowledgment of the primacy of colour over chiaroscuro.

At first he was inhibited by the Lockeian psychology in the same way as he was inhibited by the literary tradition in criticism. Locke, while exalting sight, distinguished between primary and secondary qualities of objects. Primary qualities, 'bulk, figure, number, situation, and motion or rest of their solid parts'(3.158), exist independently of our perception of the object. Secondary qualities, such as colour, sound or smell, have an effect on our senses and are therefore susceptible to the subjective influences on perception. Forgetting that even primary qualities must be subjectively perceived, Ruskin summed them up as 'form', and labelled form a primary, colour a secondary quality. In his concern for form in *Modern Painters 1* he consequently derogated colour in favour of chiaroscuro, since in practice the latter told more about the

shape of an object: 'he, therefore, who has neglected a truth of form for a truth of colour has neglected a greater truth for a less one'*(3.159)*. Such a prejudice was not entirely derived from Locke, it was inherent in the Neoclassical taste with which Ruskin had been brought up, and he may have been directly influenced by his teacher J.D. Harding, whom he describes as despising colour*(1.425)*.

Whatever the critical tradition induced him to say, the fact that Ruskin was extremely sensitive to colour is clear from his descriptions of the colour of natural scenery in *Modern Painters 1* – his outburst, 'I cannot call it colour, it was conflagration'*(3.279)*, for instance, as the sun breaks through after a storm. The battle between his sensitivity to colour and the importance of light and shade for form was fought throughout *Modern Painters* and *The Stones of Venice*, and in the end colour asserted itself. The distinction between form as an objective attribute and colour as something shared by the object with its surroundings remains, but the truth of contextual colour, what is usually called local colour, is treated as equal in importance to that of form:

The hue and power of all broad sunlight is involved in the colour it has cast upon this single thing; to falsify that colour, is to misrepresent and break the harmony of the day: also, by what colour it bears, this single object is altering hues all round it; reflecting its own into them, displaying them by opposition, softening them by repetition; one falsehood in colour in one place, implies a thousand in the neighbourhood.*(7.418–19n)*

Attention to truth of colour as well as form involves a greater realism, more truth, and less self-deception, 'as long as you are working with form only, you may amuse yourself with fancies; but colour is sacred – in that you must keep yourself to facts'*(7.419n)*.

In his *Lectures on Art* at Oxford, Ruskin divided the elements of delineation into Outline, Light and Shade, and Colour. He based this on purely perceptual information:

All objects are seen by the eye as patches of colour of a certain shape, with gradations of colour within them. . . . The outline of any object is the limit of its mass, as relieved against another mass. . . . Usually, light and shade are thought of as separate from colour, but the fact is that all nature is seen as a mosaic composed of gradated portions of different colours, dark or light. . . . Every colour used in painting except pure white and black is therefore a light and shade at the same time.*(20.121–3)*

The practice of painting distinguished chiaroscuro from colour, and Ruskin makes this the basis of his division of the schools of painting:

all schools have a common origin in outline; but the history of art split into two paths, that of light and shade, and that of colour.

The followers of light and shade, the chiaroscurists, from the Greek sculptors to Leonardo and Michelangelo, followed one path; the colourists, in Ruskin's terms the 'Gothic' school of painters like Angelico and Giotto, followed the other. The synthesis was the work of Tintoretto and Titian, Velázquez and Correggio, who combined the glory of their colour with the formal accuracy of the chiaroscurists. The problem is finally solved perceptually, in Aphorism VIII of *The Laws of Fésole*:

Every light is a shade, compared to higher lights, till you come to the sun; and every shade is a light, compared to deeper shades, till you come to the night. When, therefore, you have outlined any space, you have no reason to ask whether it is in light or shade, but only, of what colour it is, and to what depth of that colour.*(15.361)*

Ruskin solved the problem of colour versus light and shade by treating them as coexistent factors in the same field of vision. But the purely perceptual problem is complicated by his metaphysical notion that there existed a spiritual opposition between them. Since the opposition between light and dark is a basic theme in his work, it would be surprising if it did not structure his interpretations here. The result is a complicated moral and psychological distinction between the Greek and Gothic schools.

The way by colour is taken by men of cheerful, natural, and entirely sane disposition in body and mind. . . . The way by light and shade is, on the contrary, taken by men of the highest powers of thought, and the most earnest desire for truth; they long for light, and for knowledge of all that light can show. But seeking for light, they perceive also darkness; seeking for truth and substance, they find vanity. They look for form in the earth, – for dawn in the sky: and seeking these, they find formlessness in the earth, and night in the sky.*(20.139–40)*

Thus, although the school of colour is free to express visionary beauty, the chiaroscurists, 'the school of knowledge', acquire a human wisdom through the contemplation of darkness and death:

Farther, the school of colour in Europe, using the word Gothic in its broadest sense, is essentially Gothic *Christian*; and full of comfort and peace. Again, the school of light is essentially Greek, and full of sorrow. I cannot tell you which is right, or least wrong.*(20.140)*

A preference for light, whether in terms of colour or chiaroscuro, did however provide Ruskin with a workable answer.

I never speak of this Greek school but with a certain dread. And yet I told you that Turner belongs to it, that all the strongest men in times of developed art belong to it; but then, remember, so do all the basest. The learning of the Academy is indeed a splendid accessory to original power, in Velasquez, in Titian, or in Reynolds; but the whole world of art is full of a base learning of the Academy, which, when fools possess, they become a tenfold plague of fools.(22.40)

A love of colour was an essential sign of life; the Renaissance schools first showed their decay when they turned away from it. It was consistent with his earliest views on art that Salvator Rosa should lack 'the sacred sense – the sense of colour'(7.307). The more 'faithful and earnest the religion of the painter', the purer his colour, whereas 'where colour becomes a primal intention with a painter otherwise mean or sensual, it instantly elevates him, and becomes the one sacred and saving element in his work'(10.173).

To Ruskin, colour, and light the vehicle of colour, represented faith; colour, he said, was 'the type of love'(7.419). Colour and light without darkness was possible in an age of faith, as in thirteenth- and fourteenth-century Italy, but darkness showed the whole truth. Light with its necessary darkness represented the facts of man's fallen state; the battle of light and dark exemplified the heroic struggle between good and evil. When light and colour dominated, even for a moment, there was hope; but to convey the truth, the darkness must be shown as well as the light. In an appendix to the *Lectures on Art* entitled 'final notes on light and shade' Ruskin states, in terms as aphoristic as the *Laws of Fésole*, the resolution between the rival means of expressing form: 'Light and shade, then, imply the understanding of things – Colour, the imagination and the sentiment of them.'(22.489)

Ruskin's interpretation of the role of light, dark, and colour in art is both practical and symbolic at the same time. The argument based on perception works in parallel with the argument based on a moral world-view. Light, the type of energy and purity in *Modern Painters 2*, is a form of physical beauty; it also represents the creative harmony of man and God. For Ruskin this connection was absolutely real:

All up and down my later books, from *Unto this last* to *Eagle's Nest*, and again and again throughout *Fors*, you will find references to the practical connection between physical and spiritual light – of which I would fain state in the most

unmistakable terms, this sum: that you cannot love the real sun, that is to say physical light and colour, rightly, unless you love the spiritual sun, that is to say justice and truth, rightly. That for unjust and untrue persons, there is no real joy in physical light. . . . And that the physical result of that mental vileness is a total carelessness of the beauty of sky, or the cleanness of streams, or the life of animals and flowers: and I believe that the powers of Nature are depressed or perverted, together with the Spirit of Man; and therefore conditions of storm and of physical darkness, such as never were before in Christian times, are developing themselves, in connection also with forms of loathsome insanity, multiplying through the whole genesis of modern brains. (28.614–15)

Ruskin moved between the physical and the spiritual, the actual and the symbolic, the temporal and the eternal, because he believed that ultimately there was no difference between them. The problem now is to follow the processes of thought which led him to that conclusion.

Time after time, in spite of superficial incoherences, Ruskin reverts to a central core of ideas. Whatever the subject matter, and however entwined the different disciplines become, there is an underlying unity. John Rosenberg has commented on the difficulty of separating the aesthetic, moral and social strands in his thought: 'This inability to keep his subjects apart is at once the vice and virtue of Ruskin's mind. It makes chaos of single chapters, confusion even of entire books; but the whole of Ruskin's opus is dedicated to the Oneness of the many.'[14] But is 'the Oneness of the many' a sufficient description of what Ruskin was trying to demonstrate? It is true that he was trying to bring things towards unity, and the very multiplicity of the subjects he dealt with expresses this aim, but it should be possible to show more closely how this unity exists.

There is no doubt that Ruskin himself thought in terms of Oneness: 'Do you think that I am irreverently comparing great and small things? The system of the world is entirely one; small things and great are alike part of one mighty whole.'(7.452) James Sherburne has shown how Ruskin is in the Romantic tradition of Coleridge and Carlyle in emphasizing organic unity, and how this tradition is supported by the Platonic, Aristotelian and Christian philosophers, who found unity in the idea of God.[15] An emphasis on bringing things together is found throughout Ruskin's books, sometimes in their titles. *Munera Pulveris* – 'the rewards of the dust' – attacks the divisive competition of political economy; *Ethics of the Dust* uses mineralogical imagery to show people

brought together, crystallized, not atomized. It is hardly surprising that his attack on industrialization should begin by condemning the *division* of labour.

The danger of misunderstanding Ruskin's sense of unity lies in the temptation of treating it as a greater and greater inclusion of elements, so that we end up with no more than a vague description of everything being found in everything else, a universal unity that can only be broken down into its separate parts. Although Ruskin did widen his horizons continually, to take in more and more aspects – the expansion of a defence of Turner into *Modern Painters*, and of *Modern Painters* into social criticism, for instance – he did this in order to show not that they were all contained in some greater whole, but that they held, within themselves, common elements. Catherine Williams has said that

Ruskin's major faculty was the ability to synthesize information by isolating its essentials. He objected to scientific learning processes because they tended to accumulation, often based on hypothesis. Given a few 'phases', his own opus was reiterative, repeating conclusions instead of adding facts. It was a series of experiments to say the same thing.[16]

This is a much more satisfactory description of the unifying process, as a synthesis which reveals the common fundamental structure of things. It accounts for the consistency of Ruskin's imagery, and for the apparent obsession with certain themes, for it is these images which express, symbolically, the common elements in the multiplicity of matter.

For the moment, this description must be left as tentative, for there is an immediate objection to it. If one major theme has been the unity of Ruskin's thought, another has been its progression by opposites. Ruskin could never be described as a linear thinker, and he regarded such a method of thought as a limitation in other people: 'Every archaeologist, every natural philosopher, knows that there is a peculiar rigidity of mind brought on by long devotion to logical and analytical enquiries.'*(12.391)* The linear thinking of science was one of his objections to it.[17]

Ruskin's system of opposites should not be confused with Aristotle's method of finding a mean between two extremes: 'If a man were disposed to system-making he could easily throw together a counter-system to Aristotle's, showing that in all things there were two extremes which exactly resembled each other, but of which one was bad, the other good; and a mean, resembling neither, but better than one, and worse

than the other.'(*5.385–6n*) In practice Ruskin tended to use contrasting terms which acted as separate but parallel categories, each category containing polarities of an idea within it. Thus the terminology of *The Aesthetic and Mathematic Schools of Art in Florence* (1874) takes two characteristics of the whole school of Florentine painting, and traces their development out of a synthesis of Lombard-Norman art, on the one hand (the Aesthetic), and Greek-Arab, on the other (the Mathematic). In turn the Aesthetic becomes 'Christian Faithful' and the Mathematic 'Christian Classic'; the two terms are then further synthesized into 'Christian Romantic'. Ruskin was trying to change what he called the pitiable weakness of the English mind, 'its usual inability to grasp the connection between any two ideas which have elements of opposition in them, as well as of connection'(*6.482*).

If Ruskin's terminology is thought of as a series of polarities containing their own extremes of good and bad, the apparent contradictions in what he says about art become comprehensible. Thus he is able to contrast colourists and chiaroscurists, and at the same time distinguish between good and bad colourists, good and bad chiaroscurists. His critical theories depend upon a series of dynamic opposites, between one order of truth and another, between imagination and accurate perception, between realism and expression, between the particular and the ideal. The relationship between the artist and his society is a two-way process, the artist leading society, society creating the conditions in which an artist may lead. A static reconciliation is impossible, and the tension is a source of energy and movement, which Ruskin detected in the physical world: 'all forms are thus either indicative of lines of energy, or pressure, or motion, variously impressed or resisted' (*D2.370–1*).

Polarities, however, depend on the absolute opposition of north and south – in Ruskin's case, of good and bad. The conflict of good and bad could not be resolved by an Aristotelian middle way of moderate behaviour; the opposition had to be resolved on the side of good. Man himself was the battleground:

We find ourselves instantly dealing with a double creature. Most part of his being seems to have a fictitious counterpart, which it is at his peril if he do not cast off and deny. Thus he has a true and false (otherwise called a living and dead, or a feigned and unfeigned) faith. He has a true and a false hope, a true and false charity, and, finally, a true and a false life. (*8.191*)

Such was his view of man in *The Seven Lamps of Architecture*, and in 1880

he endorsed it, though he preferred to put the problem more simply, in terms now familiar: 'the real question is only – are we dead or alive?' *(8.192n)*

Although it is an essential first step to think of Ruskin's work in terms of polarities (Kingship and Queenship) and opposites (Life against Death), it is reasonable to ask whether he got further than that, and achieved any adequate synthesis. John Rosenberg has pointed out that Ruskin's prose, in individual passages, or in the whole scheme of *Modern Painters* is structured round opposing visions of heaven and hell: 'It may be that the greatest creative artists are all Manichees in spirit, possessed of a vision of blessedness beyond our grasp of joy and of an inferno more profound and actual than we can fathom.'[18] The Manichean philosophy holds that the Devil exists co-eternal with God; the consequence of such a dualistic philosophy must be pessimistic, for it means that there can be no resolution of the struggle between heaven and hell. There are times when Ruskin seems close to such a view. His moments of madness and sanity were a double vision of evil on the one hand and loving Christianity on the other. His diary entries oscillate from day to day between happiness and misery. The life of a plant, he notes, is divided between that of the leaf, which seeks light, and the root which seeks darkness(22.194). All the oppositions in his life between theory and practice suggest an irreconcilable conflict. But there is a way out, by examining more closely the philosophy which had to deal with these oppositions at work.

What then was Ruskin's philosophy? It was this question that the philosopher R. G. Collingwood tried to answer in a lecture delivered in 1919, the centenary year of Ruskin's birth. Collingwood's first point was that Ruskin never elaborated anything resembling a formal philosophical statement of his position, but that he did have a series of fundamental principles, a nucleus of ideas, 'a ring of solid thought – something infinitely tough and hard and resistent',[19] which may be called a philosophy. Collingwood distinguished between two currents of ideas in nineteenth-century thought, 'Logicism', which treated individual facts as examples of general laws, and 'Historicism', which treated facts in terms of their individual history. Logicism, he argued, the traditional, empirical (and I would add linear) philosophy, was giving way to Historicism, of which Hegel was the most systematic exponent: 'Of this historical movement Ruskin was a whole-hearted adherent, and every detail of his work is coloured and influenced by the fact. In a quite real sense he was a Hegelian'.[20]

This statement must be rapidly qualified – as Collingwood does instantly – by the fact that Ruskin never read Hegel. The suggestion of a link between Ruskin and Hegel was not new in 1919; it had been made first by Collingwood's father W.G. Collingwood, in his book *The Art Teaching of John Ruskin* (1891). W.G. Collingwood had acted as Ruskin's secretary, and was in a position to know the facts of the case. He too pointed to Ruskin's lack of training in philosophy, and the fact that Ruskin knew no German; 'His extraordinary aptitude for picking up a hint, and making the most of it, inclines me to believe that what he knew of Hegel was gathered orally from some enthusiastic friend'.[21] The most obvious source of German ideas would be Carlyle, who encouraged Ruskin to read Fichte; but the elder Collingwood, if he knew the identity of the pro-German friend, did not reveal it. When one looks at the references to German ideas in the collected *Works*, the overall impression is of a strong anti-German prejudice, based on unfamiliarity.

Although, as in the case of Marx, this is a question of parallels and not of influences, the echoes of Hegel in Ruskin are strong, and R.G. Collingwood, himself trained in Hegelian philosophy, is quick to point them out. The first of these is a parallel belief in 'the unity or solidarity of the human spirit'.[22] Thus the problem of distinguishing between the moral faculty and the aesthetic, or the religious and creative, does not really exist, since all faculties are one. This is a fundamental assumption in Ruskin's work, and in this context the concept of an all-embracing unity does have some meaning. If the human spirit is indivisible, so is external reality. Proust makes the point to show how Ruskin was able to perceive the same truth in so many different forms: 'If reality is one and undivided, and if the man of genius is he who perceives it, what does it matter whether the material in which he expresses his vision is paint, stone, music, laws or actions?'[23]

The essential nature of this unity is that all objects are seen in their context, both local and historical, influenced by their present and past surroundings, and influencing them in turn, just as the colour of an object affects and is affected by its context. This is the point of view that made Collingwood call both Hegel and Ruskin 'Historicists'. For Hegel life existed in Becoming, not Being; Ruskin's attitude to Turner shows a similar concern:

The great quality about Turner's drawings which more especially proves their transcendent truth is, the capability they afford us of reasoning on past and future phenomena, just as if we had the actual rocks before us; for this

indicates not that one truth is given, or another, not that a pretty or interesting morsel has been selected here and there, but that the whole truth has been given, with all the relations of its parts(*3.487–8*).

Above all, a historical and contextual world-view places the study of art at the centre of any study of society. Hegel gave an important lead to Marxist aesthetics when he said: 'It is in works of art that nations have deposited the profoundest intuitions and ideas of their hearts; and fine art is frequently the key – with many nations there is no other – to the understanding of their wisdom and of their religion'.[24]

It is on the question of contradiction that the parallels between Hegel and Ruskin are most important. Ruskin made his most celebrated statement on the issue in an address given in 1858:

Perhaps some of my hearers this evening may occasionally have heard it stated of me that I am rather apt to contradict myself. I hope I am exceedingly apt to do so. I never met with a question yet, of any importance, which did not need, for the right solution of it, at least one positive and one negative answer, like an equation of the second degree. Mostly, matters of any consequence are three-sided, or four-sided, or polygonal; and the trotting round a polygon is severe work for people any way stiff in their opinions. For myself, I am never satisfied that I have handled a subject properly till I have contradicted myself at least three times(*16.187*).

Collingwood comments that it was Ruskin's firm belief that by contradicting himself he got nearer the truth: 'It was an idea which he certainly did not get from Hegel; but I need hardly remind you that it is at the very centre and core of Hegel's whole philosophy'.[25]

The idea that truth is arrived at dialectically through a series of contrary propositions was fundamental to Plato and Aristotle; Hegel's contribution was to apply this process to history as well as thought. Ruskin was familiar with the classical Greek dialectic, and there is a suggestion of the triad of thesis, antithesis, synthesis in his discussion of 'the Unity of Membership' in *Modern Painters* 2:

It cannot exist between things similar to each other. Two or more equal and like things cannot be members one of another, nor can they form one, or a whole thing. Two they must remain, both in nature, and in our conception, so long as they remain alike, unless they are united by a third different from both . . . as we rise in order of being, the number of similar members becomes less, and their structure commonly seems based on the principle of the unity of two things by a third, as Plato states it in the Timaeus, ¶11.(*4.95–6*)

Ruskin's humorous talk of polygons conceals a serious point: 'the more I see of useful truths, the more I find that, like human beings, they are eminently biped . . . it is quite necessary that they should stand on two, and have their complete balance on opposite fulcra'(*5.169*). Such truths have their stability in the synthesis of opposite positions, and may themselves partake of a higher opposition, without losing their validity. Ruskin speaks of 'principles of religious faith which are so universally dependent upon two opposite truths (for truths may be and often are *opposite* though they cannot be contradictory)'(*11.xvii*). Indeed, he states elsewhere, 'in almost all things connected with moral discipline, the same results may follow from contrary causes'(*5.385*). By relying on opposing truths he is able to resolve the apparent conflict between light and shade and colour in painting:

There are many truths respecting art which cannot be rightly stated without involving an appearance of contradiction, and these truths are commonly the most important. There are, indeed, very few truths in any science which can be fully stated without such an expression of their opposite sides, as looks, to a person who has not grasp of the subject enough to take in both sides at once, like contradiction.(*13.242*)

What could be more contradictory, he asks, than the propositions that perfection in drawing and colouring are inconsistent with one another, and that they depend on one another? His answer is that they find their synthesis in form: without an eye for colour we will not correctly discern the form, without draughtsmanship in light and shade we will be unable to outline the form the colour has to take.

The problem of thinking in dialectical terms is that each resolution of a contradiction leads to a new proposition, and therefore to the need for a new synthesis. This may explain why Ruskin thought of 'perfection' in art as the cause of its own decline. Venice, itself a historical synthesis of Lombard and Arab out of the wreck of Roman architecture (*9.38*), saw the coming together in Titian and Tintoretto of the two schools: that of light and shade, and that of colour. Having reached this pinnacle it could go nowhere but into its opposite, and decline. His own solution to a seemingly permanent dualism was to translate ideas into action, and turn the energy created by the conflict of opposites to some use. The problem then was that action itself produced its own contrary difficulties, which Ruskin never resolved.

There is however one important aspect of Ruskin's theories where dialectical as opposed to linear thinking is the only valid method: his system of the three orders of truth. The orders of truth are a triad in

which the truth of fact is thesis, the truth of symbol antithesis, and the truth of thought exists between them, in what may be called dialectical suspension. Evangelical typology had familiarized Ruskin at an early age with the practice of treating objects both as real and symbolic, without regarding one condition as cancelling out the other. The result was his ability to move in parallel along separate levels of argument, of the actual and the symbolic, without any sense of contradiction. Rather, the two levels were mutually supporting, so that a visual analogy meant more than the dramatization of intellectual thought: it was a *fact*. Similarly, it was not possible to look at the real world without considering the moral laws it exemplified. Thesis and antithesis remain in a state of perpetual interchange; the synthesis does not produce its opposite, since it exists in the eternal movement between the other two.

Although the comparison with Hegel is a useful one – there can be no doubt that Ruskin was a dialectical thinker – it is not a complete explanation of Ruskin's habits of mind because it is concerned only with the way he processed information, and does not take into account the way in which the information was gathered in the first place. To do that it is necessary to examine the mechanics of visual perception.

Visual perception is a two-fold operation: first the information is gathered by the eye, and then it is passed on to the brain, which processes what it receives. But, as Rudolf Arnheim has shown in his study *Visual Thinking*,[26] the information the brain receives has already been partly processed by the eye. The visual stimuli are filtered and selected, and give only partial information about the object at any one time. It is our memory of objects which enables the brain to interpret the information which we receive. The brain restores the sense-impression to a recognizable object, and adds to it all the other things we may know and think about the object, which may not be the result of purely visual information. The information as processed by the eye may be called a percept; that information as processed by the brain may be called a concept. In Ruskin's mental processes there is unusual emphasis on the work of the eye.

To begin with, sight is essentially the sense of the simultaneous. Sound or touch is comprehensible only as a sequence; in sight, however, we are able to see many things juxtaposed, existing independent of each other, and yet continuous, and unified by the field of vision. If we translate this percept into concept, then it is not a question of holding contradictory views, which, as in logic or mathematics, exist in sequence, but simultaneous views. If we look at a picture, the dark areas and the

light areas do not contradict one another, and their opposition is also interdependence. As Ruskin says, 'every light, is a shade, compared to higher lights, till you come to the sun; and every shade is a light, compared to deeper shades, till you come to the night'*(15.361)*.

Such a viewpoint accepts a relativity in the object which may be inconvenient if we wish to establish its permanent identity. Arnheim suggests that there are two main ways in which we may view an object if we wish to establish its 'constant' identity.[27] We may deliberately try to exclude from the information we receive all those aspects which we think are the inconstants brought about by whatever context the object happens to be in; on the other hand, we may choose to accept the object and its surroundings, and observe how its identity continuously evolves within its context. The first type of perception Arnheim labels 'scientific', the second 'aesthetic', and it is this form of vision which he finds the richest and the most rewarding:

The permanence of the object, its inviolate identity, is realized by the observer of the [aesthetic] type with no less certainty than by the one of the [scientific], but his approach creates concepts quite different from those envisaged in traditional logic. A concept from which everything is subtracted but its invariants leaves us with an untouched figment of high generality. Such a concept is most useful because it facilitates definition, classification, learning, and the use of learning. The object looks the same, every time it is met. Ironically, however, this eminently practical attitude leaves the person without the support of any one tangible experience since the 'true' size, shape, colour, he perceives are never strictly supported by what his eyes show him. Also the rigidity of such constants may make the observer blind to revelations.[28]

This distinction in modes of perception explains the difference between Ruskin and linear, 'logical' thinkers, and his hostility to analytical as opposed to descriptive science. It also explains why experiences in front of pictures play such an important part in the development of his thought; it explains why he chose to describe even those key moments which were the result of long meditation – the aspen tree at Fontaine-bleau, or the unconversion at Turin – in pictorial terms. This inter-action between eye and mind, and I stress that it is a dialectical relation, is the closest we can get to a description of the processes of his imagina-tion. It does not look for fixities, and so is able to comprehend change – and contradiction.

There is a further way in which a study of visual perception may help us to understand Ruskin. Perception is a continuous process, it moves in the dimensions of time and space just as objects move in the

dimensions of time and space. Through each individual moment of perception we establish the constant identity of an object; our experience enables us to accumulate the constant factors of an object, and discount the inconstants. Thus as we walk round a cube its image changes shape, yet we recognize it as a cube, although we have never seen, and never will see, all its six sides at once. In other words we abstract the invariant structure of an object from a series of variants. But the abstraction is made by recognizing that the invariants are a sequence, and that we are continuously perceiving the same object. Thus each momentary vision of the object indicates a part of its general structure, and the general structure is inherent in every partial view.[29] It seems to me that Ruskin was using this method when he tried to show the underlying coherence and unity of things. He read each partial view as showing that the same structure existed inherently in economics or crystallography. This explains what might otherwise be a paradox, that the images illustrating this underlying structure *are not strong visual images.*

Life-death, light-dark, kingship-queenship, clouds, air, water, do have visual content – otherwise they could not be called images – but they do not have a determined visual form. Light and dark clearly do not; clouds and water are formless; even Athena is dissolved into the air. Of course, if these images did have strong visual associations they would be less flexible and less useful to Ruskin. It is not a question of a theme illustrating an idea in a certain picture, but of discovering the same theme more or less exemplified by all pictures. The image can easily reside within a certain fixed and delimited form, but like the Biblical type its significance is not that particular entity, but a continuous reference forward and back. Finally, the ambiguity of the image is its advantage, for it can be read as particularity, or generality, and can comprehend change within itself. Another non-linear thinker, Ezra Pound, has expressed this more simply, and in visual terms: 'The image is not an idea. It is a radiant node or cluster; it is what I can, and must perforce, call a VORTEX, from which, and through which, and into which, ideas are constantly rushing.'[30]

What, then, is Ruskin's own interpretation of visual perception? I will not repeat all the references already quoted to the importance of sight, but I would add this one, which shows that Ruskin recognized a distinction between scientific and aesthetic perception: 'Not by "mathesis", not by deduction or construction, not by measuring, or searching, canst thou find out God, but only by the faithful cry from the roadside of the world as He passes – "Open Thou mine eyes that I may behold the wondrous things out of Thy law." '(23.250)

As I have said, perception does not depend on the eye alone, and Ruskin, speaking in nineteenth-century language of the relation between physiology and psychology, stresses that 'the physical splendour of light and colour, so far from being the perception of mechanical force by a mechanical instrument, is an entirely spiritual consciousness, accurately and absolutely proportioned to the purity of the moral nature, and to the force of its natural and wise affections'(22.208). Mind and eye work together, and Ruskin found in the language of the Greek philosophers exactly the word he needed to describe such a function: *theoria*.

Ruskin's conception of the theoretic faculty dates from the Evangelical period when, unconsciously, he learned to practise dialectical thought. The theoretic faculty represents the dialectical relationship between eye and mind, involving both, but resting finally in neither. The area in between he defined as the moral: 'Ideas of beauty, then, be it remembered, are the subjects of moral, but not of intellectual perception.'(3.111) The idea of beauty – the Evangelical type – is abstracted from the undifferentiated mass of information bombarding the eye, but it does not reach the level of conscious thought. 'I have throughout the examination of Typical Beauty, asserted our instinctive sense of it; the moral sense of it being discoverable only by reflection.' (4.211) Ruskin, I suggest, is distinguishing between a concept and a percept, something already structured by the perceptual process, but not yet at the level of thought. The forms of beauty are detected in each momentary view of reality; the artist, through his imaginative faculty, translates these perceptions into a work of art.

The very word *theoria* contains two levels of meaning: as the perceptual process 'contemplation', and as the highest intellectual activity of man. Ruskin quotes Aristotle: 'Perfect happiness is some sort of energy of Contemplation'(4.7). Hegel – a dialectician – uses the same word to describe the same function, and Ruskin originally drew a parallel between *theoria* and the German *Anschauung*, but he later revised this view, significantly because he thought it did not take sufficient account of the physiological element in perception. 'Anschauung does not (I believe) *include* bodily sensation, whereas Plato's does, so far as is necessary, and mine, somewhat more than Plato's.'(25.124)

Ruskin abandoned the theoretic faculty almost as soon as he had found it, and in the middle period of his life often disparaged *Modern Painters 2*. But it was the Evangelical trappings that he was attacking. The symbolism which he first learnt as Evangelical typology was vital to his work, for it taught him dialectical thought. He continued to use

the Evangelical method although he no longer believed in the specifically Evangelical application of types. I do not believe that his view of perception changed either.

At the end of his life Ruskin came to recognize the significance of what he had said in *Modern Painters* 2 and decided to republish the volume, intending to leave out 'the passages concerning Evangelical or other religious matters, in which I have found out my mistakes' *(25.123)*. In 1877 he publicly acknowledged the importance of the theory he seemed to have neglected: 'I find now the main value of the book to be exactly in that systematic scheme of it which I had despised, and in the very adoption of and insistence upon the Greek term Theoria, instead of sight or perception, in which I had thought myself perhaps uselessly or affectedly refined.'

Theoria includes sight, and it includes imagination. Musing on the words he had written so long ago, he wrote: ' "Intellectual lens, and moral retina" – the lens faithfully and far collecting, the retina faithfully and inwardly receiving. I cannot better the expression.'*(22.513)*

Notes

References are to the editions cited in the Bibliography.

CHAPTER I
RUSKIN AND NATURE (pp. 13–29)
Epigraph: 35.95

1 See V. A. Burd's introduction to *The Ruskin Family Letters*, pp. xvi–xxiii.

2 Typewritten transcript of MS. of 1830 diary, 'A Tour to the Lakes in Cumberland', Bodleian Library, Oxford, MS. Eng. Misc. C.234, f.3.

3 Ibid., f.7.

4 This description was published in various forms: in 1810 to accompany a set of views, in 1820 to accompany a set of sonnets by Wordsworth, and in 1822 as a separate volume, *A Description of the Scenery of the Lakes*. After being revised and enlarged in 1823 it was reissued as *A Guide through the District of the Lakes*. I refer to it in its final form, as last revised by Wordsworth in 1835. There is no direct evidence that I know of that Ruskin actually used the guide; but, since, as he said, he used Wordsworth as 'a daily text-book from youth to age'*(34.349)*, it is reasonable to suppose that he used him as a guide book as well. *The Poetry of Architecture* (1837–38) was almost certainly influenced by the guide (see *1.46n*).

5 W. Wordsworth, *A Guide through the District of the Lakes*, in *The Prose Works . . .*, vol. 2, p. 167.

6 Ibid., p. 234.

7 W. Wordsworth, *The Prose Works . . .*, vol. 1, p. 132.

8 W. Wordsworth, 'Lines Composed a Few Miles above Tintern Abbey . . .', lines 94–102.

9 W. Wordsworth, *The Prose Works . . .*, vol. 1, p. 126.

10 W. Wordsworth, *The Excursion*, book 4, lines 978–92.

11 E. T. Cook, *The Life of John Ruskin*, vol. 1, p. 32.

12 John James Ruskin bought an unidentified edition of Jameson's *System of Mineralogy* in 1832; see *RFL* 260n.

13 H. B. de Saussure, *Voyages dans les Alpes*, vol. 1, p. i.

14 R. Jameson, *System of Mineralogy*, vol. 1, p. iii.

15 R. Jameson, *Manual of Mineralogy*, pp. 363–4.

16 W. Buckland, *Geology and Mineralogy, Considered with Reference to Natural Theology*, p. 9.

17 Ibid., pp. 535–8.

18 Ibid., p. 588.

19 Ibid., p. 593.

20 J. C. Ryle, *Evangelical Religion . . .*, p. 139. For Ruskin on Ryle see *36.180*.

21 Kenneth Clark says that Ruskin's biblical references are 'embarrassing and incredible . . . whenever I have seen a biblical quotation in the offing I have begun to lose interest, because I know that at this point Ruskin will cease to use his own powers of intelligent observation, and will rely on holy writ to save him further thought' *(Ruskin Today*, p. xv). In fact Ruskin, as a Bible scholar, used his references carefully, and reference to the biblical context illuminates what Ruskin is saying. It is we, not Ruskin, who neglect our powers of observation if we ignore the importance of the Bible to him.

22 J. C. Ryle, *Evangelical Religion . . .*, p. 139.

23 Ibid., p. 140.

24 H. Melvill, *Sermons*, vol. 2, p. 309.

25 For a full discussion of Evangelical typology and its significance for Ruskin,

see G. P. Landow, *The Aesthetic and Critical Theories of John Ruskin*, ch. 5.

26 W. Wilberforce, *A Practical View of . . . Christianity*, p. 305.

CHAPTER 2
RUSKIN AND THE PICTURESQUE
(pp. 30–53)
Epigraph: L45.142.

1 J. D. Rosenberg, *The Darkening Glass . . .*, p. 19.

2 S. T. Coleridge, *Notebooks*, ed. K. Coburn, London 1962 (2.2546), quoted in P. M. Ball, *The Science of Aspects*, p. 34.

3 W. Wordsworth, 'Lines Composed a Few Miles above Tintern Abbey . . .', line 91.

4 A. Alison, *Essays on the Nature and Principles of Taste*, pp. 25–6.

5 P. Walton, *The Drawings of John Ruskin*, p. 9.

6 See A. M. Holcomb, 'A Neglected Classical Phase in Turner's Art: His Vignettes for Rogers's *Italy*'.

7 Although this drawing is not signed by Ruskin, its provenance and similarity to other Ruskin-associated drawings of the period make it almost certain that it is by him.

8 S. Prout, *Prout's Microcosm*, p. 1.

9 J. D. Harding, *Elementary Art*, p. 41.

10 For more on the 1836 essay see V. A. Burd, 'Ruskin's Defence of Turner: the Imitative Phase'.

11 See V. A. Burd, 'Another Light on the Writing of *Modern Painters*'.

12 W. Walker, 'J. D. Harding', p. 30.

13 See G. P. Landow, 'Ruskin's Revisions of the Third Edition of *Modern Painters*, Volume 1'.

14 *Modern Painters*, 1st edition, vol. 1, p. 398.

15 U. Price, *An Essay on the Picturesque*, vol. 1, p. 63.

16 Quoted in C. P. Barbier, *William Gilpin*, p. 106.

17 Paul Walton says of these drawings: 'This is the old concern with the picturesque, with its combination of visual delight and associated ideas, but now the moral and expressive meaning of the subjects began to take on a tragic tone.'

(*The Drawings of John Ruskin*, p. 94.) The moral overtones would seem to justify their description as exercises in the 'Turnerian picturesque'.

CHAPTER 3
RUSKIN AND BEAUTY (pp. 54–64)
Epigraph: 11.83.

1 G. P. Landow, *The Aesthetic and Critical Theories of John Ruskin*, pp. 101–3.

2 Ibid., pp. 107–8.

3 Although George Landow (ibid., p. 68) stresses the importance of Ruskin's religious views for his theory of beauty, and acknowledges that both typical and vital beauty are ultimately expressions of God, he treats vital beauty as having a different basis from typical beauty, arguing that it is the result of Romantic poetic theory. He is right to point to the danger to Ruskin's theory of objective beauty which the emotional element of vital beauty introduces, but it seems to me that vital beauty has a natural-theological basis (for instance his reference to a work by Sir Charles Bell, author of one of the Bridgewater treatises, 4.179), and so is more consistent with typical beauty than Landow suggests. Surely the point is that the perception of the Romantic poet, the natural-theologian scientist, and the preacher, come very close.

4 See G. P. Landow, *The Aesthetical Critical Theories of John Ruskin*, p. 115.

5 See J. Sherburne, *John Ruskin or the Ambiguities of Abundance*, p. 6; also his comments on the use of the word 'purity', ibid., pp. 4–5.

6 As Allen Staley has shown in *The Pre-Raphaelite Landscape*, Ruskin was initially impressed by Millais and Holman Hunt. As Ruskin himself pointed out, it is an over-simplification to treat the Pre-Raphaelites as a single group; there are 'the poetical Pre-Raphaelites and the prosaic Pre-Raphaelites' (14.468). He regarded the 'prosaic', that is to say the hard-edge naturalists, as the more important. I have not got the space to discuss Ruskin's relations with the 'poetic' Rossetti, or to make more than

the point that Ruskin was first attracted to the PRB because of its apparently anti-picturesque attitude to landscape.

CHAPTER 4

RUSKIN AND THE IMAGINATION
(pp. 65–118)

Epigraph: 17.208.

1 The question of the literary sources of Ruskin's theory of the imagination is as complicated as the theory itself, and for the sake of clarity I have left it out. Ruskin acknowledges Wordsworth's preface of 1815 to the *Lyrical Ballads* (4.229–30) and refers to Leigh Hunt's *Imagination and Fancy*, London 1844 (4.254). The extent to which he knew about Coleridge's theory in the *Biographia Litteraria* has not been finally established, although it is becoming clearer that he knew more about Coleridge's general ideas than was formerly supposed. For discussion of Ruskin's theory in the light of Romanticism see: H. Ladd, *The Victorian Morality of Art . . .*, pp. 203–44; V. A. Burd, 'Ruskin's Quest for a Theory of Imagination'; J. Sherburne, *John Ruskin or the Ambiguities of Abundance*, pp. 12–25.

2 A. F. Rio, *De la poésie chrétienne . . .*, published in English in 1854.

3 Ruskin was probably using a Brussels edition of 1838(L45.53n).

4 H. Ladd, *The Victorian Morality of Art . . .*, p. 189.

5 Ruskin's instructions are: 'Let the reader first cover with his hand the two trunks that rise against the sky on the right, and ask himself how any termination of the central mass so *ugly* as the straight trunk which he will then painfully see, could have been conceived or admitted without *simultaneous conception* of the trunks he has taken away on the right? Let him again conceal the whole central mass, and leave these two only, and again ask himself whether anything so ugly as that bare trunk in the shape of a Y, could have been admitted without reference to the central mass? Then let him remove from this trunk its two arms, and try the effect; let him again

remove the single trunk on the extreme right; then let him try the third trunk without the excrescence at the bottom of it; finally, let him conceal the fourth trunk from the right, with the slender boughs at the top: he will find, in each case, that he has destroyed a feature on which everything else depends; and if proof be required of the vital power of still smaller features, let him remove the sunbeam that comes through beneath the faint mass of trees on the hill in the distance.'(4.245)

6 Ruskin chooses to ignore his own comments on the picture, made in his *Notes on the Turner Gallery at Marlborough House* (1856), where, discussing the mountain forms, rather than the dragon, he attacks Turner for inaccurate geology, blaming this on the influence of Nicolas Poussin(*13.113–19*).

CHAPTER 5

THE ARTIST AND SOCIETY (pp. 119–47)

Epigraph: see note 21.

1 For a sympathetic account of the Ruskin marriage see M. Lutyens, *The Ruskins and the Grays* and *Millais and the Ruskins*. For an unsympathetic account see W. James, *The Order of Release*.

2 See P. Walton, *The Drawings of John Ruskin*, p. 81. He suggests that working so closely with Millais influenced this and later drawings.

3 D. Leon, *Ruskin, the Great Victorian*, p. 196.

4 He did, however, prepare a defence, blaming Effie and saying 'I can prove my virility at once'. See Ruskin's formal statement to his Proctor in J. H. Whitehouse, *Vindication of Ruskin*, p. 16.

5 D. Leon, *Ruskin, the Great Victorian*, p. 198.

6 *Essays and Reviews* (1860) was the work of seven Broad Church contributors who wished to stimulate free discussion of controversial theological subjects, including the historicity of the Mosaic account, and the question of whether or not the Bible should be handled with the same critical techniques as other works, for instance, Homer. Two con-

tributors, Rowland Williams, who attacked the literalism of current Biblical interpretation, and Henry Bristow Williams, who called for freedom of opinion for clergy as well as laity, were prosecuted for heresy in the Church Courts and censured, although their appeals were upheld in 1864.

Bishop John William Colenso's *The Pentateuch and the Book of Joshua Critically Examined* (1862–79) was a much more controversial book, since he claimed that little, if any, of the Pentateuch was written in the Mosaic age, and that the Bible was certainly *not* the word of God in any literal sense. Attempts were made to remove him from his see of Natal, in South Africa, and in 1866 he was excommunicated by the South African Anglican church. See F. W. Cornish, *The English Church in the Nineteenth Century*, vol. 2, pp. 215–54 (on *Essays and Reviews*), pp. 245–63 (on the Colenso controversy).

7 I am indebted to George Landow's chapter on Ruskin's religious belief in his *Aesthetic and Critical Theories of John Ruskin*. I would disagree only with his view that Ruskin never publicly supported Colenso. The donation of the Colenso diamond to the British Museum was one gesture (see also *14.285, 18.416, 28.244, 28.250, 28.514*).

8 C. Lyell, *Principles of Geology*, vol. 1, p. 58.

9 The Book of Job plays an important part in 'The Moral of Landscape' in *Modern Painters 5*.

10 This quotation comes from some notes on the gallery sent to his father at the time. They are the most immediate account we have of the impression made on him by the picture. The chronology of his accounts will be seen to be important.

11 G. P. Landow, *The Aesthetic and Critical Theories of John Ruskin*, pp. 281–4.

12 F. G. Townsend, *Ruskin and the Landscape Feeling*, p. 49.

13 A. W. Pugin, *Contrasts; or A parallel between the Noble Edifices of the Fourteenth and Fifteenth Centuries, and Similar Buildings*

of the Present Day; shewing the Present Decay of Taste: Accompanied by Appropriate Text*, first published at his own expense in 1836; reprinted in 1841, extensively revised, and enlarged to nearly twice its original length. The additions tend to shift Pugin's pro-Roman Catholic polemic away from Protestantism towards the Renaissance as the cause of the decline of Gothic architecture. See H. R. Hitchcock's introduction to the Leicester reprint of the second edition.

For further discussion of the links between Pugin and Ruskin see K. Clark, *The Gothic Revival*, pp. 145–9, 192–204; F. G. Townsend, *Ruskin and the Landscape Feeling*, pp. 37–44.

14 See E. Alexander, 'Art amidst Revolution: Ruskin in 1848', p. 10.

15 See 8.254, 9.271, 9.128.

16 'St Mark's' is 1852; 'Mountain Gloom' is based on notes made in 1854, and was published in 1856. I took the later passage first for thematic convenience.

17 A. Smith, *An Inquiry into the Nature and Causes of the Wealth of Nations*, vol. 1, p. 8.

18 Karl Marx, *Early Texts*; 'Alienated Labour', pp. 133–45; 'Private Property and Communism', pp. 145–57; 'Money', pp. 178–83.

19 The texts Ruskin used were D. Ricardo, *Principles of Political Economy and Taxation*, London 1821, and J. S. Mill, *Principles of Political Economy*, 2nd edition, London 1848. Ruskin's copy of the latter, with interesting marginalia, is now in the British Library, London, c.60.1.10.

20 A. Smith, *An Enquiry into the Nature and Cause of the Wealth of Nations*, vol. 1, p. 89; T. R. Malthus, *Essay on the Principle of Population*, p. 507.

21 T. Carlyle, 'Goethe', p. 208.

CHAPTER 6

THE QUEEN OF THE AIR (pp. 148–66)

Epigraph: 19.300.

1 Anon., *Saturday Review*; *Manchester Review*.

2 J. Sherburne, *John Ruskin or the Ambiguities of Abundance*, p. 202.

3 See K. Millett, *Sexual Politics*, pp. 88–108 ('Mill versus Ruskin').

4 The text of *The Queen of the Air* finally included material from the following sources:

> Ruskin's Rede Lecture at Cambridge in 1867;
> Ruskin's lecture to the Royal Institution on 'The Flamboyant Architecture of the Somme', 29 January 1869;
> Ruskin's pamphlet *Notes on the General Principles of Employment for the Destitute and Criminal Classes*, 1868;
> Ruskin's articles for the *Art Journal* under the general title *The Cestus of Aglaia*, the article 'Modesty' for March 1865, and the article 'Liberty' for July 1865;
> Ruskin's lecture 'The Hercules of Camarina' at the South Lambeth Art School, 15 March 1869.

Ruskin also twice mentions using unpublished fragments.

5 The idea that myths derived from natural phenomena was one of the half-dozen themes then currently used to explain their origins. The chief exponent of this 'solar' theory of myth was F. Max Müller, whose *Lectures on the Science of Language* are referred to in *The Queen of the Air* (19.335n). Ruskin was also influenced by Müller's work as a philologist.

6 For more on this point see G. P. Landow, *The Aesthetic and Critical Theories of John Ruskin*, p. 351.

7 For instance, his paintings of snakes in the collection of the Ruskin Drawing School, and his description of the snake's motion in *The Queen of the Air* (19.362).

8 J. Fergusson, *Tree and Serpent Worship*, p. 71n.

9 Unpublished letter to Miss Corlass, n.d., but marked 'Xmas 1863', seen at Sotheby's, London, December 1968 (Lot 797).

10 W. James, *The Order of Release*, p. 255.

11 Rose had her own cloud theme. Her book of poetry and stories, *Clouds and Light*, quotes Job 37: 11, 15, 21, on the title page: 'He wearieth the thick cloud; he scattereth his bright cloud. And caused the light of his cloud to shine. Men see not the bright light which is in the clouds.'

12 Born Georgiana Tollemache Tollemache, married to the Hon. William Cowper, stepson of Lord Palmerston, from whom they inherited their country house Broadlands. In 1869 he became Cowper-Temple, and Lord Mount-Temple in 1880. For the importance of the Cowper-Temples to Ruskin see the introduction to *The Letters of John Ruskin to Lord and Lady Mount-Temple*, ed. J. L. Bradley. For Ruskin's interest in spiritualism in 1863 and 1864 see D. Home, *D. D. Home, his Life and Mission*, pp. 116–17.

> Catherine Williams has revealed the important connection between the Cowper-Temples and the American reformer Thomas Lake Harris, who had founded a community called the Brotherhood of the New Life and held semi-spiritualist views on the nature of matter: C. Williams, 'Ruskin's Late Works *c.* 1870–1890 . . .', pp. 12–13, 16–22, 272 note 23.

13 Unpublished letter to Mrs A. Tylor dated 31 December 1875, no address, Guild of St George collection, Reading University. The conversation probably took place on 14 December (*D.3.876*).

14 For the significance of vervain see H. Viljoen's analysis in *The Brantwood Diary of John Ruskin*, pp. 120–1.

CHAPTER 7
ACTION (pp. 167–90)
Epigraph: 29.137.

1 For the true context and significance of the project, see T. Hilton, 'Road Digging and Aestheticism, Oxford 1875'.

2 For a survey of nineteenth-century art education see S. Macdonald, *The History and Philosophy of Art Education*.

3 Ibid., p. 228.

4 Ibid., pp. 219–20.

5 *Oxford University Gazette*, no. 193 (1 June 1875), p. 634.

6 It would be possible to restore the

collection, without disturbing present arrangements, by reproducing the sequence in slide form. This would make the whole collection accessible, and it would be possible to relocate some of the items that have gone astray. In the sequence in the 1878 rearrangement of the Rudimentary Series, for instance, Nos. 289 to 292, which I have illustrated, 289 is in the Guild collection, 290 and 291 are at Oxford, and 292 has disappeared, although it is illustrated in the Library Edition.

7 For a *catalogue raisonné* of Ruskin's Turner gifts to Oxford see L. Herrmann, *Ruskin and Turner*.

8 In almost the last issue of *Deucalion* in 1883, he announced that he was going to republish *Modern Painters 2*, which, 'though in affected language, expresses the first and foundational law respecting human contemplation of natural phenomena ... that they can only be seen with their properly belonging joy, and interpreted up to the measure of proper human intelligence, when they are accepted as the work and gift, of a Living Spirit greater than our own' (26.334).

9 For a full examination of possible meanings see 27.xix–xxii.

10 E. H. Scott, *Ruskin's Guild of St George*, pp. 33–4.

11 For a thorough demonstration of the relationship between the grammars and the Museum collection, see C. Williams, 'Ruskin's Late Works ...', pp.120–91.

12 Plato, *The Republic*, trans. H. D. P. Lee, introduction, pp. 16–17.

CHAPTER 8
ON SEEING WHAT RUSKIN MEANT
(pp. 191–212)
Epigraph: M. Proust, 'John Ruskin', p. 60.

1 J. D. Rosenberg, *The Darkening Glass ...*, p. 147.

2 R. H. Wilenski, *John Ruskin*, p. 10.

3 D. Sonstroem, 'John Ruskin and the Nature of Manliness', p. 14; H. Lemaître, *Les Pierres dans l'œuvre de Ruskin*, p. 195.

4 *The Gulf of Years, Letters of John Ruskin to Kathleen Olander*; J. A. C. Sykes, *Mark Alston*.

5 J. D. Rosenberg, 'Style and Sensibility in Ruskin's Prose', p. 193.

6 K. Clark, *Ruskin Today*, p. xx.

7 M. Proust, 'John Ruskin', p. 69.

8 Ibid., p. 84. It is important to know that the essay I am quoting was a compilation by Proust of several articles on Ruskin written at different stages of his enthusiasm. The exoneration of 'fetishism' was written in 1902; the harshest criticism, such as this, was written in 1904, when the influence of Ruskin was on the wane.

9 R. de la Sizeranne, *Ruskin and the Religion of Beauty*, p. 96.

10 F. G. Townsend, *Ruskin and the Landscape Feeling*, p. 57.

11 J. Evans, *John Ruskin*, p. 411.

12 'Les préoccupations multiples mais constantes de cette pensée, voilà ce qui assure à ces livres une unité plus réelle que l'unité de composition généralement absente, il faut bien le dire.' M. Proust, *Sésame et les lys*, p. 62n.

13 R. H. Wilenski, *John Ruskin*, p. 138.

14 J. D. Rosenberg, *The Darkening Glass ...*, pp. 41–2.

15 J. Sherburne, *John Ruskin or the Ambiguities of Abundance*, pp. 3–4.

16 C. Williams, 'Ruskin's Late Works ...', p. 107.

17 At one point he suggested an alternative method, at least as far as the connection between species was concerned: 'They touch at certain points only; and even then are connected, when we examine them deeply, in a kind of reticulated way, not in chains, but in chequers'(19.359). Ruskin could almost be repeating the words of the eighteenth-century Swiss botanist Albrecht von Haller, 'Nature connects its genera in a network, not in a chain', quoted in R. Arnheim, *Visual Thinking*, p. 234. Ruskin knew of Haller's work.

18 J. Rosenberg, 'Style and Sensibility in Ruskin's Prose', p. 189.

19 R. G. Collingwood, *Ruskin's Philosophy*, p. 6.

20 Ibid., p. 14.

21 W. G. Collingwood, *The Art Teaching of John Ruskin*, p. 17.
22 R. G. Collingwood, *Ruskin's Philosophy*, p. 16.
23 M. Proust, 'John Ruskin', p. 63.
24 G. W. F. Hegel, *The Introduction to Hegel's Philosophy of Fine Art*, p. 13. I have referred to the Bosanquet edition because of W. G. Collingwood's remark that 'there are many coincidences in point of view' with Ruskin (*The Art Teaching of John Ruskin*, p. 16).
25 R. G. Collingwood, *Ruskin's Philosophy*, p. 22.
26 R. Arnheim, *Visual Thinking*, ch. 2, 'The intelligence of Visual Perception (1)', pp. 13–36.

27 Ibid., p. 43. In fact he says there are three possible perceptual approaches to an object; but the first must be discounted as an attempt to produce a constant identity for the object, since 'One kind of observer perceives the contribution of the context as an attribute of the object itself. He sees, more or less, what a photographic camera records, either because he stares restrictively and unintelligently at a particular target or because he makes a deliberate effort to ignore the context and to concentrate on the local effect.'
28 Ibid., p. 45.
29 Ibid., pp. 47–50.
30 E. Pound, *Gaudier-Brzeska*, p. 106.

Bibliography

JOHN RUSKIN

The Works of John Ruskin (Library Edition), ed. E. T. Cook and A. Wedderburn, 39 vols, London, George Allen, 1903–12.

(With Mary Richardson) 'A tour to the Lakes in Cumberland', typewritten transcript of MS. of 1830 diary, Bodleian Library, Oxford, MS. Eng. Misc. c.234.

Modern Painters, 1st edition, London, Smith, Elder, 1843.

Letters of John Ruskin to Charles Eliot Norton, ed. C. E. Norton, 2 vols. Boston and New York, Houghton Mifflin, 1904.

Ruskin in Italy, Letters to his parents 1845, ed. H. I. Shapiro, Oxford, Clarendon Press, 1972.

The Ruskin Family Letters (1801–1843), ed. V. A. Burd, 2 vols, Ithaca and London, Cornell University Press, 1973.

The Winnington Letters of John Ruskin, ed. V. A. Burd, London, Allen & Unwin, 1969.

Ruskin's Letters from Venice 1851–1852, ed. J. L. Bradley, New Haven, Yale University Press, 1955.

The Letters of John Ruskin to Lord and Lady Mount-Temple, ed. J. L. Bradley, Columbus, Ohio State University Press, 1964.

The Gulf of Years, Letters from John Ruskin to Kathleen Olander, ed. R. Unwin, London, Allen & Unwin, 1953.

The Diaries of John Ruskin, ed. J. Evans and J. H. Whitehouse, 3 vols, Oxford, Clarendon Press, 1956.

The Brantwood Diary of John Ruskin, ed. H.G. Viljoen, New Haven and London, Yale University Press, 1971.

Anon., *Manchester Review*, vol. 2 no. 33 (18 August 1860).

Anon., 'Mr Ruskin again', *Saturday Review*, vol. 10 no. 263 (10 November 1860), pp. 582–4.

Abrams, M.H., *The Mirror and the Lamp, Romantic Theory and the Critical Tradition*, New York, Oxford University Press, 1953.

Alexander, E., 'Art Amidst Revolution: Ruskin in 1848', *Victorian Newsletter*, no. 40 (Fall 1971), pp. 8–13.

Alison, A., *Essays on the Nature and Principles of Taste*, Dublin 1790.

Arnheim, R., *Visual Thinking*, London, Faber & Faber, 1970.

Autret, J., *Ruskin and the French before Marcel Proust*, Geneva, Droz, 1965.

Ball, P.M., *The Central Self*, London, Athlone Press, 1968.

——, *The Science of Aspects*, London, Athlone Press, 1974.

Barbier, C.P., *William Gilpin*, Oxford, Clarendon Press, 1963.

Betirac, P., 'Justice et économie politique, Unto this last de John Ruskin', unpublished thesis for University of Lyons, *n.d.*

Bragman, L.J., 'The Case of John Ruskin: A Study in Cyclothymia', *American Journal of Psychiatry*, vol. 91 (March 1935), pp. 1137–59.

Brunhes, H.J., *Ruskin et la Bible*, Paris, Perrin, 1901.

Buckland, W., *Geology and Mineralogy Considered with Reference to Natural Theology*, 2 vols, London 1836.

Burd, V.A., 'Ruskin's Defence of Turner: The Imitative Phase', *Philological Quarterly*, vol. 37 no. 4 (1958), pp. 465–83.

——, 'Ruskin's Quest for a Theory of the Imagination', *Modern Language Quarterly*, vol. 17 no. 1 (March 1956), pp. 60–72.

——, 'Another Light on the Writing of *Modern Painters*', *PMLA*, vol. 68 no. 4, part 1 (September 1953), pp. 755–63.

Carlyle, T., 'Goethe' (1828), *Works of Thomas Carlyle*, Centenary edition, London, Chapman & Hall, 1899, vol. 26.

Clark, K., *Ruskin Today*, London, John Murray, 1964.

——, *The Gothic Revival*, 3rd edition, London, John Murray, 1962.

——, *English Romantic Poets and Landscape Painting*, London, privately printed, 1945.

——, *Ruskin at Oxford*, Oxford, Clarendon Press, 1947.

Coleridge, S.T., *Biographia Litteraria*, ed. J. Shawcross, 2 vols, Oxford, Clarendon Press, 1907.

Collingwood, R.G., *Ruskin's Philosophy* (first published 1922), reprinted Chichester, Quentin Nelson, 1971.

Collingwood, W.G., *The Art Teaching of John Ruskin*, London, Methuen, 1891.

——, *The Life of John Ruskin*, London, Methuen, 1900.

Cook, E.T., *The Life of John Ruskin*, 2 vols, London, G. Allen, 1911.

Cornish, F.W., *The English Church in the Nineteenth Century*, 2 vols, London 1910.

Cundall, H.M., *A History of British Water Colour Painting*, London, Murray, 1908.

Davison, E., *Ruskin and his Circle*, exhibition catalogue, London, Arts Council, 1964.

Dearden, J.S., *Facets of Ruskin*, London, Charles Skilton, 1970.

——, 'Some Portraits of John Ruskin', *Apollo*, vol. 72 no. 430 (December 1960), pp. 190–5.

——, 'Further Portraits of John Ruskin', *Apollo*, vol. 74 no. 436 (June 1961), pp. 171–8.

Dougherty, C.T., 'Of Ruskin's Gardens', *Myth and Symbol*, ed. B. Slote, Lincoln, University of Nebraska Press, 1963, pp. 14–151.

Evans, J., *John Ruskin*, London, Cape, 1954.

Fain, J.T., *Ruskin and the Economists*, Nashville, Vanderbilt University Press, 1956.

——, 'Ruskin and his Father', *PMLA*, vol. 59 (1944), pp. 236–42.

Fergusson, J., *Tree and Serpent Worship*, London, India Museum and W.H. Allen, 1868.

Finberg, A.J., *The Life of J.M.W. Turner, R.A.*, revised edition, London 1961.

Fontaney, P., 'Ruskin and Paradise Regained', *Victorian Studies*, vol. 12 no. 3 (March 1969), pp. 347–56.

Gage, J., *Colour in Turner*, London, Studio Vista, 1969.

——, 'Turner and the Picturesque', *Burlington Magazine*, vol. 107 (1965), pp. 16–25, 75–81.

Geddes, P., *John Ruskin, Economist (Round-table Series III)*, Edinburgh, William Brown, 1884.

Giddey, E., *Samuel Rogers et son poème 'Italy'*, Geneva, Droz, 1959.

Gide, C., and C. Rist, *A History of Economic Doctrines*, trans. R. Richards, 2nd English edition, London, Harrap, 1948, reprinted 1967.

Gilbert, K., 'Ruskin's Relation to Aristotle', *The Philosophical Review*, vol. 49 (1940), pp. 52–62.

Hagstotz, H. B., *The Educational Theories of John Ruskin*, Lincoln, University of Nebraska Press, 1942.

Harding, J. D., *Elementary Art*, 4th edition, London 1854.

Harrison, F., *Tennyson, Ruskin, Mill, and Other Literary Estimates*, London, Macmillan, 1899.

Hayman, J., 'John Ruskin and the Art of System-making', *The Yearbook of English studies*, vol. 4 (1974), pp. 197–202.

Hegel, G. W. F., *The Introduction To Hegel's Philosophy of Fine Art*, trans. B. Bosanquet, London, Kegan Paul & Trench, 1886.

Herbert, R. L. (ed.), *The Art Criticism of John Ruskin* (selections), New York, Doubleday, 1964.

Herford, C. H., 'Ruskin and the Gothic Revival', *Quarterly Review*, vol. 206, pp. 77–96.

Herrmann, L., *Ruskin and Turner*, London, Faber & Faber, 1968.

Hewlett, H. G., 'The Rationale of Mythology', *Cornhill Magazine*, vol. 35 (April 1877), pp. 407–23.

Hilton, T., *The Pre-Raphaelites*, London, Thames & Hudson, 1970.

——, 'Road Digging and Aestheticism, Oxford 1875', *Studio International*, vol. 188 no. 972 (December 1974), pp. 226–9.

Hipple, W. J., *The Beautiful, the Sublime, and the Picturesque in Eighteenth Century British Aesthetic Theory*, Carbondale, University of Illinois Press, 1957.

Hobson, J. A., *John Ruskin, Social Reformer*, London, Nisbet, 1898.

Holcomb, A. M., 'A Neglected Classical Phase in Turner's Art: his Vignettes for Rogers's *Italy*', *The Journal of the Warburg and Courtauld Institutes*, vol. 32 (1969), pp. 405–10.

Holloway, J., *The Victorian Sage, Studies in Argument*, London, Macmillan, 1953.

Home, D., *D. D. Home, his Life and Mission*, revised edition, ed. A. Conan Doyle, London, Kegan Paul, Trench & Trubner, 1921.

Honig, E., *Dark Conceit: The Making of Allegory*, New York, Oxford University Press, 1966.

Hough, G., *The Last Romantics*, London, Duckworth, 1949.

Hussey, C., *The Picturesque*, London, Putnams, 1927.

Jameson, R., *System of Mineralogy*, 3rd edition, Edinburgh 1820.

——, *Manual of Mineralogy*, Edinburgh 1821.

James, W., *The Order of Release*, London, John Murray, 1947.

Joyce, J., *Scientific Dialogues*, London 1808–9.

Kissane, J., 'Victorian Mythology', *Victorian Studies*, vol. 6 no. 1 (September 1962), pp. 5–28.

Ladd, H., *The Victorian Morality of Art: An Analysis of Ruskin's Esthetic*, New York, Long & Smith, 1932.

Landow, G. P., *The Aesthetic and Critical Theories of John Ruskin*, Princeton, Princeton University Press, 1971.

——, 'Ruskin's Revisions of the Third Edition of *Modern Painters*, Volume 1', *Victorian Newsletter*, no. 33 (Spring 1968), pp. 12–16.

——, 'Ruskin's version of "Ut Pictura Poesis"', *The Journal of Aesthetics and Art Criticism*, vol. 26 no 4 (Summer 1968), pp. 521–8.

La Sizeranne, R. de, *Ruskin and the Religion of Beauty*, trans. Countess of Galloway, London, George Allen, 1899.

La Touche, R., *Clouds and Light*, London 1870.

Lemaître, H., *Les Pierres dans l'œuvre de Ruskin*, Caen, Faculté des Lettres et Sciences Humaines, 1965.

Leon, D., *Ruskin, the Great Victorian*, London, Routledge & Kegan Paul, 1949.

Lindsay, J., *J. M. W. Turner*, London, Cory, Adams & Mackay, 1966.

——, *The Sunset Ship, Poems of J. M. W. Turner*, Lowestoft, Scorpion Press, 1966.

Lutyens, M., *Millais and the Ruskins*, London, John Murray, 1967.

——, *The Ruskins and the Grays*, London, John Murray, 1972.

——, *Effie in Venice*, London, John Murray, 1965.

Lyell, C., *Principles of Geology*, 3rd edition, 4 vols, London, John Murray, 1834.

MacDonald, G., *Reminiscences of a Specialist*, London, Allen & Unwin, 1932.

Macdonald, S., *The History and Philosophy of Art Education*, London, University of London Press, 1970.

Maidment, B. E., ' "Only Print" – Ruskin and the Publishers', *Durham University Journal*, vol. 63 no. 3 (June 1971), pp. 196–207.

Malthus, T. R., *Essay on the Principle of Population*, revised edition, London, Johnson, 1803.

Marx, K., *Early Texts*, ed. D. McLellan, Oxford, Blackwell, 1971.

Maurois, A., 'Proust et Ruskin', *Essays and Studies*, vol. 17 (1932), pp. 25–32.

Melvill, H., *Sermons*, 2 vols, London, Rivington, 1833.

Mészáros, I., *Marx's Theory of Alienation*, London, Merlin Press, 1970.

Mill, J. S., *Principles of Political Economy*, 2nd edition, 2 vols, London, Parker, 1848.

Millett, K., *Sexual Politics*, London, Hart Davis, 1971.

Müller, F. M., *Lectures on the Science of Language*, first series, London, Longmans, Green, Longman & Roberts, 1861.

——, *Lectures on the Science of Language*, second series, London, Longmans, Green, Longman, Roberts & Green, 1864.

——, *Chips from a German Workshop*, 3 vols, London, Longmans, Green, 2 vols 1867, 3rd vol. 1870.

Nicolson, M. H., *Mountain Gloom and Mountain Glory*, Ithaca, Cornell University Press, 1959.

Ollmann, B., *Alienation, Marx's concept of Man in Capitalist Society*, Cambridge, Cambridge University Press, 1971.

Painter, H. D., *Marcel Proust, a Biography*, 2 vols, London, Chatto & Windus, 1959, 1965.

Penny, N., 'John Ruskin and Tintoretto', *Apollo*, vol. 99 no. 146 (April 1974), pp. 268–73.

Plamenatz, J., *The English Utilitarians*, Oxford, Blackwell, 1949.

Plato, *The Republic*, trans. H. D. P. Lee, Harmondsworth, Penguin, 1955, reprinted 1963.

Pound, E., *Gaudier-Brzeska*, London, Laidlaw & Laidlaw, (1939).

Price, U., *An Essay on the Picturesque*, 3rd edition, 3 vols, London 1810.

Proust, M., *La Bible d'Amiens, traduction, notes et préface*, Mercure de France, 1904, reprinted 1947.

——, *Sésame et les lys, traduction, notes et préface*, Paris, Mercure de France, 1906.

——, *Marcel Proust, a Selection from his Miscellaneous Writings*, trans. G. Hopkins, London, Wingate, 1948.

Prout, S., *Prout's Microcosm*, London, 1841.

Pugin, A. W., *Contrasts*, 2nd edition (1841), reprinted Leicester, Leicester University Press, 1969.

Rawnsley, H. D., *Ruskin and the English Lakes*, Glasgow, Maclehose, 1901.

Ricardo, D., *Principles of Political Economy and Taxation*, London 1821.

Rio, A. F., *De la Poésie chrétienne dans son principe, dans sa matière, et dans ses formes*, 1st edition, 2 vols, Paris 1836, first published in English as *The Poetry of Christian Art*, London, Bosworth, 1854.

Robinson, J., *Economic Philosophy*, Harmondsworth, Penguin, 1964, reprinted 1970.

Roe, W., *The Social Philosophy of Carlyle and Ruskin*, London, Allen & Unwin, 1922.

Rogers, S., *Italy, a Poem*, London, Cadell & Moxon, 1830.

Roget, J. L., *The History of the Old Water-Colour Society*, 2 vols, London, Longmans, Green, 1891.

Roscoe, T., *The Tourist in Spain (Jennings' Landscape Annual)*, with illustrations by David Roberts, 4 vols, London, Jennings, 1835–38.

Rosenberg, J.D., *The Darkening Glass, a Portrait of Ruskin's Genius*, London, Routledge, Kegan Paul, 1963.

——, 'Style and Sensibility in Ruskin's Prose', *The Art of Victorian Prose*, ed. G. Levine and W. Madden, New York, London and Toronto, Oxford University Press, 1968.

Ryle, J.C., *Evangelical Religion, What It Is and What It Is Not: Truths for the Times*, London, 1867.

Salamon, L., 'The Pound-Ruskin Axis', *College English*, vol. 16 (February 1955), pp. 270–6.

Saussure, H.B. de, *Voyages dans les Alpes*, 4 vols, Neuchâtel 1779–96.

Scott, E.H., *Ruskin's Guild of St George*, London, Methuen, 1931.

Shaw, B., *Ruskin's Politics*, London, Christophers, 1921.

Sherburne, J., *John Ruskin or the Ambiguities of Abundance*, Cambridge, Mass., Harvard University Press, 1972.

Smith, A., *An Inquiry into the Nature and Causes of the Wealth of Nations*, ed. Cannan, 6th edition, 2 vols, London, Methuen, 1961.

Sonstroem, D., 'John Ruskin and the Nature of Manliness', *Victorian Newsletter*, no. 40 (Fall 1971), pp. 14–17.

Spence, M.E., 'The Guild of St George', *Bulletin of the John Rylands Library*, vol. 40 no. 1 (September 1959), pp. 147–201.

Staley, A., *The Pre-Raphaelite Landscape*, Oxford, Clarendon Press, 1973.

Sykes, J.A.C., *Mark Alston, an Impression*, London, Eveleigh Nash, Fanside House, 1908.

Townsend, F.G., *Ruskin and the Landscape Feeling (Illinois Studies in Language and Literature*, vol. 35 no. 3), Urbana, University of Illinois Press, 1951.

Walker, W., 'J.D. Harding', *The Portfolio, An Artistic Periodical* (1880), pp. 29–33.

Walton, P., *The Drawings of John Ruskin*, London, Oxford University Press, 1972.

Warren, A.H., *English Poetic Theory 1825–1865*, Princeton, Princeton University Press, 1950.

Whitehouse, J.H., *Vindication of Ruskin*, London, Allen & Unwin, 1950.

Wilberforce, W., *A Practical View of the Prevailing Religious System of Professed Christians . . . Contrasted with Real Christianity*, 6th edition, London, Cadell & Davies, 1798.

Wilenski, R.H., *John Ruskin*, London, Faber & Faber, 1933.

Williams, C., 'Ruskin's Late Works, *c.* 1870–1890: with particular reference to the Collection made for the Guild of St George, the St George's Museum established at Sheffield, 1875–1953, and now at Reading University', unpublished Ph.D. thesis for University of London, 1972.

Williams, R., *Culture and Society*, Harmondsworth, Penguin, 1961.

Williams, S., *A Disciple of Plato*, Glasgow, Wilson & McCormick, 1883.

Wordsworth, W., *The Prose Works of William Wordsworth*, ed. W.J.B. Owen and J.W. Smyser, 3 vols, Oxford, Clarendon Press, 1974.

Zorzi, A., 'Ruskin in Venice', *Cornhill Magazine*, new series vol. 21 (August & September 1906), pp. 250–265, pp. 366–80.

Sources of Illustrations

The medium is given in each case. Illustrations from printed books were photographed at the British Library, London (BL).

Pages 8–12: 1 Oil; Galleria Sabauda, Turin. 2 Water-colour; Wellesley College Library. 3 Water-colour, body-colour, pencil; Fogg Art Museum, Harvard University, gift of Mr and Mrs Philip Hofer. 4 Water-colour; Ashmolean Museum, Oxford. 5 Oil; Tate Gallery, London.
Pages 85–115: 6 Water-colour; Ashmolean Museum, Oxford. 7 Pencil; University of Reading (Guild of St George and Ruskin Collection). 8 Water-colour, pencil; Ruskin Galleries Trust, Bembridge School, Isle of Wight. 9 Engraving; B.L. 10 Engraving from *Works*, vol. 2; B.L. 11 Engraving; B.L. 12 Water-colour, pencil; Museo Capitolino, Rome. 13 Lithograph from *Works*, vol. 1; B.L. 14 Oil; National Gallery, London. 15 Water-colour; British Museum, London. 16 Engraving; B.L. 17 Water-colour; Victoria and Albert Museum, London. 18 Pencil; Ruskin Galleries Trust, Bembridge School, Isle of Wight. 19 Pen, water-colour; Ashmolean Museum, Oxford. 20 Engraving from *Works*, vol. 6; B.L. 21 Engraving from *Works*, vol. 9; B.L. 22 Oil; by permission of Sir Francis Cooper, Bt. 23 Pencil, wash; Brantwood Trust, Coniston, Cumbria. 24 Oil on panel; Museo di S. Marco dell'Angelico, Florence; photo Mansell. 25 Pen, wash; Ruskin Galleries Trust, Bembridge School, Isle of Wight. 26 Pen and sepia, for *Liber Studiorum*; British Museum, London. 27 Oil; Tate Gallery, London. 28–9 Engravings from *Works*, vol. 6; B.L. 30 Water-colour, brown ink; Fogg Art Museum, Harvard University, gift of friends and former pupils of Professor C. H. Moore. 31 Oil; private collection. 32 Pen, wash; Ashmolean Museum, Oxford. 33 Engravings (as arranged in *Contrasts* . . .); B.L. 34 Pen, water-colour; Ruskin Galleries Trust, Bembridge School, Isle of Wight. 35 Detail of fresco; Lower Church, Assisi; photo Mansell. 36 Engravings from *Works*, vol. 20; B.L. 37 Water-colour; Somerville College, Oxford; photo R. L. Wilkins. 38 Engraving; B.L. 39 Pencil; Brantwood Trust, Coniston, Cumbria; photo Sanderson & Dixon. 40 Water-colour; Ashmolean Museum, Oxford. 41 Photograph; University of Reading (Guild of St George and Ruskin Collection). 42–3 Water-colour; Ashmolean Museum, Oxford. 44 Illustration from *Works*, vol. 1; B.L. 45 Water-colour; Ashmolean Museum, Oxford. 46 Engraving; Ashmolean Museum, Oxford. 47–8 Water-colour; Ashmolean Museum, Oxford. 49 Engraving from *Works*, vol. 22; B.L. 50 Photograph; University of Reading (Guild of St George and Ruskin Collection).

Index

Figures in italic are illustration numbers.

Ackworth, Mrs 162–3
agriculture 183–4, 185–6
alienation 136–7, 145
Alison, Archibald 33, 55
allegory 27, 155–6, 157; in art 34, 80, 81–3
Alps 19–20, 21, 27, 29, 30–1, 75, 149; *7, 8*
Amalfi 66, 75; *3, 23*
*Amateur's Portfolio of Sketches,
The* 38; *12, 13*
Amiens 49, 187
anatomy 21, 130, 178–9
Angelico, Fra 68, 144, 145, 164, 199; *24*
Architectural Magazine 51
architecture: Greek 134; Gothic 51–2, 128–9, 131, 134–5, 138; JR's interest in 37, 67; and JR's social theory 128–35, 138, 144–5; and nature 48–52, 62–3, 128, 130–1, 134–5; and the picturesque 48–9, 50, 51–2; Renaissance 131, 134, 145; Roman 134, 207; and St George's Museum project 186–7
Aristotle 66, 197, 201, 202, 206, 211
Arnheim, Rudolf 208–9
art education, *see* education
Arundel Society 175
Assisi 164
association 55–6, 151, 158
Athena 156–8, 162, 210; *36*
authoritarianism 140, 190

Bacon, Francis 151
beauty, classes of: 'typical' 58–9, 61–4, 71, 75, 77, 127–8, 211; 'vital' 58, 59
Bellini, John (Giovanni) and Gentile 68
Bentham, Jeremy 139
Bible 82, 146, 158, 181, 196, 197; authority of 23, 24, 26; Eighth Psalm 165; erosion of authority of 121–3, 127; and justice 140, 151; *and see* typology
bird, image of 157
Blackwood's Magazine 80
Blenheim Palace 15
Board of Trade 183, 185
botany 158, 175–8, 179, 185, 186
Brett, John 64, 65, 75; *22*
Brevent 30, 53, 55, 125
Bridgewater, eighth Earl of 22
Broadlands 162–3, 166
Brown, Ford Madox 180
Buckland, Rev. William 22–4, 25, 58, 122, 176
Burke, Edmund 32–3, 34, 49
Burne-Jones, Sir Edward 175
Byron, George Gordon, Lord 14, 16

capitalism (-ists) 140–3, 150, 153, 182, 183, 184–5
Carlyle, Thomas 123, 138, 143, 144, 168, 180, 201, 205
Carpaccio, Vittore 163, *37*
Carshalton 168
Chamonix 19, 30
Chatsworth House 15–16, 47
Chaucer, Geoffrey 151
Christ 26, 27, 71–2
Cimabue 164
Clark, Kenneth, Lord 192
classicism 34, 61, 74, 134, 203, *and see* Greek culture
Claude Lorrain 15, 34, 38, 39, 40, 47, 52, 67; *Marriage of Isaac and Rebecca*, 43–4, 74; *14*
Claude glass 35
cloud, image of 155, 159–60, 191, 192, 210
Cole, Henry 171, 172
Colenso, Bishop John William 121
Coleridge, Samuel Taylor 20, 31, 70, 73, 201
Collingwood, R.G. 204–5, 206
Collingwood, W.G. 205
colour: Athena and 157–8; and

form 207; and harmony 74; and heraldry 158, 179; primacy of over chiaroscuro 197–200; symbolism of 158, 179, 194; Turner's use of 83–4, 158; Whistler's use of 196
Communism 130; *and see* Marx
Continental tours, JR's: (1833) 19, 36, 37; (1840–41) 37; (1845) 41, 46–7, 54, 67
Copley Fielding, Anthony Vandyke 36–7, 38, 40, 45
Cornhill, The 138–9, 149
Correggio, Antonio 199
Cowper-Temple, Mrs (Lady Mount-Temple) 162–3
Cox, Margaret, *see* Ruskin, Margaret
Creation of the world 23, 63, 77, 155–6
Crystal Palace 186

Daily Telegraph 139
Dante Alighieri 72–3, 82, 83, 151
Darwin, Charles 176
death: conflict with life 123, 141–3, 146–7, 151, 154, 160, 190; fear of 78, 123, 178–9; 'laws of' 131; and mountains 126–7; Queen of 156; and snake image 157
Department of Science and Art 170
Dixon, Thomas 180
Domecq, Adèle 25, 38, 160, 192
Domecq, Pedro 38
drawing, teaching of 169–73, 177, 178–9, 189
drawings, JR's 14, 36–7, 38–9, 41–2, 46, 51, 66, 75–6; *7, 8, 10, 12, 13, 16, 18, 19, 23, 28–30, 32, 34, 39*
dreams: in Bible 79; JR's 157, 159
Dublin lecture (1868) 159, 161
Dürer, Albert (Albrecht) 175
Dutch painting 34–5, 39, 43, 52–3

economics: classical 137, 139; JR and 117, 120, 132, 136–43, 148, 149, 150–2, 182, 201–2; Utilitarian 136, 137, 138, 139–40
economy, political 132, 138, 149–50, 201
Edinburgh lectures (1854) 120, 170

education: in art 169–74, 177–80, 189; JR's, 24–5, 195, 196; museums and 186; popular 149, 152, 167, 170–2, 177–8, 180, 182–3, 184–5, 190
Energy, type of 61, 63
Essays and Reviews 121
Evangelicalism, *see* Protestantism
evil 27, 142, 159, 204
Eyre, Governor 168

Fate 180–1; Queen of 156
Fergusson, James 157
Florence 38, 68
Florentine artists 68, 179, 187, 203; *and see* Angelico; Giotto
Fontainebleau 41–2, 209
France 19, 41, 135; revolutions in (1848) 129–30
Franco-Prussian war 153, 168
Fraser's Magazine 149, 151

Gainsborough, Thomas 164
Geological Society 177
geology: and architecture 130–1; and art 43–4; and the Bible 27, 121–2; JR's interest in 19–23, 27, 41, 68, 149, 158, 177, 185, 186
Gilpin, Rev. William 33, 48
Giorgione 147
Giotto 164, 199
Goethe, J.W. von 143, 151
Gothic architecture 51–2, 128–9, 131, 134–5, 138, 152, 191
Gothic art 35, 78, 145, 173, 174, 199
Gothic Revival 128–9
Gray, Euphemia (JR's wife) 119–21, 130, 161, 192
Greek culture: architecture 134; art 164, 173, 174, 175, 203; and colour 157–8; mythology 82, 155, 158, 181, 186; philosophy 66, 142, 186, 211; *and see* Aristotle, Plato, Socrates; sculpture 173, 199
'Greek school' in art 199–200
grotesque, the 78–80
Guild of St George, *see* St George

Harding, J.D. 39–40, 41, 42, 45, 46, 68, 198
Harpies 158–9
Hegel, G.W.F. 205, 206, 208, 211
Hegelianism 204–5

heraldry 158, 174, 175, 179; *49*
Herbert, George 151
Herne Hill 14
Hill, Octavia 168
Historicism 204, 205
Hobbes, Thomas 70
Homer 82, 151, 153, 158
Hooker, Richard 54
Hunt, William 38, 174–5
Hunt, William Holman 63

imagery, *see* symbolism
imagination: associative 69–70, 73–4, 76–7, 131; contemplative 69–70, 77–8; JR's views on 55, 57, 65–118, 146, 155; penetrative 69–70, 71–2, 73, 76, 197; symbolic 76–81, 155; sympathetic 57; visual 194–5, 197
Industrial Revolution, industrialization 52, 83, 135–6, 143, 160, 166, 168
Italian painting 34–5, 39, 43, 52–3, 67–8, 144–5; Primitive 67, 68, 80, 129, 146–7, 164–5, 200; *35*; *and see* Florentine art, Venetian art
Italy, JR in: (1833) 19; (1840–41) 38, 66; (1845) 45–6, 47, 54, 67–9, 75; (1858) 123–5; (1874) 164; (1876) 163; *and see* Florence, Italian painting, Venice

Jameson, Robert 19, 21, 22, 44
Job 122
Joyce, Jeremiah 19
justice 60–1, 140, 141, 151–4, 156, 184

kingship 151–4, 156, 159, 160, 165, 167, 184, 191, 204, 210
Knight, Richard Payne 33–4, 48

labour, JR's social theories and 136–49 *passim*; and art 137, 143, 148–9, 171, 185; division of, 136, 201–2; and moral regeneration 129, 149; value of 140–1, 183–4
Ladd, Henry 73
Landow, George 55, 56, 124
landscape: JR's loss of feeling for 125–6; JR's passion for 13, 17–19, 28; *and see* landscape painting
landscape painting: and decline of architecture 131; Dutch

34–5, 39, 43, 52–3; Gothic 35; Italian 34–5, 39, 43, 52–3; JR on 17–18, 22, 28, 32, 43–5, 63, 66–7, 73, 75–6, 125–6, 146, 195; and man 146; Pre-Raphaelite 64; pre-Renaissance 146–7; Romantic 35; topographical 35, 66, 75; and 'typical beauty' 63; Victorian 44–5, 52; *and see* picturesque; Turner
La Sizeranne, Robert de 194
La Touche, John 160, 161
La Touche, Mrs John 160, 161, 163
La Touche, Rose 160–4, 191–2; *39*
Leonardo da Vinci 145, 199
Liddell, H.G. 66
life: JR's affirmation of 123–5, 145, 164; conflict with death 123, 141–3, 146, 151, 154, 160, 203–4, 210; force 156–7; 'laws of' 131; type of 63; as wealth 141
light: conflict with dark 84, 141–2, 146, 151, 153–4, 160, 199–200, 201, 204, 210; and colour 157–8, 198–200; in Fra Angelico 68; and shade 198–200, 207, 209; and spiritual insight 196–7, 200–1, 211; Turner's use of 59, 68, 83–4, 200; type of 59, 61, 63, 142, 200–1
Linnaeus, Carolus 176
Locke, John 70, 197–8
Logicism 204
Lombard art 203, 207
London 28, 129, 147, 181–2; British Institution 177; British Museum 177; National Gallery 81, 174, 186; Working Men's College 138, 167, 170, 185
Loudon, J.C. 51
Lyell, Charles 122

MacDonald, Alexander 172, 175
madness, JR's 148, 158, 159–61, 165–6, 167, 180, 181, 192, 204
Madonna 156, 158
Malthus, Rev. Thomas 139
Manchester Art Treasures Exhibition (1857) 138
Manchester Review 149
Manichean philosophy 204

Mansion House Committee 168
Marx, Karl 136–7, 138, 140, 143, 145, 205; Marxism 206
Maurice, Rev. F.D. 138, 180
Mechanics' Institutes 170
Meersbrook Park 188
Melvill, Henry 25, 26
Michelangelo Buonarroti 45, 60, 145, 179, 199
Mill, John Stuart 138–9
Millais, John Everett 63, 120–1; *31*
Millais, William 120
Milton, John 82, 151
mineralogy 19, 21, 22, 23, 142, 179, 186, 187, 201
mind, models of 70, 79
mirror: as image of soul 146; Platonic image of 70, 79, 80
Moderation, type of 59
Moreau, Gustave 193
Morris, William 138
Moses 23, 26, 158
mountains 13, 16, 18, 19–21, 28, 30–1, 43–4, 68; and architecture 131; 'Gloom of' 126–7, 159; 'Glory of' 127; symbolism of 27; *and see* Alps, the
mythology: and botany 175–6; Greek 82, 155, 157, 181, 186; JR and 82–177; JR's personal 155–60; and natural science 177

Napoleon III, Emperor 130, 153
natural science, *see* science
natural theology 58, 122, 127, 176; *and see* Buckland
Neoclassicism 40, 51, 59, 61, 198
'National Store' 183–4, 186, 189
Newdigate poetry prize 17, 37
Normandy 120, 129; Norman art 203
Norton, Charles Eliot 124–5, 149, 160

Olander, Kathleen 192
Old Water-Colour Society 32, 36, 39, 45
opposites, JR's system of 148, 202–7
order 59–60, 73; and society 140
ornithology 177
Oxford: Ashmolean Museum 171, 173; Natural History

Museum 51, 167, 186; *19*; Ruskin School of Drawing 169, 170, 174, 175–6, 178, 187, 188; University Galleries 171, 173, 179–80

Oxford University: JR at 14, 17, 22, 37–8, 70, 122; JR's lectures at (1870s) 153–4, 164, 169, 171, 179–80, 188, 198; JR Slade Professor of Art at 49, 169–76, 179–80, 188–9; road-building project at 168

Paris 129, 168; Louvre 195

Pascal, Blaise 122

pathetic fallacy 72–3, 195

Pausanias 82

perfection, evils of 135, 144–5, 207

philosophy: Greek, *see under* Greek culture; JR's 204–12; Manichean 204; nineteenth-century 204–5

Picturesque, the: 32–9, 55; and architecture 131; JR's criticisms of 32, 42–53, 63–4, 74, 180

Pisa 67, 187

plague-wind, image of 159–60, 166, 191

Plato 66, 70, 79, 151, 155, 197, 201, 206, 211; *Laws* 189; *The Republic* 140, 189

poetry 14; JR's, 14, 17–18, 31, 37, 46; and painting 72; Romantic 16–18, 24, 25–6, 28, 31, 59, 73, 144; *and see* Coleridge, Wordsworth

politics, JR's 130, 152, 190

Pound, Ezra 210

Poussin, Gaspard (Gaspard Dughet) 34, 38, 67

Poussin, Nicolas 34

Pre-Raphaelite Brotherhood 63–4, 170

Price, Uvedale 33, 35, 47, 48

prophet, artist as 79, 80–1, 82, 118

proportion 60

Proserpine 156

Protestantism, Evangelical: and architecture 128–9, 134; and authoritarianism 140; and authority of Bible 24, 26, 121–3, 127; and dialectical thought 211–12; and John La Touche 160; and JR's loss of faith 121–4, 127; and

JR's upbringing 14–15, 24–7, 30, 67, 73, 77, 78, 79, 80–1, 127; and JR's writing 31, 54–5, 61–2, 63, 80–1, 155, 211–12; and justice 140, 152; *and see* typology

Proust, Marcel 193–5, 205

Prout, Samuel 19, 37, 38–9, 40, 45, 48, 49–50, 174, 175; *17, 48*

psychology: JR's 117, 119, 121, 159–60, 178, 191–3; *and see* madness; Jungian 191; Lockeian 70, 197; nineteenth-century 57, 211; and snake image 157

Pugin, Augustus Welby 51, 129, 134; *33*

Purity, type of 61, 63, 131, 142

Queen of the Air, *see* Athena

Queenship 154–5, 158, 159, 160, 166, 191, 204, 210

Raphael (Raffaelle Sanzio) 144, 145

Reading University 188

Rembrandt van Rijn 15, 196

Renaissance 52, 71, 134, 145; decadence of 67–8, 78, 129, 131, 164, 200

Repose, type of 59–60, 71

revolutions (1848) 129

Reynolds, Sir Joshua 15, 60, 164, 195, 200

Rhodes, Cecil 153

Ricardo, David 137, 138–9, 140

Richardson, Mary (JR's cousin) 15, 16

Rio, Alexis 67, 129

Roberts, David 37, 39, 40; *11*

Rogers, Samuel 36, 40, 44, 174; *16*

Roman Catholicism 38, 67, 127, 128–9

Romantic movement 201; art of 35, 59, 203; and the mind 70, 79; poetry of 24, 25–6, 28, 31, 59, 73, 144; *and see* Coleridge, Wordsworth

Romanticism, JR's 30, 31, 41, 42, 61, 143; loss of 126

Rome 38; *12, 13*

Rosa, Salvator 34, 52, 67, 200

Rosenberg, John 31, 191, 192, 201, 204

Rouen 129, 135

Rousseau, Jean-Jacques 24, 137

Royal Academy 30, 39, 40, 45,

54, 64, 66, 200; School of 170, 171, 172

Runciman, Charles 36

Ruskin art collection 173–5; *45–8*

Ruskin, Euphemia, *see* Gray

Ruskin, John, works mentioned in text:
The Aesthetic and Mathematical Schools of Art in Florence 203; *The Bible of Amiens* 187; *Deucalion* 177, 187; *Eagle's Nest* 200; *The Elements of Drawing* 50, 74–5, 172; *The Elements of English Prosody* 187; *The Elements of Perspective* 172; *Ethics of the Dust* 201; *Fors Clavigera* 124, 150, 159, 163, 175, 180–2, 185, 189, 196, 200; *Guide to . . . the Academy at Venice* 187; *Iteriad* 16, 19; *The King of the Golden River* 119–20; *The Laws of Fésole* 172–3, 174, 179, 187, 199; *Lectures on Art* 198, 200; *Love's Meinie* 177, 187; *Modern Painters* 14, 32, 42, 44–5, 75, 128, 165, 198, 202, 204, vol. 1 42–6, 48, 54, 76, 146, vol. 2 54–62, 76, 77, 176, 206, 211–12, vol. 3 28, 54, 69, 73, 80, 125–6, 195, 206, vol. 4 22, 46, 49, 75, 76, 126, vol 5 47, 76–7, 81, 119, 128, 143, 145, 146–7, 150, 184; *Mornings in Florence* 87; *Munera Pulveris* 149, 151–2, 154, 201; 'The Mystery of Life and its Arts', 159, 161; *The Poetry of Architecture* 51, 131; *The Political Economy of Art* 138; *Praeterita* 14, 19, 24, 36, 41–2, 124, 130, 160, 181, 196; *Proserpina* 177, 187; *The Queen of the Air* 154–9, 162, 176, 194; *St Mark's Rest* 153, 187, 196; *Sesame and Lilies* 154, 159; *Seven Lamps of Architecture* 48, 51, 125, 128, 129, 132, 203; *The Stones of Venice* 52, 78, 80, 128, 132–5, 137, 176–7, 187, 198; *The Storm Cloud of the Nineteenth Century* 142; *Time and Tide* 180; *The Two Paths* 170, 171; *Unto this last* 138–43, 146, 148, 151, 154, 194, 200

Ruskin, John James (father) 13–15, 16, 19, 38, 40, 68, 130,

138; death of 149–50; JR's relations with 14, 30, 45, 119, 140, 149–50

Ruskin, Margaret (mother) 13–15, 24, 26, 37, 38, 119, 120, 149, 168

Rydal 16

Ryle, Rev. J.C. 24, 26

St George 190

St George, Guild of 158, 172–3, 177, 182–90, 196; Museum of 174, 185–8, 189; *50*

St Paul 123

St Ursula 163, 165; *37*

Saturday Review 149

Saussure, H.B. de 19, 20, 21, 29, 176

science 20–1, 26; 'of aspects' 28–9, 46, 126, 177–8; JR's later writings on 176–9; natural 19–21, 24, 30, 157, 185, 186, 187 (and architecture), 130–1; JR's objections to 177–9, 202, 209; and oppositions 207; and religion 20–1, 22–4, 28–9, 63, 121–3, 176; *and see* anatomy, botany, geology, mineralogy

Scotland 13, 120–1

Scott, Sir Walter 14, 153

sculpture 67, 78, 130, 158, 173, 185, 186

Severn, Joan 163

Shakespeare, William 14, 82, 151

Sheffield 185, 186, 187; Corporation of 188

Sherburne, James 201

sin 24–5, 27, 60–1, 84; fear of 78, 123

Sion 127, 133

Sirens 158–9

Sismondi, J.C.L. de 67

Slade, Felix 169

Smith, Adam 136, 137, 138, 139, 140

snake, image of 82–3, 84, 157, 196–7

social criticism, JR's 46–8, 61, 78, 129, 136–7, 138, 142, 149, 166, 180, 181–2, 202

social theory, JR's 128ff., 147–54 *passim*; and action 149, 167f., 180, 182–4, 188–90; and artist's role in society 125, 128, 132, 138, 143–7, 203

Socrates 189

'South Kensington system'

170–1, 172, 173

Spenser, Edmund 82, 151

Spiritual Times 35

spiritualism 162–4

Stanfield, Clarkson 45, 50, 66

symbols(-ism), JR's 63, 65, 73, 76–84, 117, 146, 155–60, 167, 168, 176, 181; consistency of 202; and JR's psychology 117, 191, 193; obsessiveness of 193–5, 202; and reading of JR 194–7, 200–1, 208, 210, 211–12; theory of universal 128, 142

Symbolist movement 193

Symmetry, type of 60–1, 140

system, JR's rejection of 69, 151, 165, 212

sublime, the 33, 35, 49

Swan, Henry 185

Switzerland 19, 40, 51, 126–7, 149

Sykes, Jessica: *Mark Alston* 192

Thackeray, William Makepeace 138

theoretic faculty, *theoria* 57–8, 61, 66, 69–70, 165, 211, 212

Times, The 64

Tintoretto, Jacopo 68–9, 71–2, 80, 133, 145, 164, 179, 199, 207; *25*

Titian (Tiziano Vecelli) 68, 145, 164, 199, 200, 207

Townsend, Francis 125

Turin 123–5, 145–6, 164, 209

Turner, J.M.W.: *Apollo and Python* 81, 83–117, 147, 155; *5*; attacks on 30, 31–2, 40, 42, 65; bequest of 81, 186; and colour 83–7, 158; 'delight drawings' by 40–1, 75; *1*; *The Garden of the Hesperides* 81–3, 147; *27*; JR's admiration for 30, 36, 38–53 *passim*, 54, 66, 75–7, 80; JR's analysis of 43, 49–50, 54–5, 74, 75–7, 80–5, 117–18, 143–4, 147, 192; JR's defence of 40, 42, 54–5, 65, 83, 128, 202; and landscape 44, 147, 187; *Liber Studiorum* 39–40, 74, 174; *26*; and light 44, 59, 68, 83–4, 200; and London 147; and the picturesque 49, 50, 52–3; and Ruskin Art Collection 174, 175; and social conditions 159, 164, 165, 167; and

truth 40, 43–4, 205; *5, 9, 15, 16, 26, 27, 45*

Turner Gallery 81, 186

truth, three orders of 65, 69–70, 82, 117, 155, 165, 172, 207–8

typology 26–7, 58–63, 77, 79, 128, 142, 208

unity; JR's sense of 61, 74, 201–2, 205, 210; type of 60, 61

Utilitarianism 136, 137, 138, 139–40

Velázquez, Diego Rodríguez de Silva y 164, 199, 200

Venetian art 145, 147, 164, 187, 207; *and see* Tintoretto, Titian

Venice: architecture of 52, 78, 129, 130–4, 147, 187; Austrian occupation of 120, 130; decline of 78, 127, 130–1, 132–4, 147, 153; Doges of 153, 183, 196; JR in 46, 120, 123, 163; St Mark's 132–4; Santa Maria Formosa 78, 79; as 'Sea-Queen' 158; *and see* Venetian art

Veronese, Paul (Paolo) 68, 123–4, 145, 164, 195–6; *1*

Virgil 83

visual perception 198–9, 208–12; and association 55–6; and imagination 70–2, 194–5; and importance of sight 71, 171, 196–7, 208; and spiritual insight 196, 200–1

Wales 13, 14–15, 185

Walkley 185; *50*

Walton, Paul 36

war, JR's views on 153–4

Whistler, James 168, 196

Whitelands College, Chelsea 174

Wilberforce, William 27

Wilenski, R.H. 191, 196

Williams, Catherine 202

Winnington School 192

women: JR and, *see* Domecq, Gray, La Touche; JR's view of 154

Wordsworth, William 16–19, 20, 21, 23, 25, 28, 31, 37, 51, 58, 70, 144

Working Men's College, *see* London

Xenophon 187